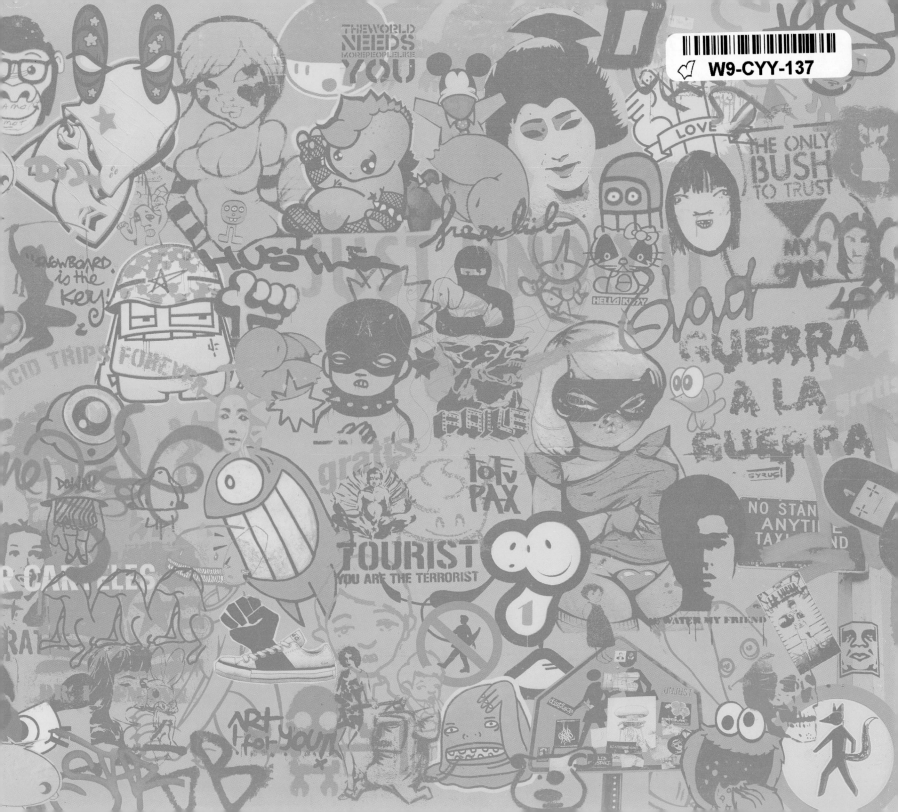

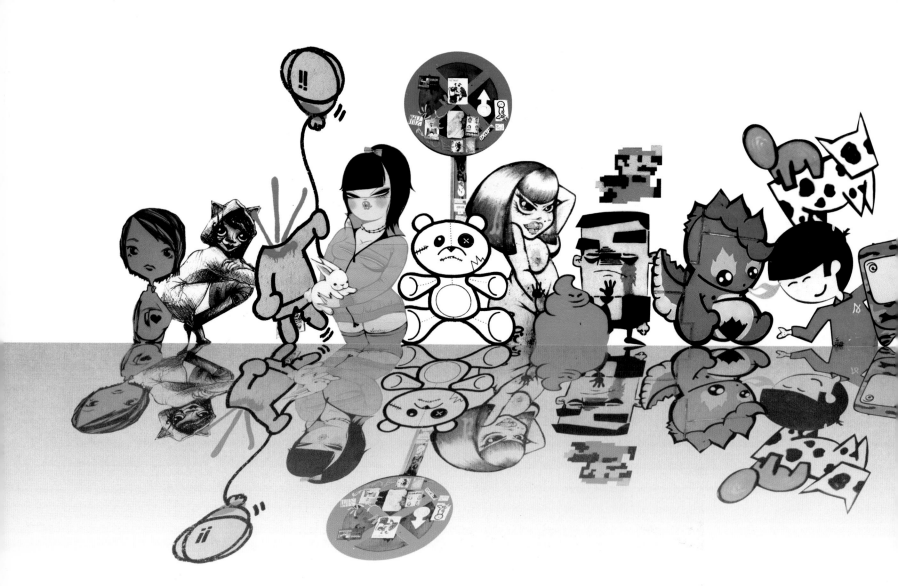

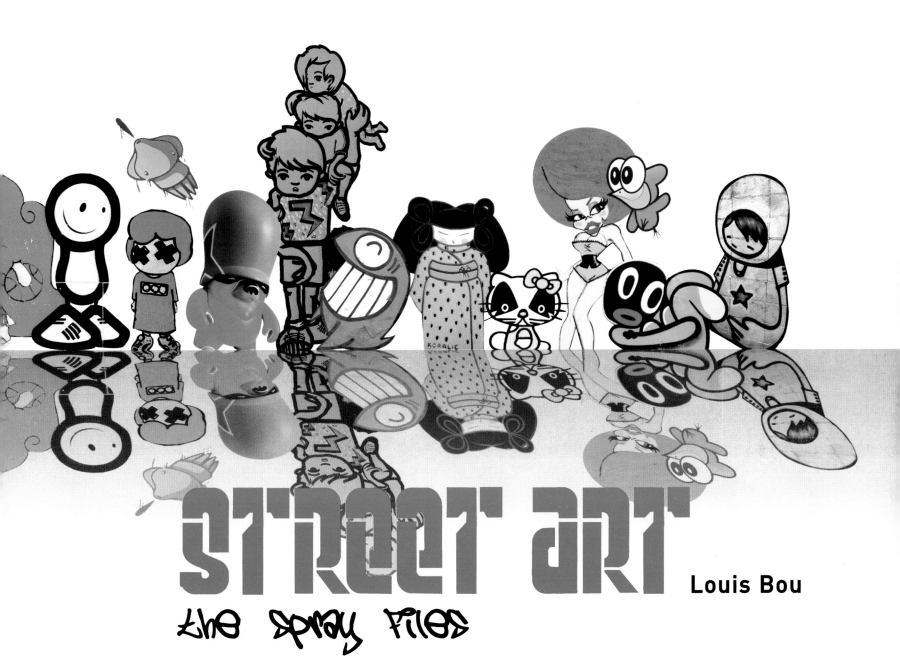

STREET ART

the spray files

Louis Bou

COLLINS | DESIGN

An Imprint of HarperCollinsPublishers

STREET ART. THE SPRAY FILES

First Edition

First published in 2005 by:
Collins Design
An Imprint of HarperCollins*Publishers*
10 East 53rd Street
New York, NY 10022
Tel: (212) 207-7000
Fax: (212) 207-7654
collinsdesign@harpercollins.com
www.harpercollins.com

Distributed throughout the world by:
HarperCollins*Publishers*
10 East 53rd Street
New York, NY 10022
Fax: (212) 207-7654

Author:
Louis Bou

Photographs:
Louis Bou

Design and layout:
Louis Bou

Library of Congress Number 2005929666

ISBN-10: 0-06-083338-6
ISBN-13: 978-0-06-083338-1

Printed in Spain by:
Industrias Gráficas Mármol, S.L

First Printing, 2005

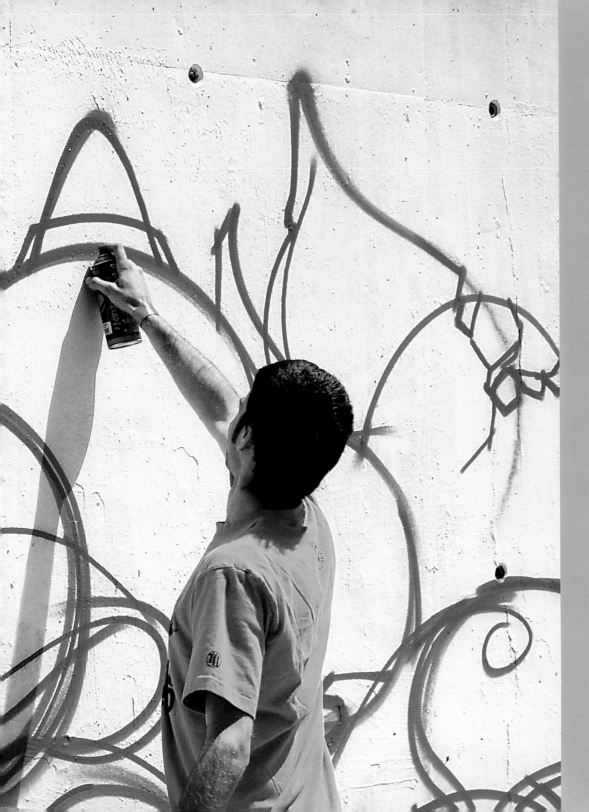

CONTENTS

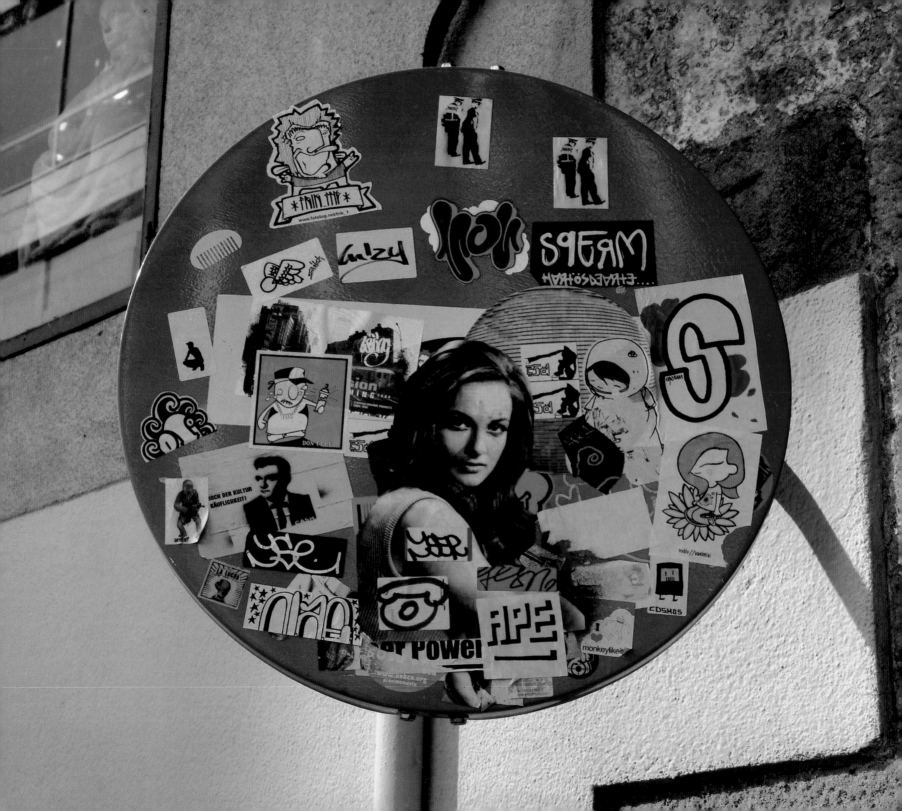

graffiti
vs
STREET ART

Street art, as its name implies, encompasses all artistic incursions into the urban landscape and derives directly from the graffiti painted on Harlem (New York) train cars in the late 1970s. Its philosophy and raison d'être have evolved, as have those of all the arts and artistic movements, as society has undergone socio-political and cultural changes, but its essence remains the same (delinquent and antisystem). Many artists call this movement "post-graffiti."

The new concept of urban art resists being caged within the walls of factories in outlying areas. Its motives are much broader than those of thirty years ago—we can speak of a new "renaissance," an explosion of creativity, new ideas, and talent with thousands of artists from all over the world who display their innovative works of art on the streets, using them as a gigantic museum. Like any evolution, street art or post-graffiti has clearly brought with it new techniques and styles, and the artists use, in addition to the sprays and permanent felt-tip markers, other forms and materials to create their works: stencils, stickers, posters, acrylics applied with paintbrushes, airbrushes, chalk, charcoal, photograph-based collages, photocopies, mosaics, and on and on. At the same time, this evolution has led to many students and professionals in the world of graphic design using street art to make their work known, studying people's reactions, and having no qualms about signing their creations with e-mail addresses, web pages, and even their telephone numbers—a clear departure from the pure "ephemeral and illegal" essence of graffiti. In any

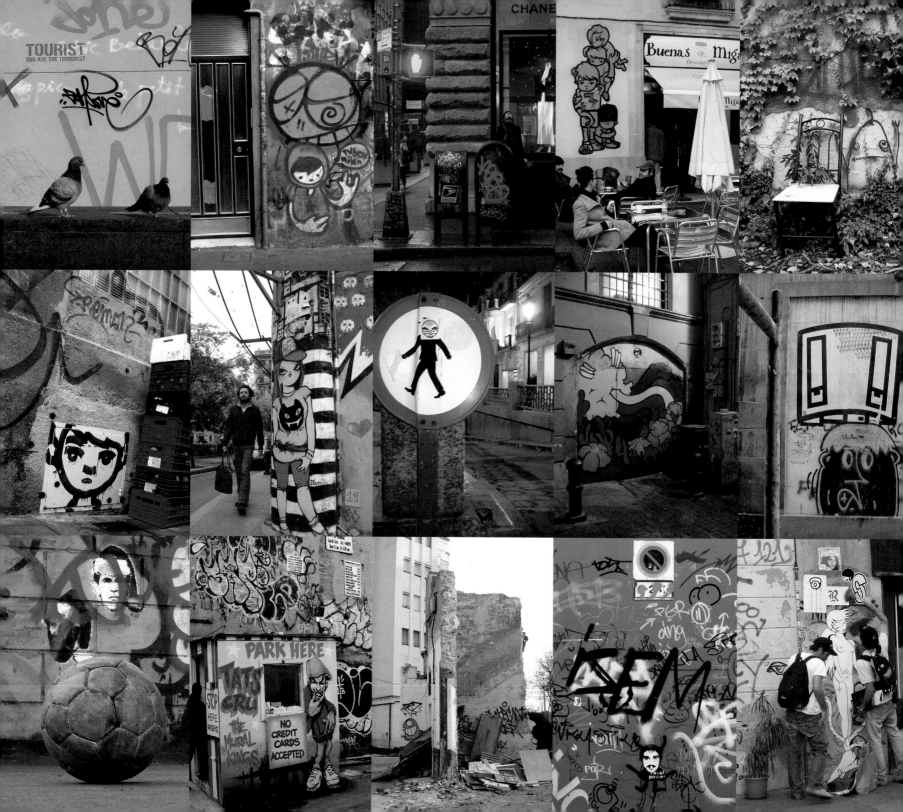

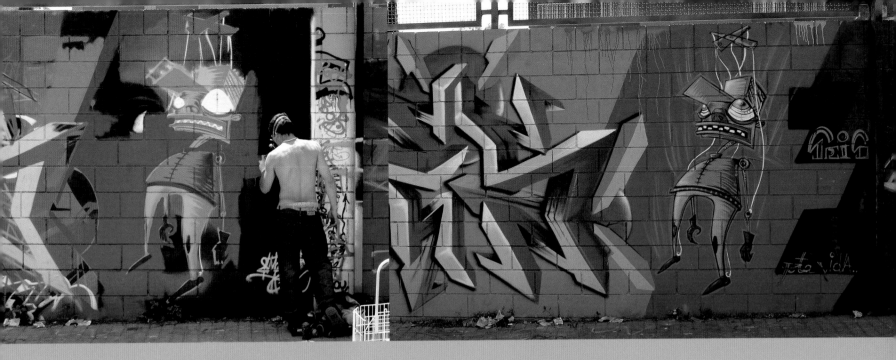

event, many artists avoid the signature or tag because they do not need to make their authorship obvious or because they do not want to create an imbalance in their work and detract from its artistry. One of the most serious concerns in the development and design of today's cities is the so-called urban landscape. Street art turns big-city streets into open-air art exhibitions, producing significant socio-cultural impact and making for more universal communication, because people who have never set foot in a museum are absorbed by this artistic macroexhibition.

The "writer" (as graffiti artists are generally called) creates his or her work as a function of the medium and the circumstances, taking advantage of the opportunities offered by the urban landscape, such as its accidents. Off the street the media can be diverse—including cardboard, paper, or canvas, which will later be moved and exhibited in a public place, although for a "writer," painting away from the street environment is not graffiti, because it is distanced from the "underground" and closer to accepted art.

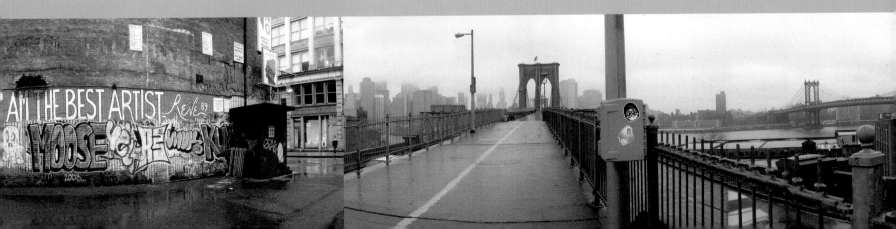

Stencils have become the favorite of thousands of artists the world over, basically because of the speed and quality they offer. We can say that stencils are classifiable as graffiti because they can be included in the concept of illegality which is implicit in the term.

The use of stencils as a mode of artistic expression goes back to the Paris of the early 1990s, which wanted to differentiate its graffiti from the graffiti that originated in New York—which had been, until then, the only model for urban artists.

Stencils are one more vehicle the artist can use to express his or her ideas, whether protesting some current sociopolitical circumstance or endlessly repeating his or her logos, drawings, and messages on any surface, as long as passersby can see it.

STENCILS

Making a stencil requires any rigid material, such as plastic laminates, cardboard, acetate, metal, wood, and even X-rays. After choosing the material, one draws or traces the motif with which the artist will later "bombard" the entire city.

Sometimes, several stencils are produced for a single work, adding various shapes and colors and more suggestive finishes.

So the artist who works with stencils needs just three basic elements:

IDEA + STENCIL + SPRAY

On the street, he or she repeats the motif insistently, marking the territory with the stencil as a tag. The more times the artist repeats his or her logo, the more prestige and respect he or she will earn from the other artists who paint in the street.

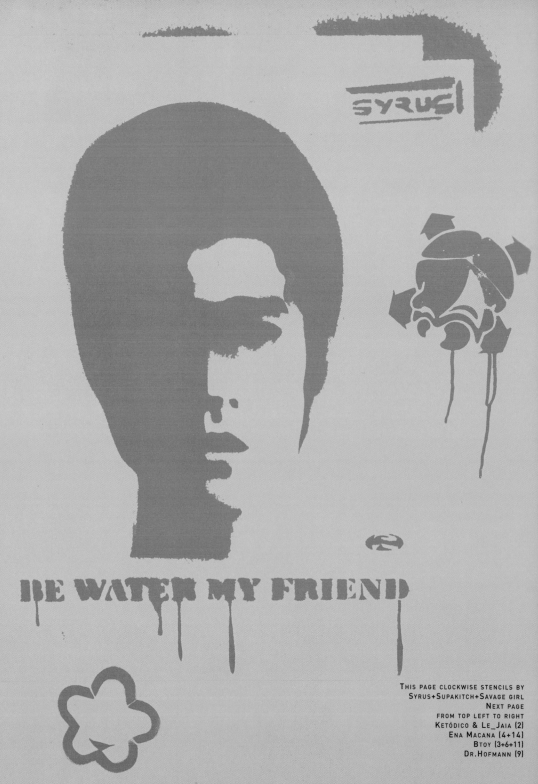

BE WATER MY FRIEND

THIS PAGE CLOCKWISE STENCILS BY
SYRUS+SUPAKITCH+SAVAGE GIRL
NEXT PAGE
FROM TOP LEFT TO RIGHT
KETÓDICO & LE_JAIA (2)
ENA MACANA (4+14)
BTOY (3+6+11)
DR.HOFMANN (9)

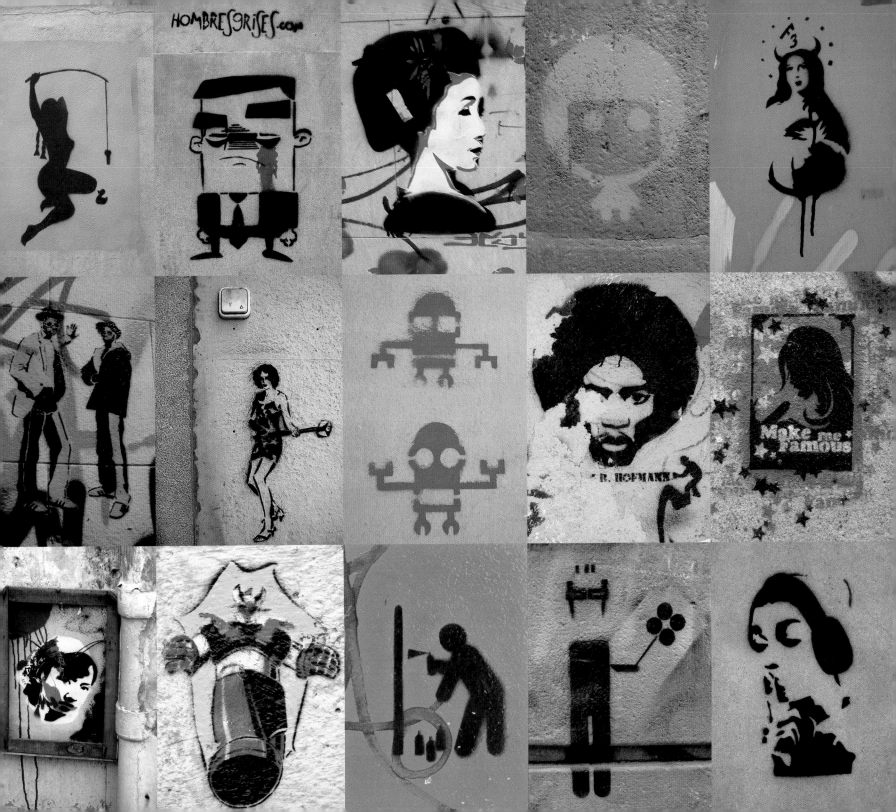

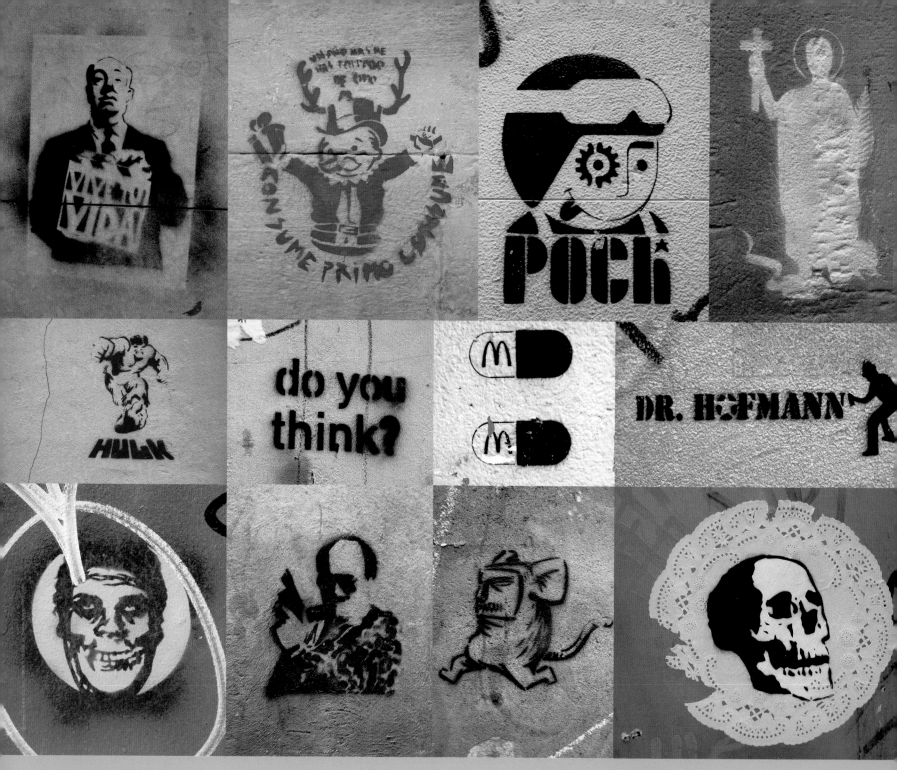

This page from top left to right Pock (3). Dr.Hofmann (8). Andre The Misfit (9).

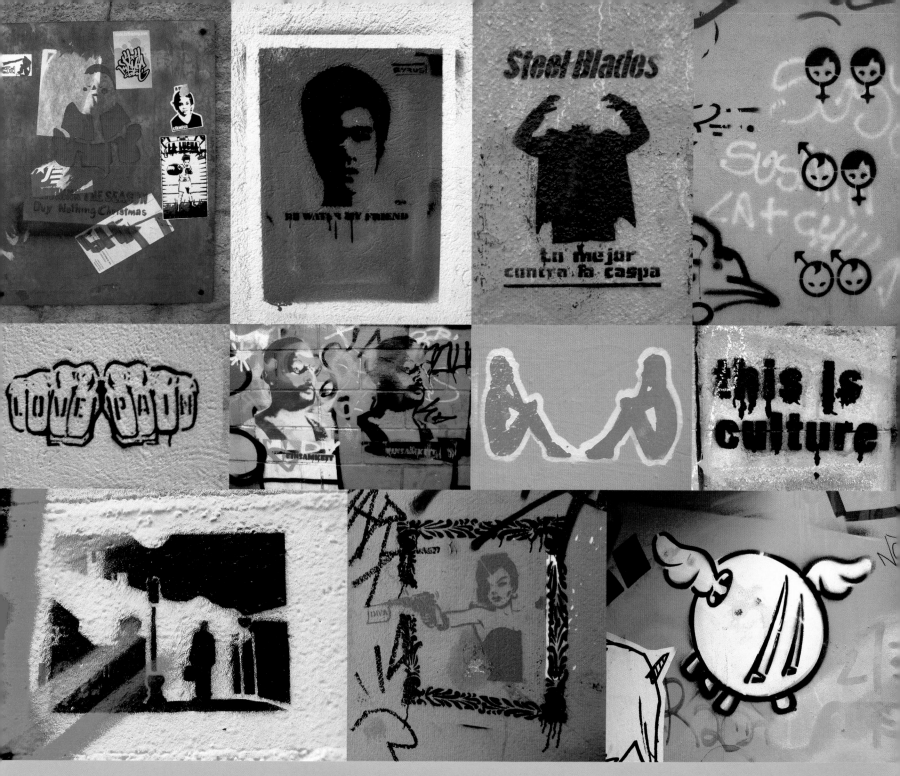

THIS PAGE FROM TOP LEFT TO RIGHT SYRUS (2). EINSAMKEIT (6). DIVA (10). D*FACE (11).

13

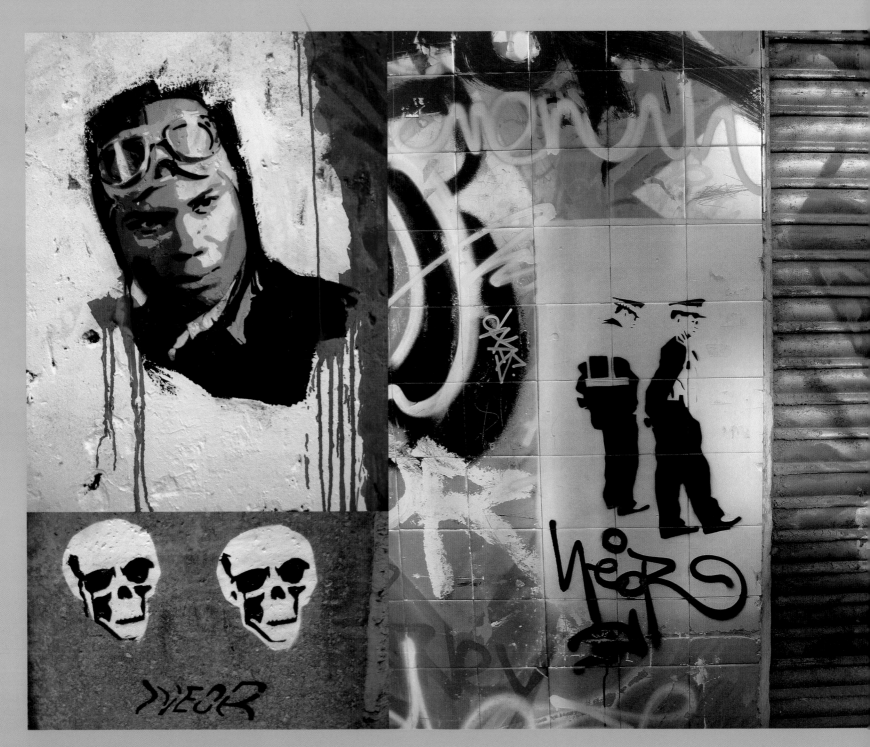

Clockwise Btoy (1). Neor (2+3).

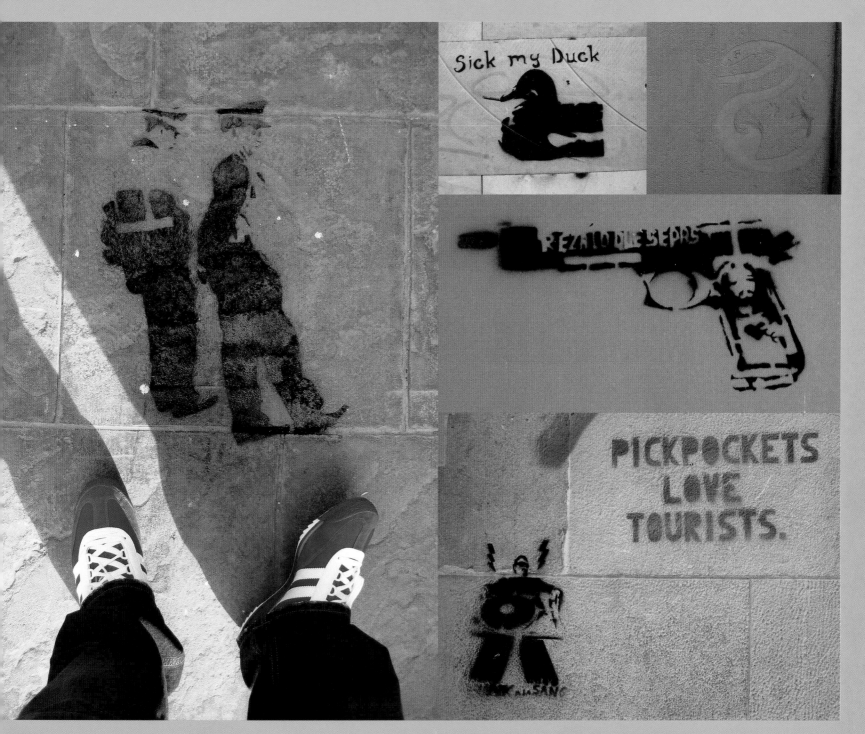

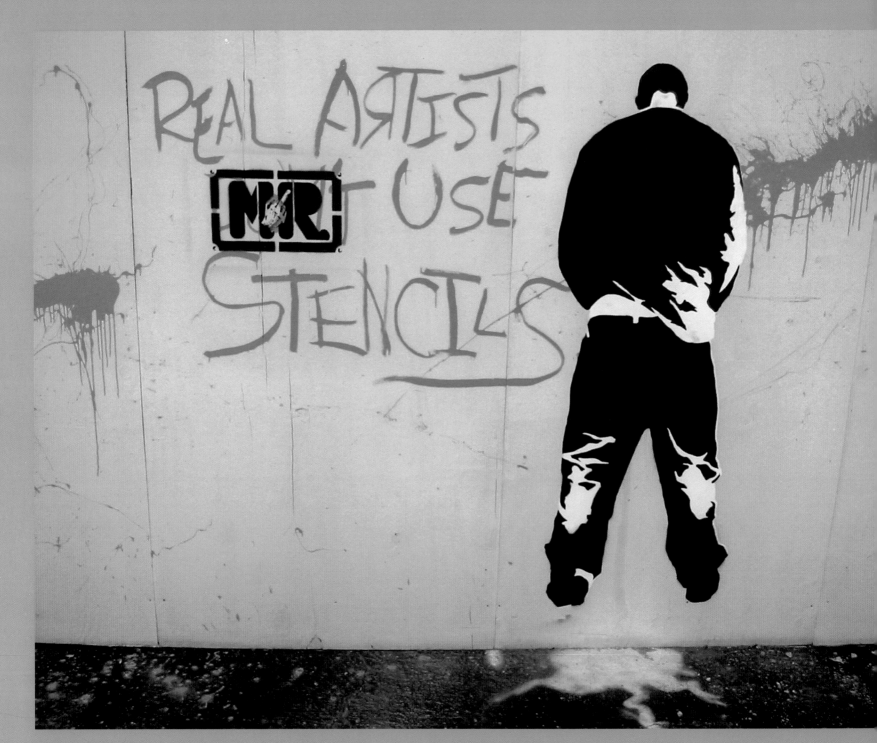

THIS PAGE MURAL BY RIPO.

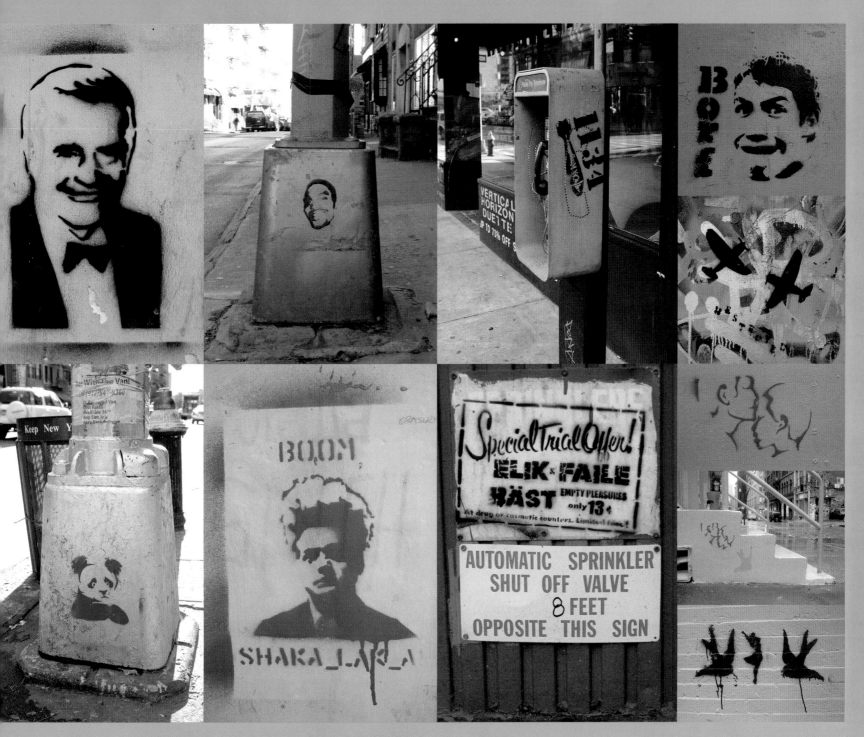

THIS PAGE FROM TOP LEFT TO RIGHT 1134 NYC (3). BORF (4). ELIK+FAILE+BÄST (8).

17

BTOY use stencils as a principal means of expression for displaying their ideas on the walls of Barcelona. Inspired by the geisha and Japanese culture, they create highly sophisticated stencils using at least three colors, achieving very attractive results of admirable quality.
Acrylic and brush is also a technique they have perfected to create characters inspired by Japanese comics, deftly mixing them with stencils.

NAME BTOY **AGE** 27&30 **CITY** BARCELONA **WORKING AREA** DESIGN AND MUSIC **SPRAY FRIENDS** EVERYONE WHO ENJOYS PAINTING & PEOPLE WHO SUPPORT THEM **SPRAY ENEMIES** PEACE AND LOVE **ARTIST YOU WOULD LIKE TO COLLABORATE WITH** WE ARE ALREADY A COLLECTIVE **YOUR FIRST GRAFFITI** IN AN ABANDONED FACTORY **YOUR DEFINITION OF STREET ART** RED BLOOD GREY CLY . . . DIRTY HANDS TWENTY THOUSAND YEARS AGO ANIMALS ON THE CAVE WALLS . . . STILL TODAY **FUTURE** A HUGE BALL OF RADIANT COLORS **FAME** 1980s DANCE TV SERIAL **SURVIVAL KIT** FOOD FOR BODY, MIND, & SOUL

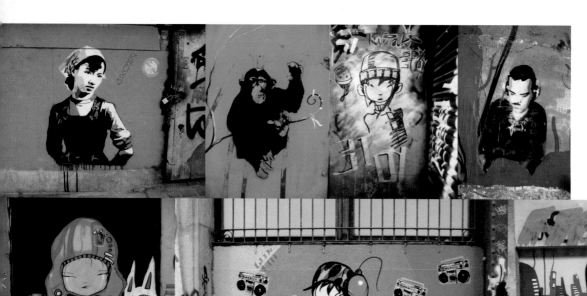

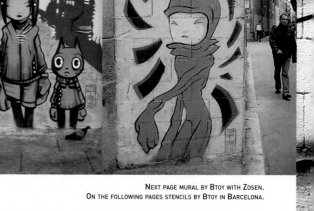

NEXT PAGE MURAL BY BTOY WITH ZOSEN.
ON THE FOLLOWING PAGES STENCILS BY BTOY IN BARCELONA.

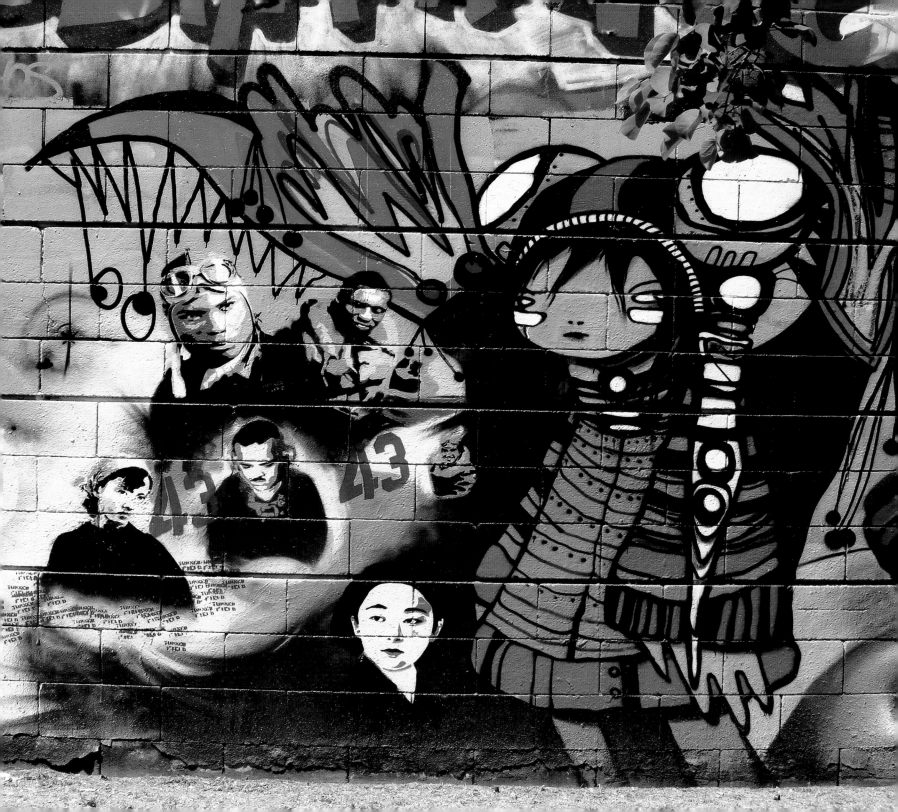

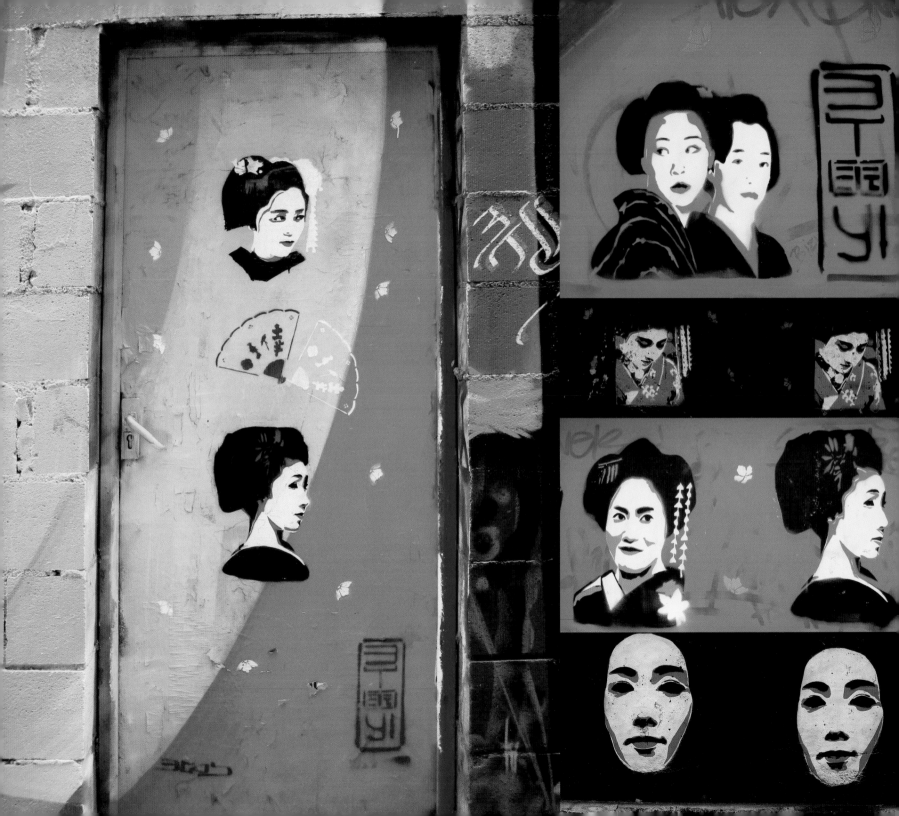

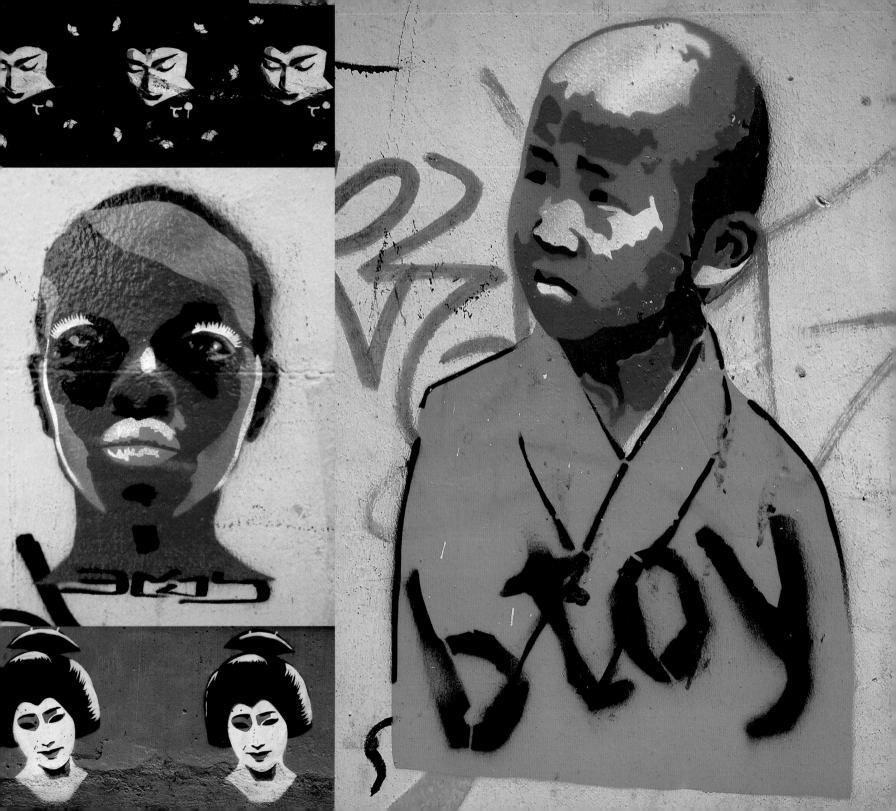

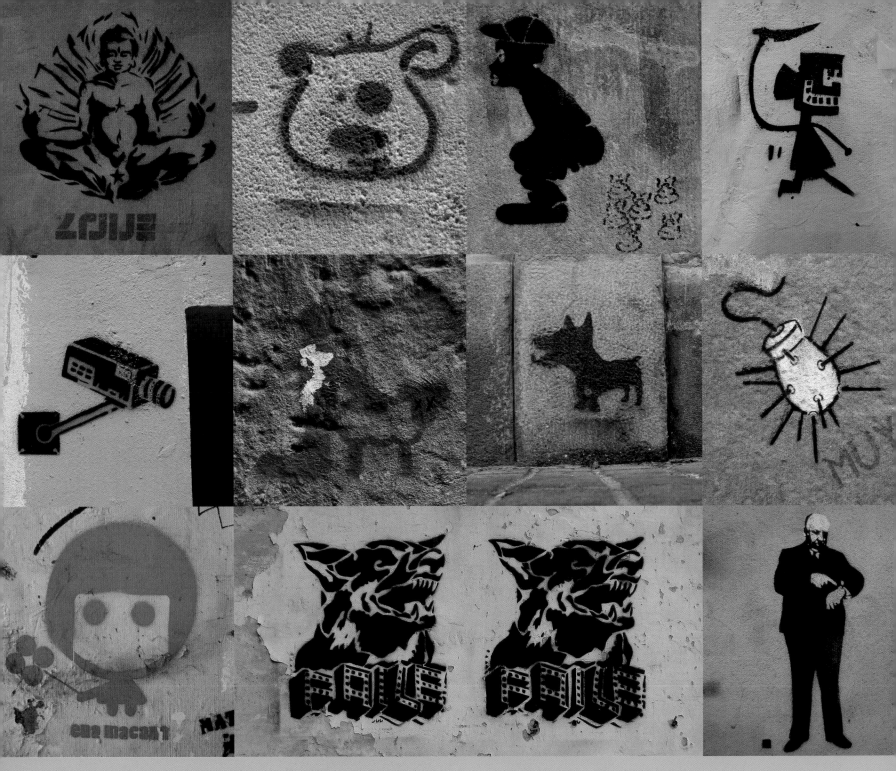

THIS PAGE FROM TOP LEFT TO RIGHT ETRON (3). ENA MACANA (9). FAILE (10).

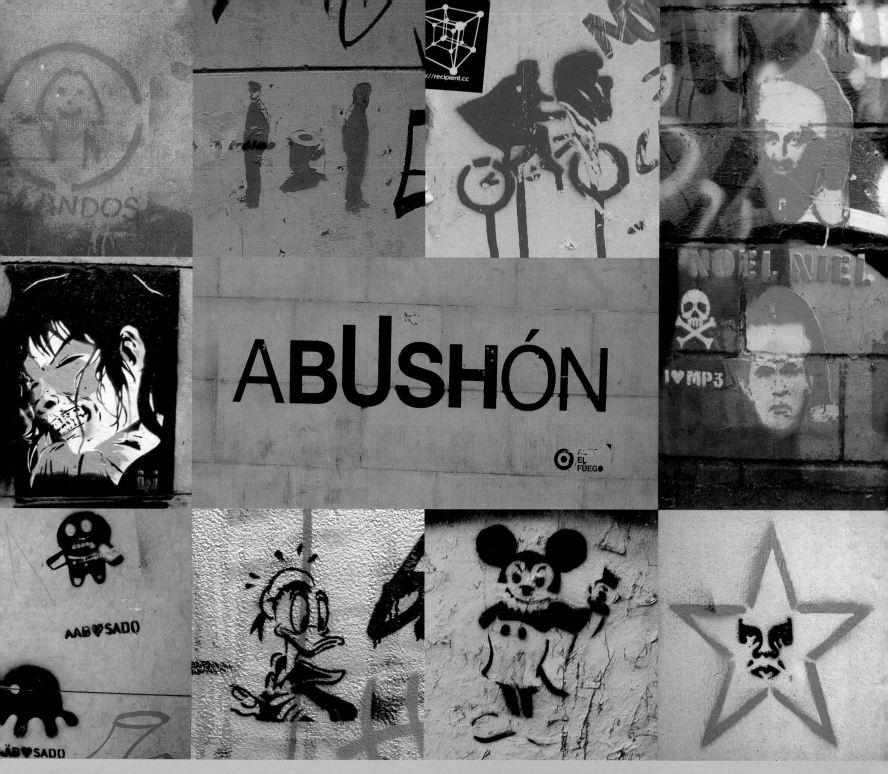

This page from top left to right Borja Martínez (6). Neor (9). Obey Giant (10). On the following pages stencils by Killbush.net.

23

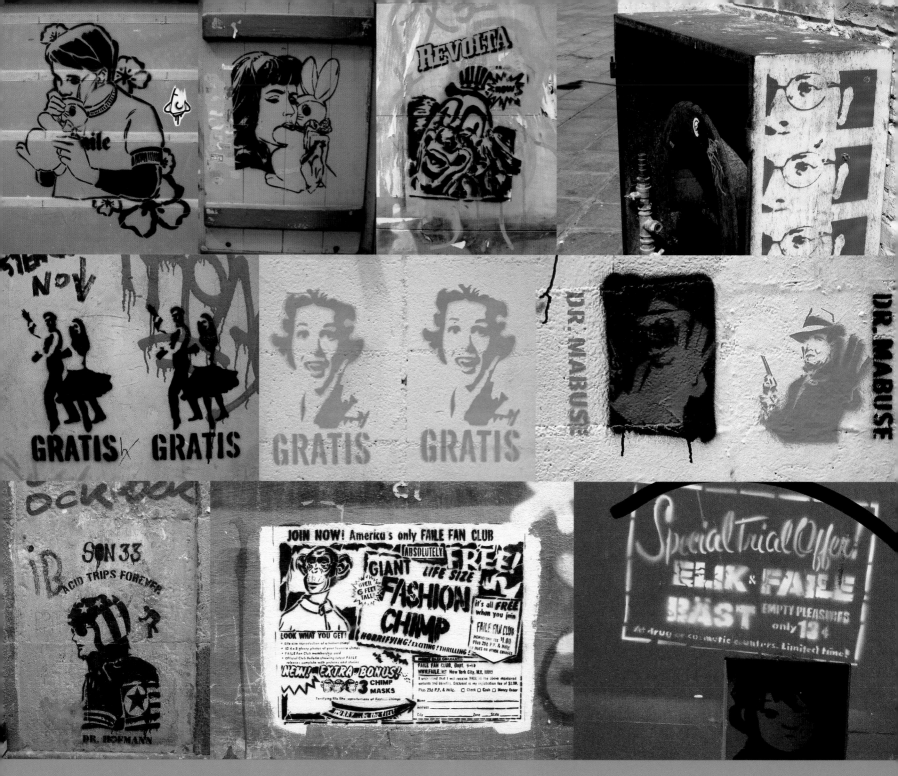

THIS PAGE FROM TOP LEFT TO RIGHT FAILE (1+2+9). DR. MABUSE (7). DR.HOFMANN (8). ELIK+FAILE+BÄST AND A CHARACTER BY LOLO (10).

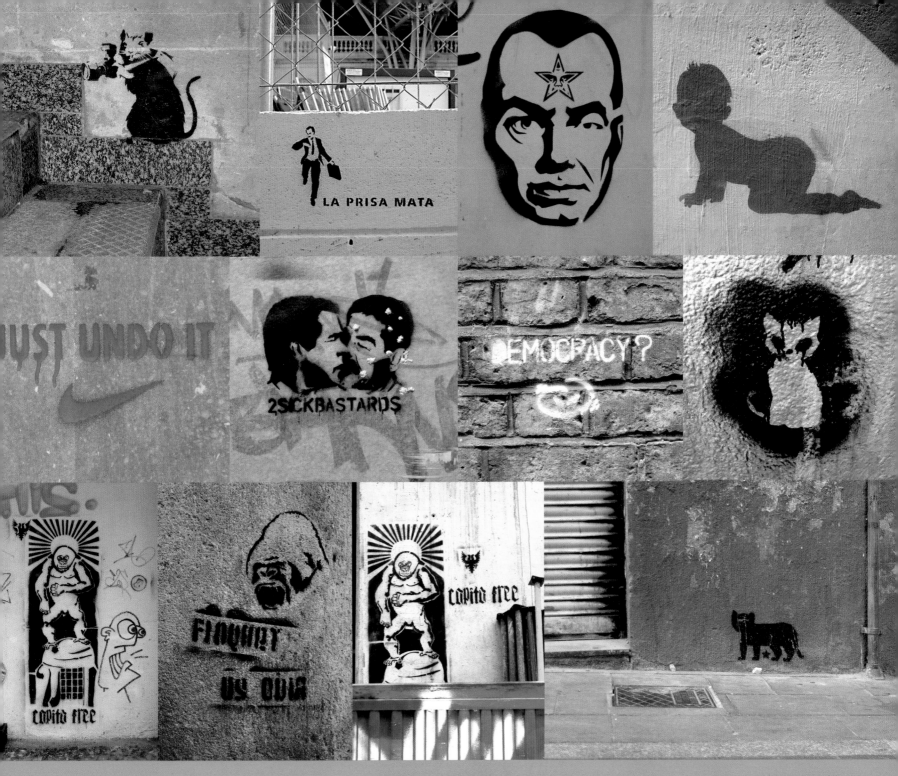

LA PRISA MATA

JUST UNDO IT

2SICKBASTARDS

DEMOCRACY?

THIS PAGE FROM TOP LEFT TO RIGHT BANSKY (1). OBEY GIANT (3).

27

Barcelona's LOLO, Tokyo's SOSAKU, and Iceland's SIGGY constitute the artists' collectively known as KAMIKAZE CREW.
While their works are quite minimalist, since they generally use just black and white as base colors, they achieve strong visual impact. The main character is an innocent-looking little boy surrounded by an aura of mystery. These almost-ectoplasmic visions hide content that is more romantic than diabolical, since they are filled with great beauty.
LOLO collaborates closely with FREAKLÜB, with whom he has created many murals and other works on the walls of the Catalonian capital.

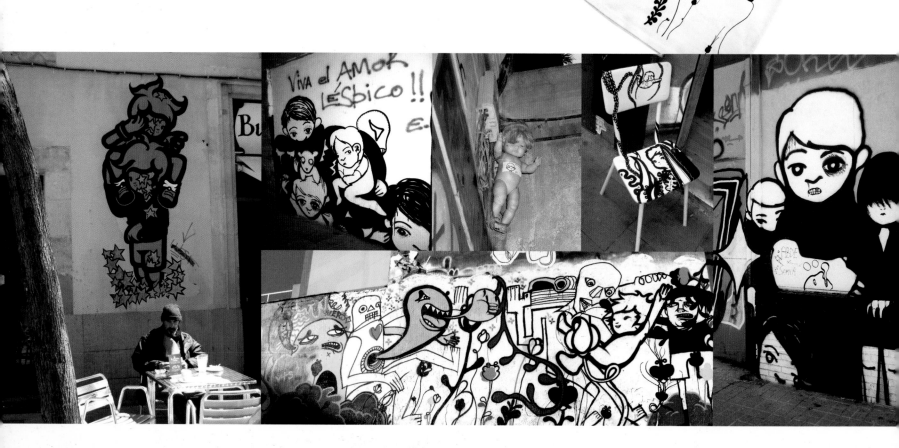

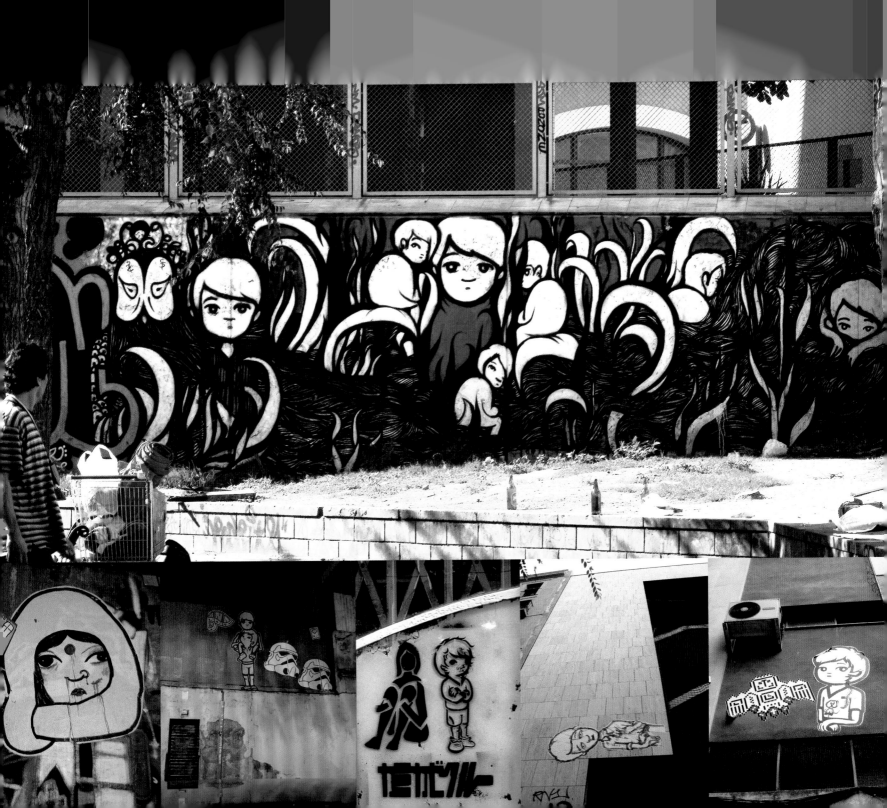

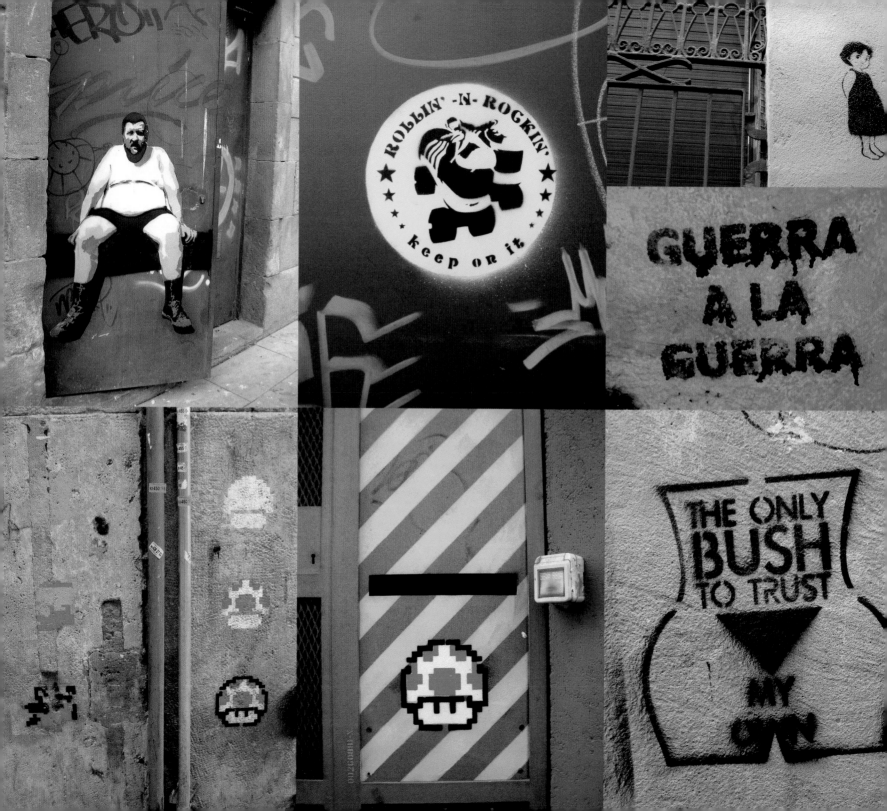

Zoorum
BARCELONA
2004

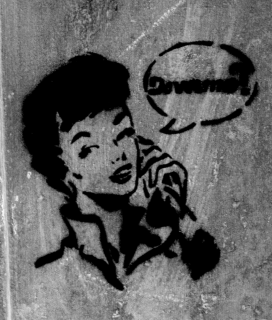

BARCELOCA

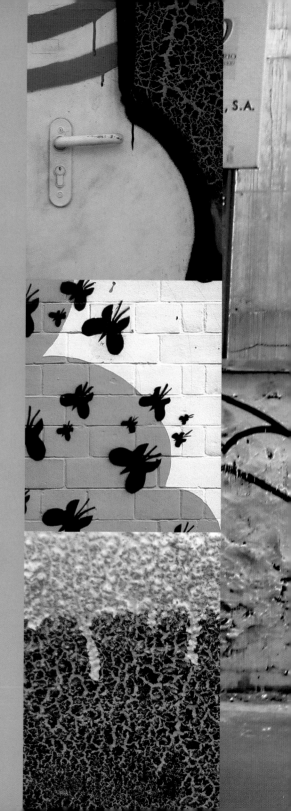

The city offers an infinite number of textures, which present themselves as perfect backgrounds on which to place art that will remain there at the mercy of all kinds of wear and tear.

Work surfaces can be as diverse as concrete walls, brick, wood, plastic, traffic sign metals, automobiles, or train car to name just a few. The choice of location is definitive and, although the artisst almost always prefer smooth walls, others find great expressive opportunities on irregular, rough surfaces; places marked by history and time, sites that no one is using for anything else, and abandoned houses are used as artistic media, giving new value and utility to their textures.

CITY
TEXTURES

In these cases, the background material becomes central to the work, and we can delight in different textures, some capricious, that awaken sensations in the viewer.

So many walls, signs, benches, streetlamps, and so forth go totally unnoticed until an artist decides to create on them and revive them. These spaces and objects, once dead, gain new meaning in and of themselves and with respect to the material of which they are made.

When the graffiti artist has finished his or her work, it is not immune from the action of other street artists, inclement weather, and other elements that tend to destroy it. This deterioration affords us precious images of certain unexpected qualities of the materials that remind us of informalism or American abstract expressionism.

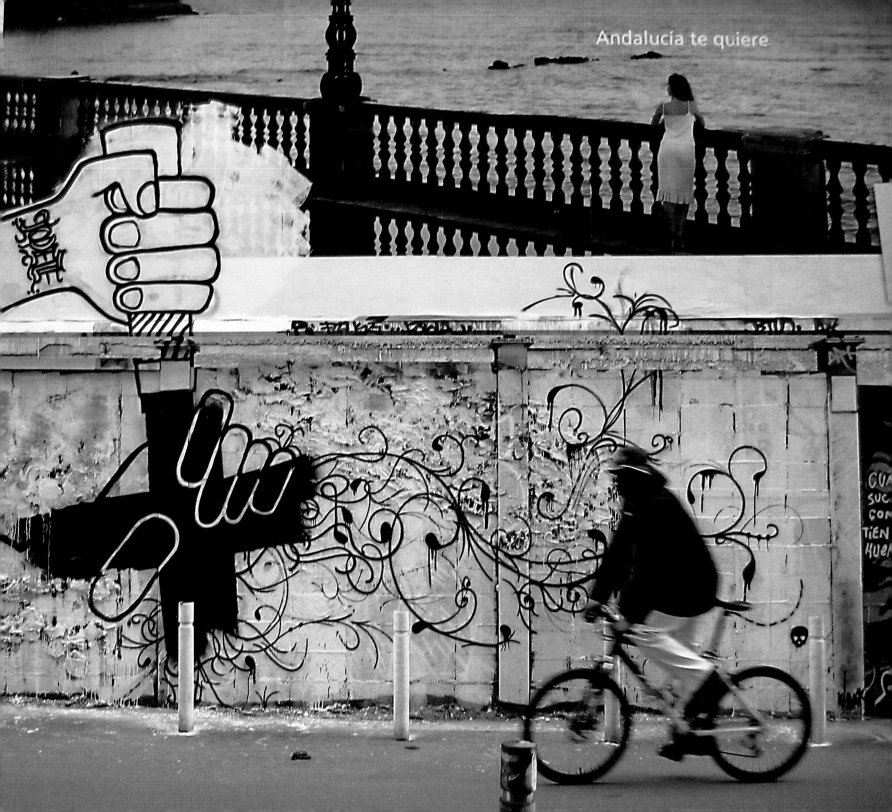

Andalucía te quiere

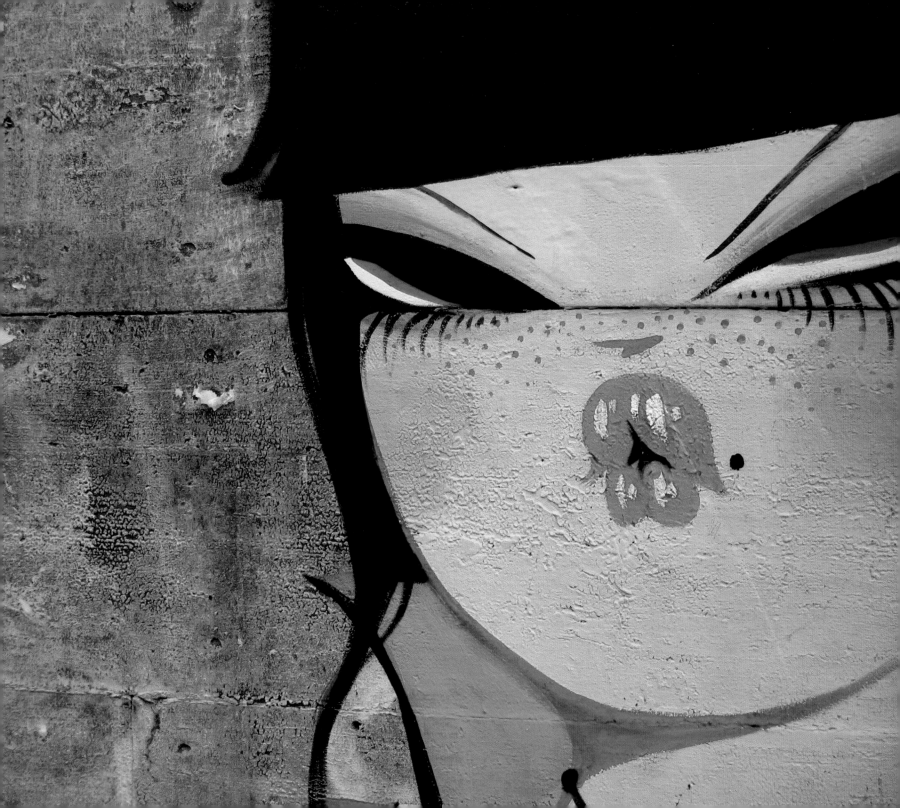

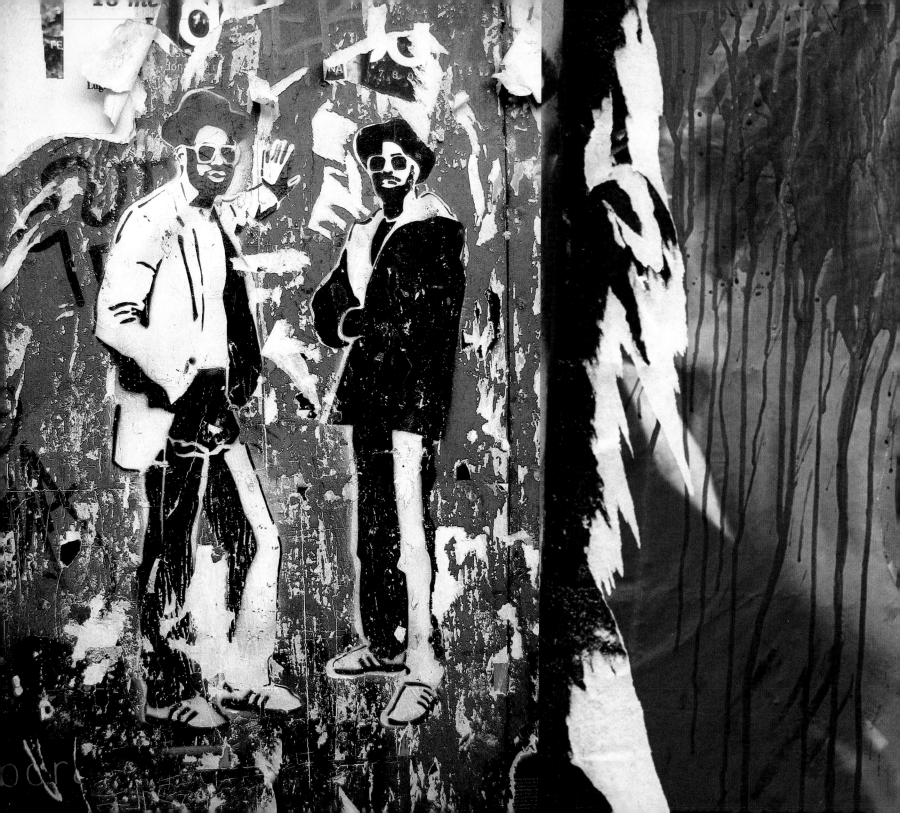

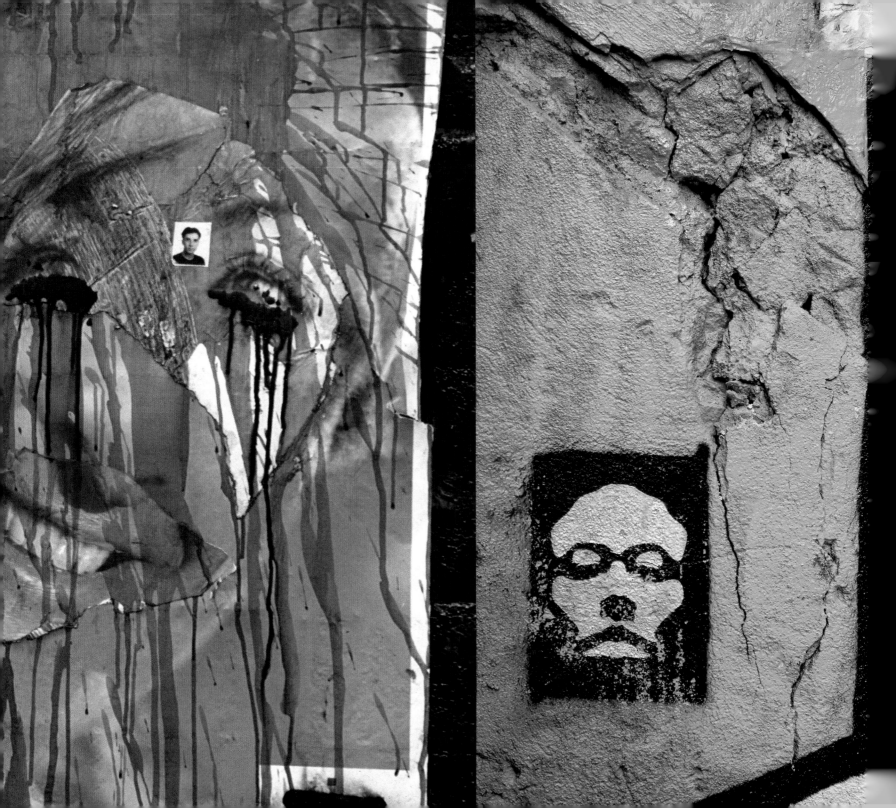

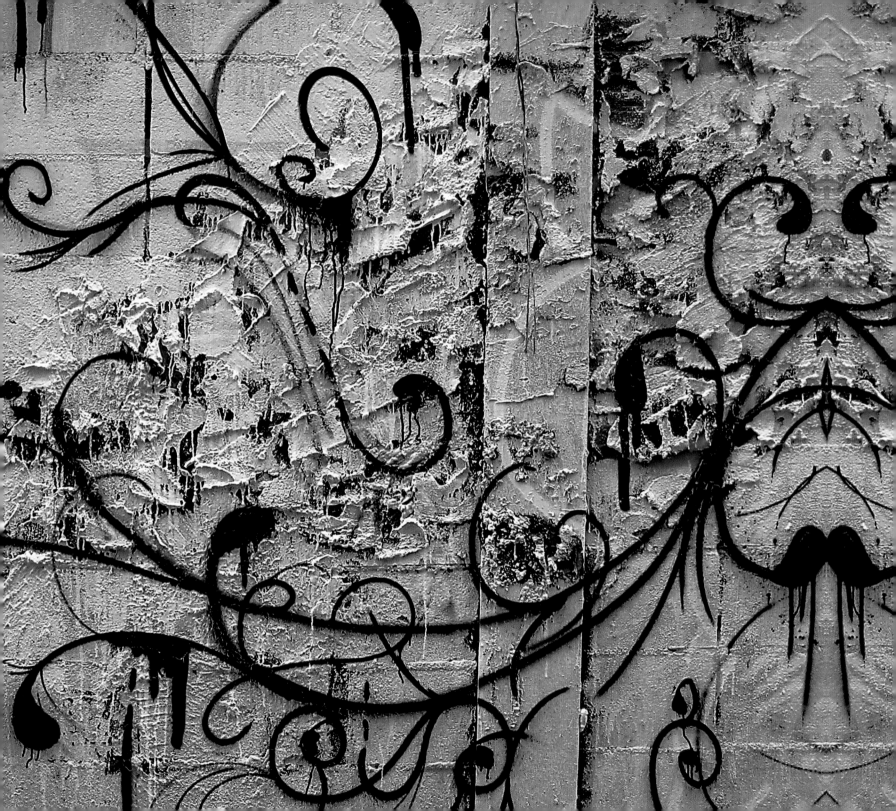

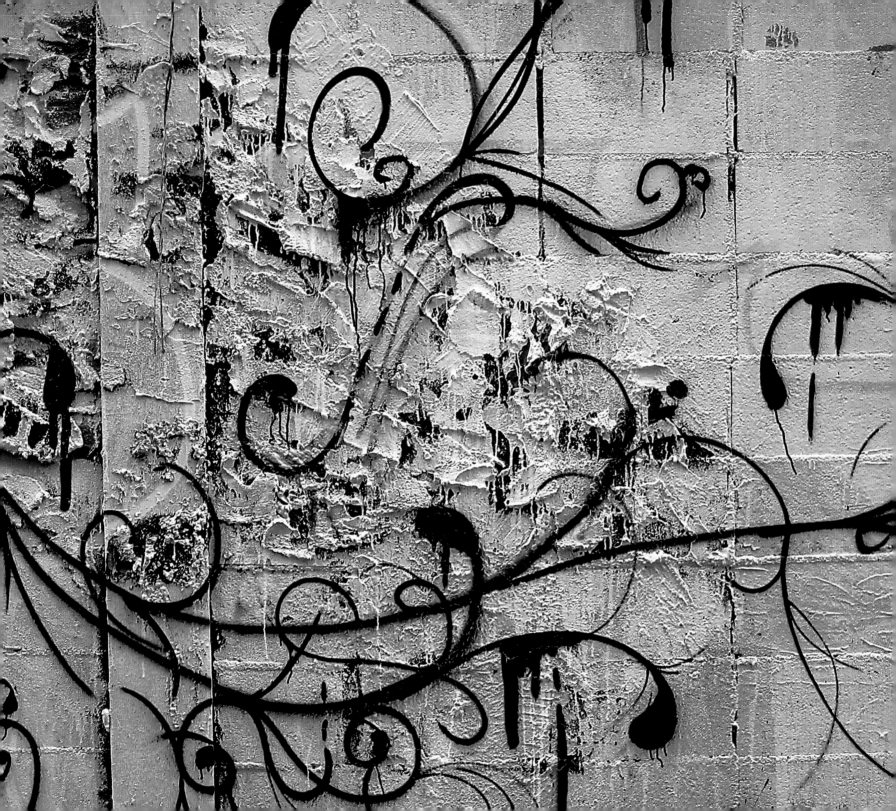

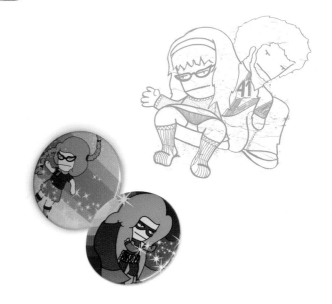

FREAKLÜB's main character is Aunara, an eight-year-old girl with an indie look and long orange hair. FREAKLÜB opens up for us, in each spectacular painting, a window to Aunara's private and fascinating world, a place that reflects her moods. So when she is happy—but never smiling—the backgrounds are replete with bright, vibrant colors and endless rainbows. But when Aunara is sad, her world turns melancholic and, at times, chaotic. Aunara has a large and motley crew of friends, such as the candle boy and a girl with curly blue hair. FREAKLÜB do not consider themselves graffiti artists. They just paint on the street as one more way to disseminate their works.

We can find FREAKLÜB on exclusive items of secondhand clothing which they have customized themselves, with felt, or sometimes hand painted. They collaborate mainly with Lolo of Kamikaze crew, Miss Van, and Boris Hoppek.

ON THE FOLLOWING PAGES ARTWORKS BY FREAKLÜB ON BARCELONA.

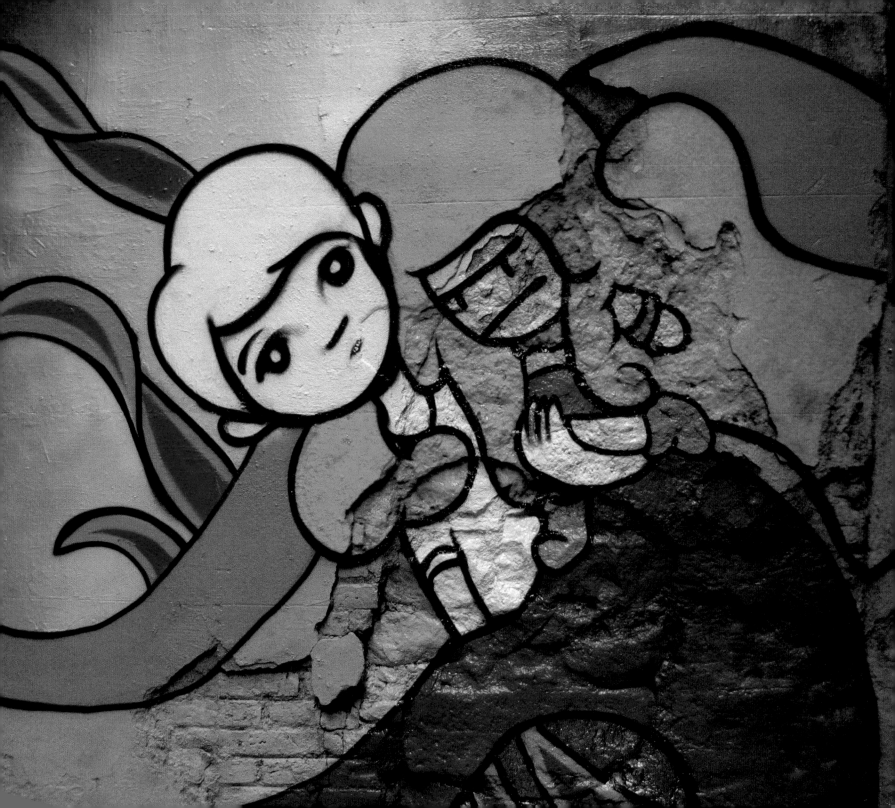

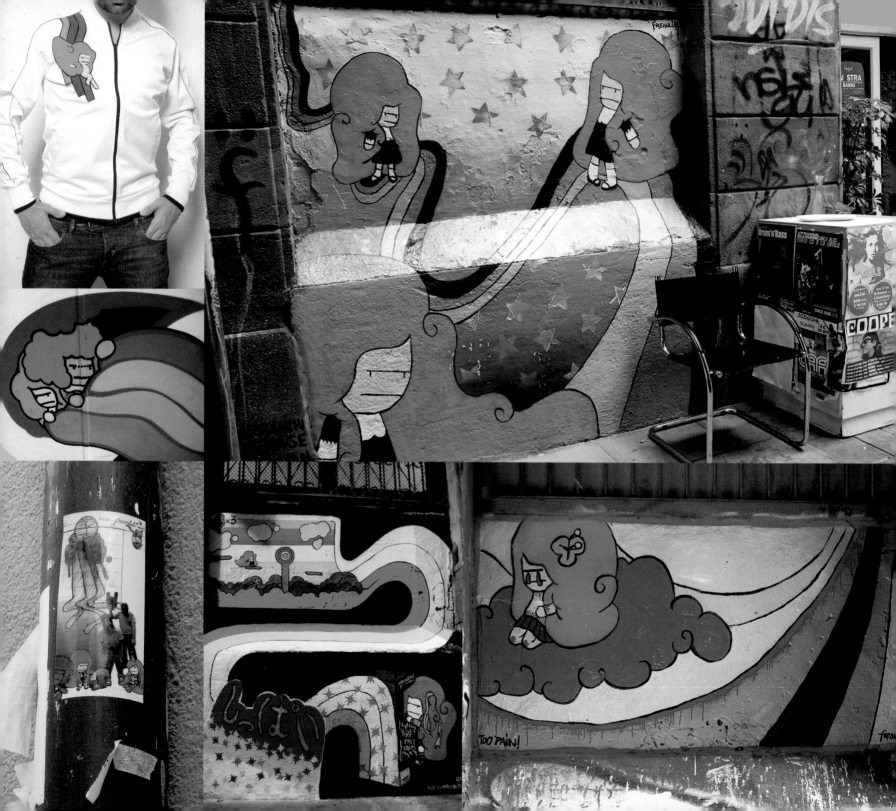

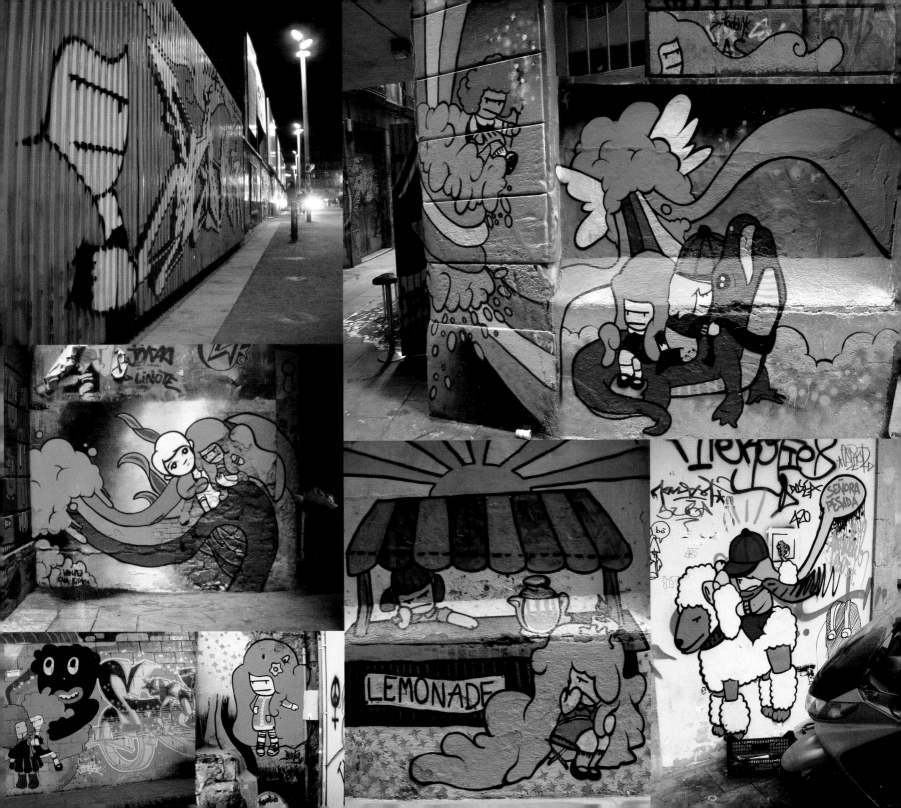

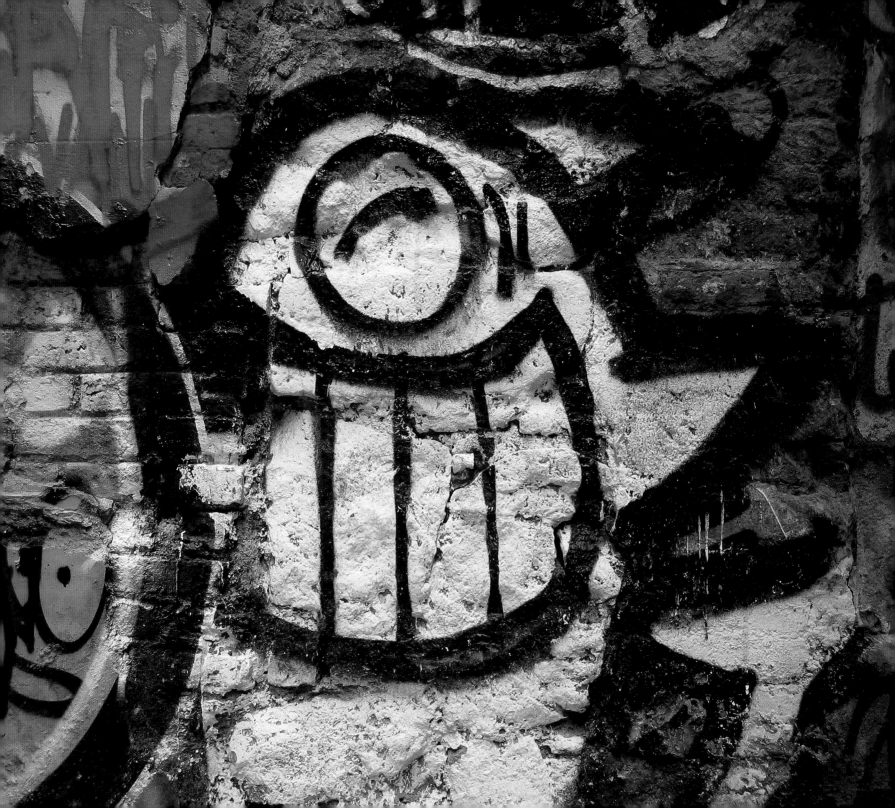

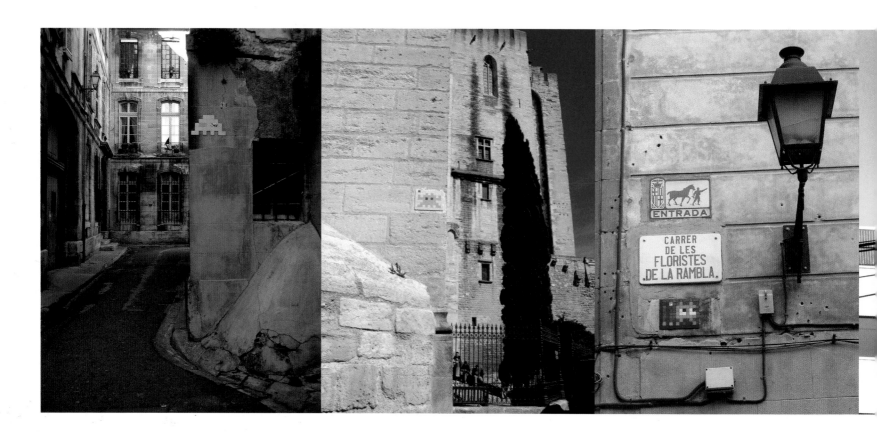

The little Martians of the 1980s video games are the inspiration for this Parisian artist. His mosaics of aliens now invade major cities the world over. His works appear in hidden, inaccessible places, so finding one of them can be a real adventure for lovers of street art.
The technique and the materials he uses ensure that his works are long-lasting, exposed as they are at the site of their creation. The invasion has just begun!!!

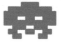
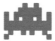

SOME SPACE INVADER'S MOSAICS ON THE STREETS OF BARCELONA, NEW YORK, AND AVIGNON (FRANCE).

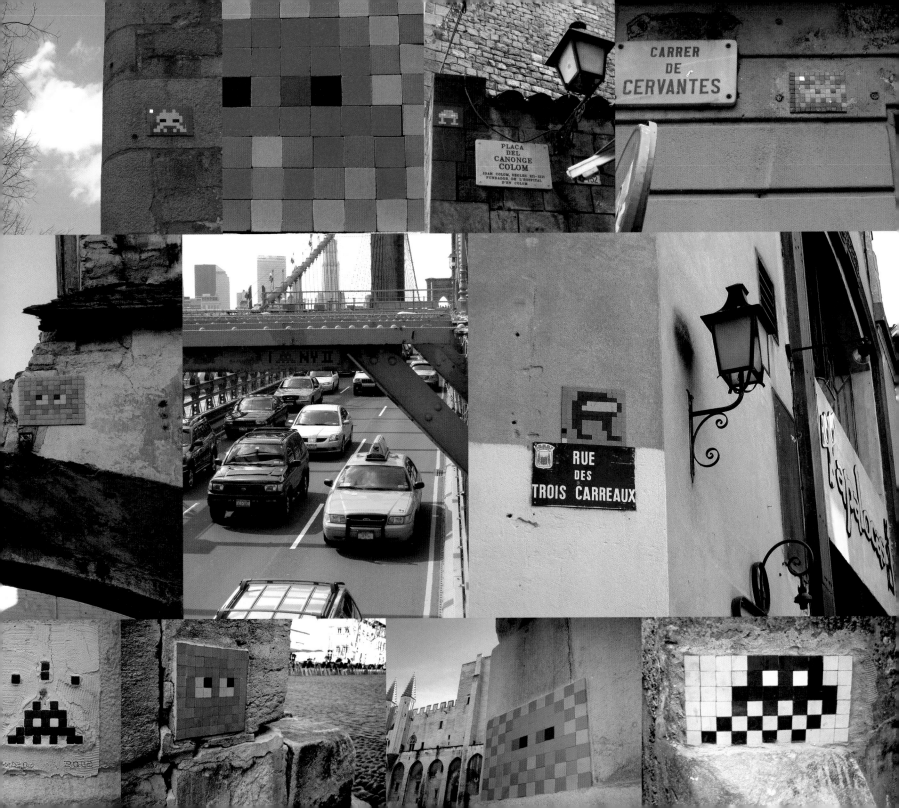

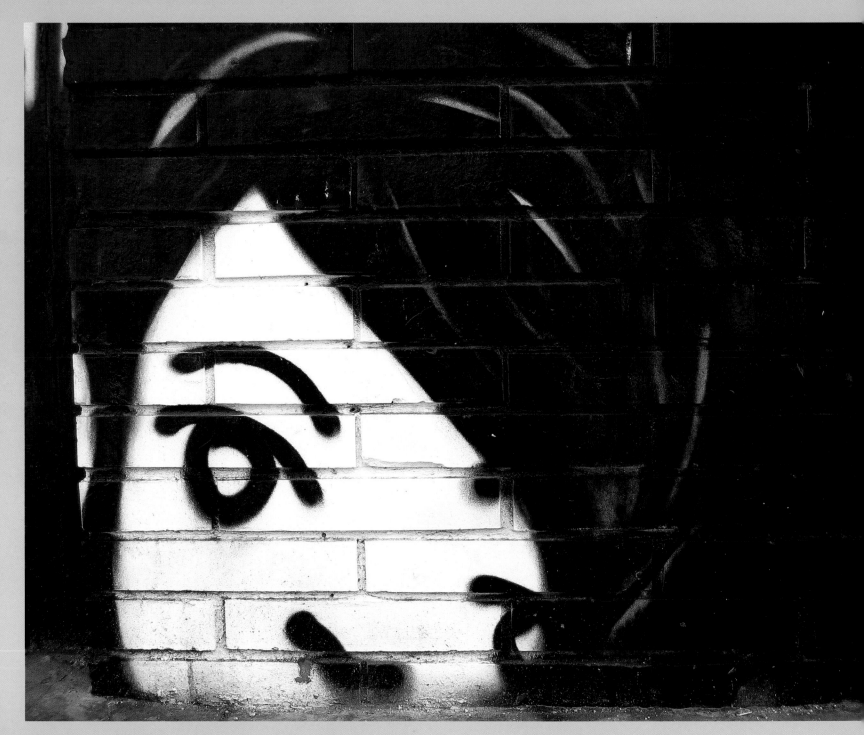

KAMIKAZE CREW IN BARCELONA.

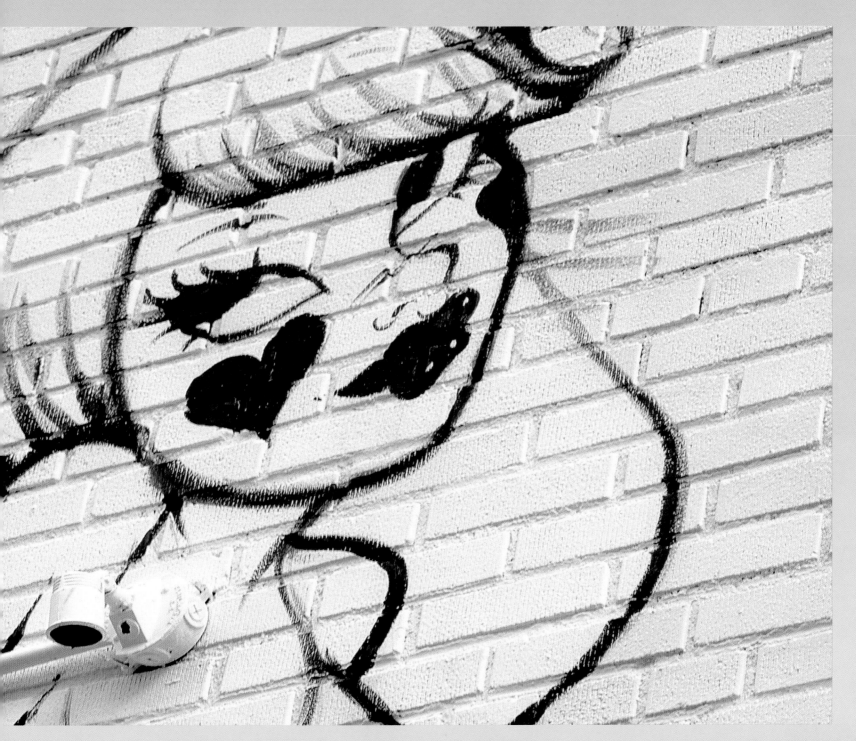

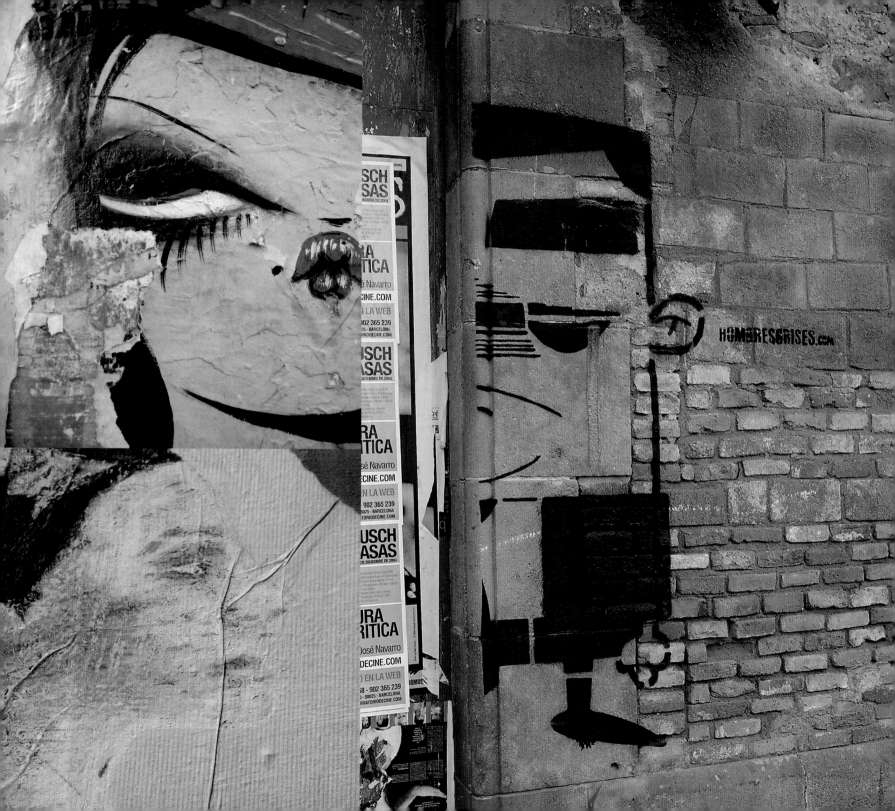

HOMBRESGRISES.com

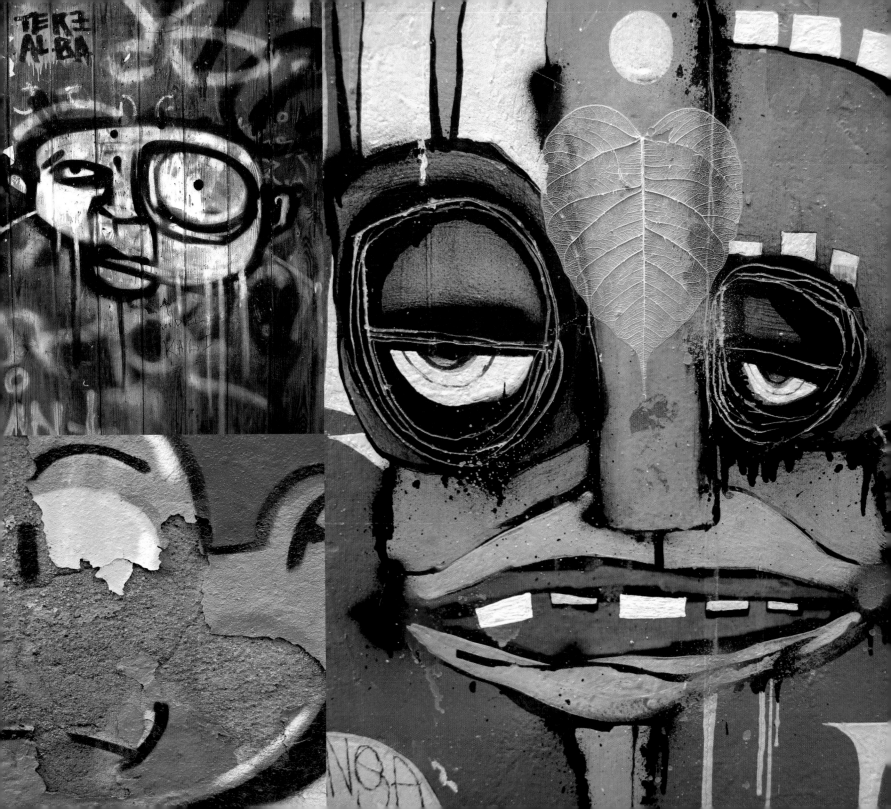

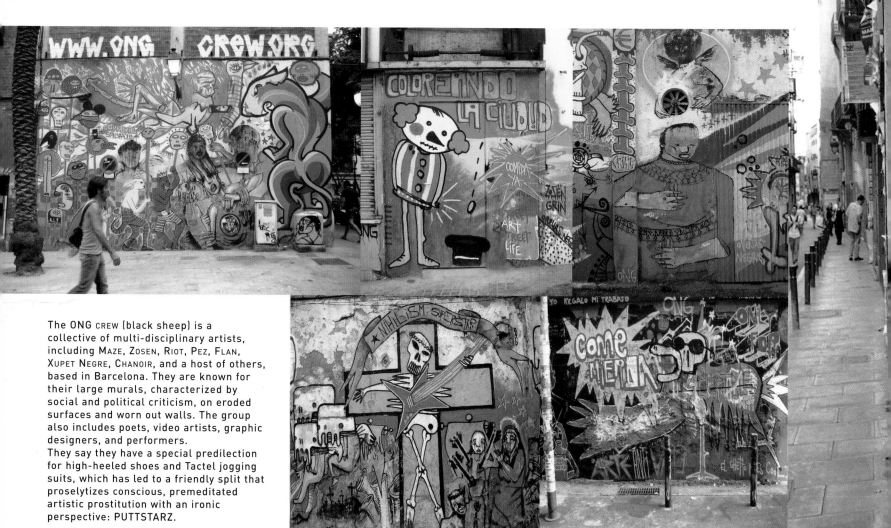

The ONG CREW (black sheep) is a collective of multi-disciplinary artists, including MAZE, ZOSEN, RIOT, PEZ, FLAN, XUPET NEGRE, CHANOIR, and a host of others, based in Barcelona. They are known for their large murals, characterized by social and political criticism, on eroded surfaces and worn out walls. The group also includes poets, video artists, graphic designers, and performers.

They say they have a special predilection for high-heeled shoes and Tactel jogging suits, which has led to a friendly split that proselytizes conscious, premeditated artistic prostitution with an ironic perspective: PUTTSTARZ.

ON THE FOLLOWING PAGES MURAL BY ONG CREW.

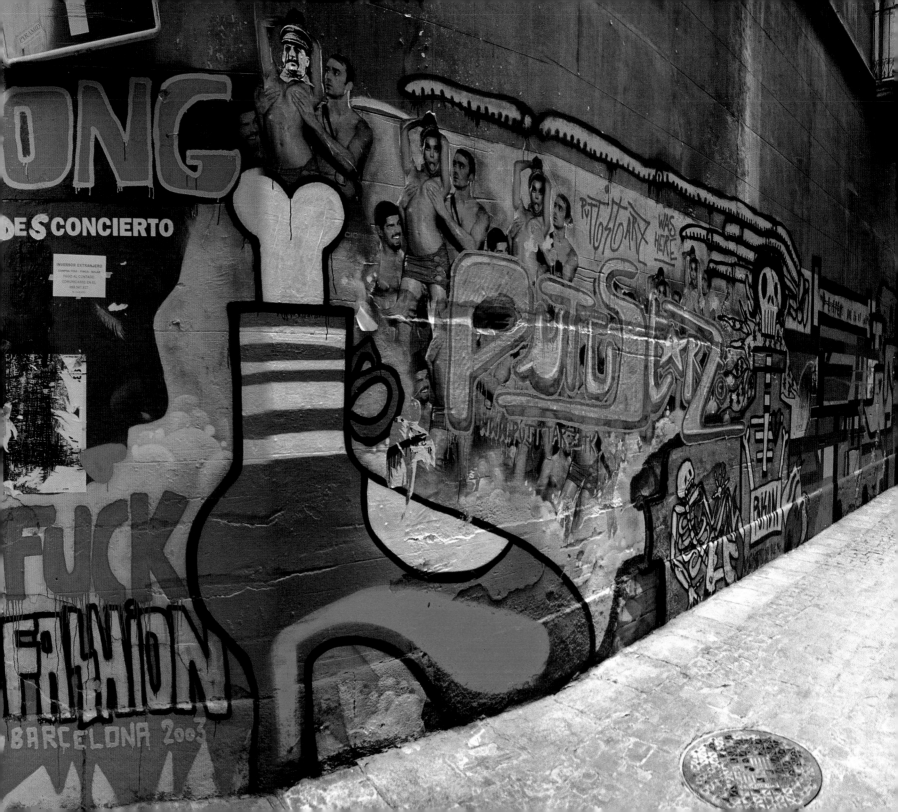

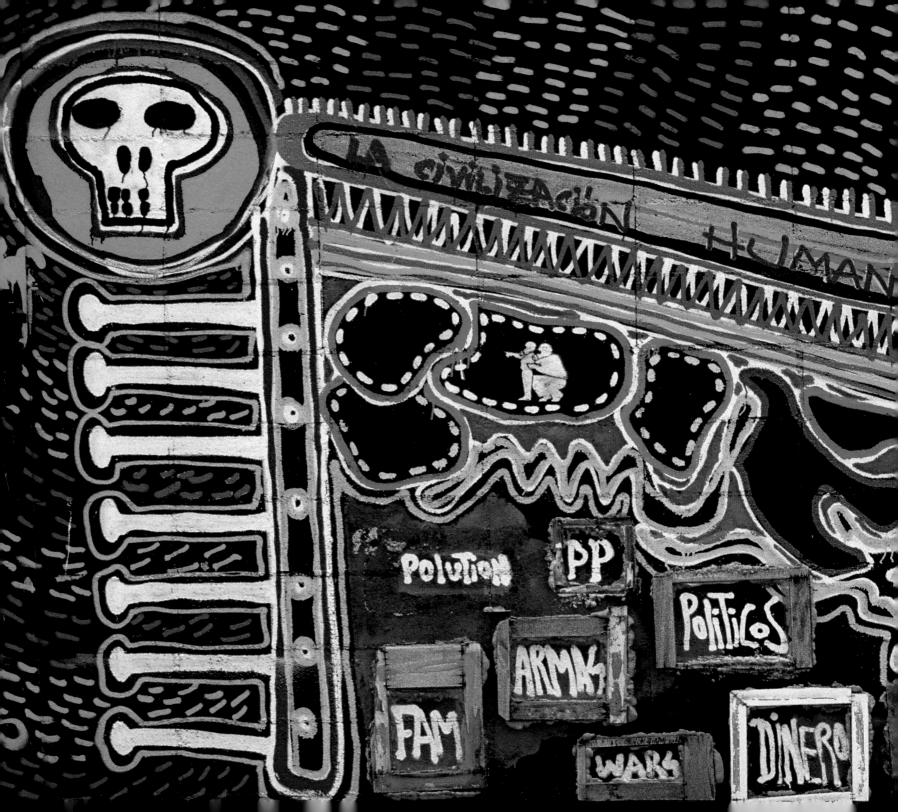

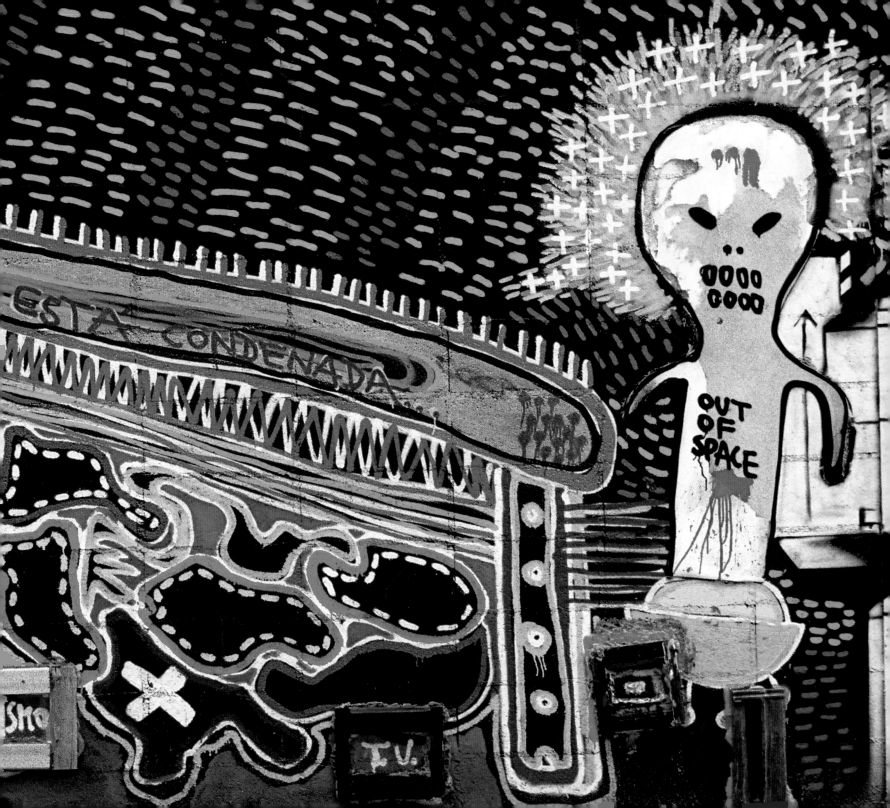

There's nothing easier than grabbing a bunch of stickers from your backpack and plastering them wherever you like, avoiding the risk of being caught red-handed. Sticker art is, without a doubt, one of the fastest and most discreet techniques, along with the stencil, in the exciting world of urban art.

Almost all of the artists use this medium as one more means of bombing the streets, so we can say that the sticker is a kind of semi-industrialized "tag," since it can be produced easily and conveniently at home using a computer and laser printer. We find all kinds of stickers, from the most rudimentary, made with photocopies or hand-drawn on any adhesive surface, to four-color prints and more sophisticated paper.

Sticker art consists of much more than just the typical stickers; it encompasses any work that can be stuck, in the street, to any surface—in other words, anything from posters to the charming SPACE INVADERS mosaics.

Things get complicated when you have a large poster, because the artist will need the help of a comrade at arms, not just to gain access to the ideal place, generally pretty high up, but also to transport the bucket of glue and the wallpapering brush. The poster's visual impact is greater than that of conventional stickers, and can be defined, within the modality, as a "masterpiece."

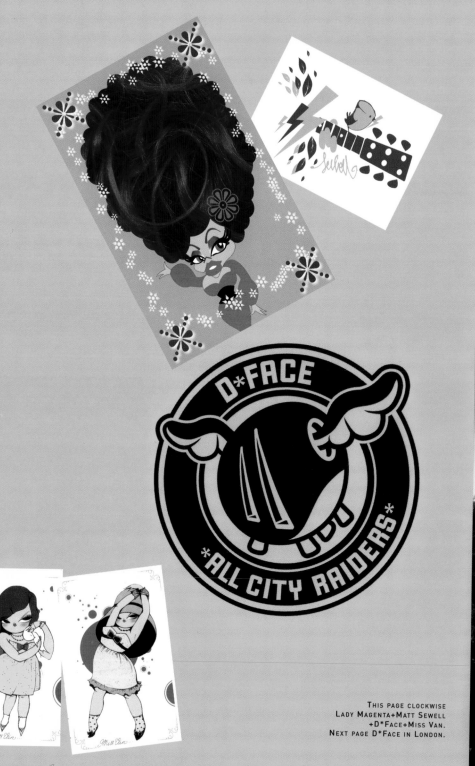

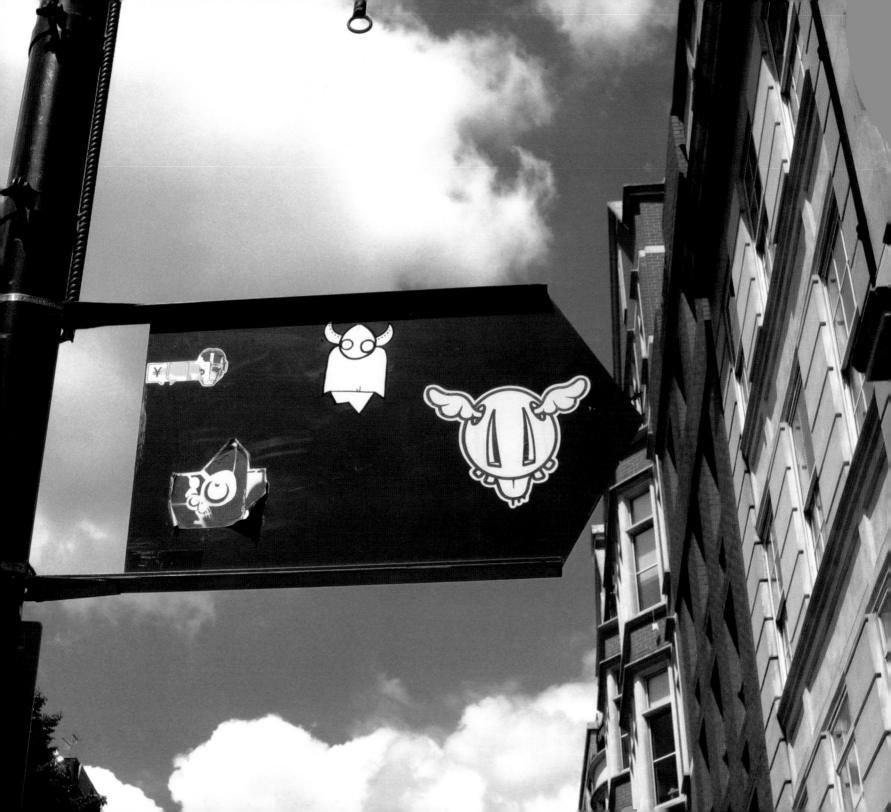

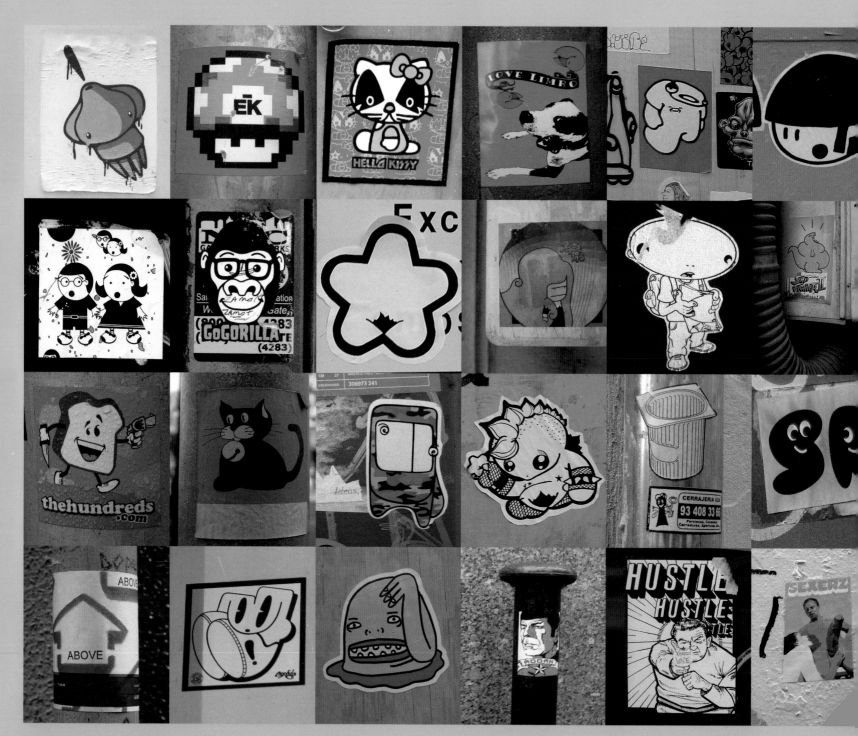

THIS PAGE FROM TOP LEFT TO RIGHT NANO 4814 (1). ESM (3). LIMBO (4). B0130 (5). MR.EPS (6).GOGORILA (8). SAVAGE GIRL (9+16). FREAKLÜB (10). KARL TOON (11). CAPTAIN ROUGET (12). ABOVE (19). CREEPER (21). SEXERZ (24).

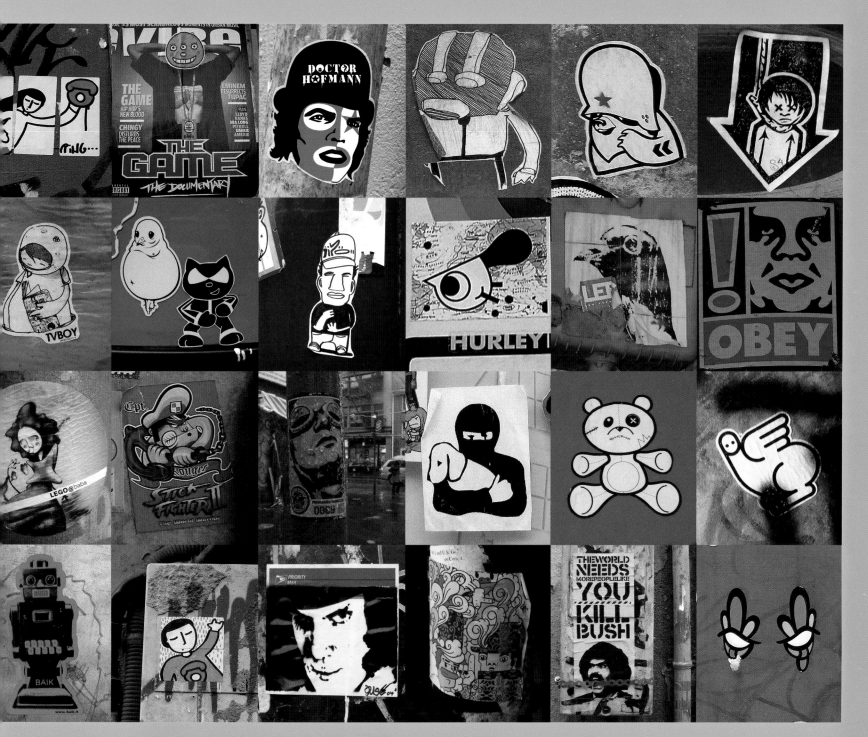

From top left to right Ring (1+20). Dave (2). Dr.Hoffman (3). Flying Fortress (5). Castro (7). Showchicken (8). Obey Giant (12+15). Lego (13). Captain Rouget (14).Baik (19). Kill Bush (23). KMR (24). **61**

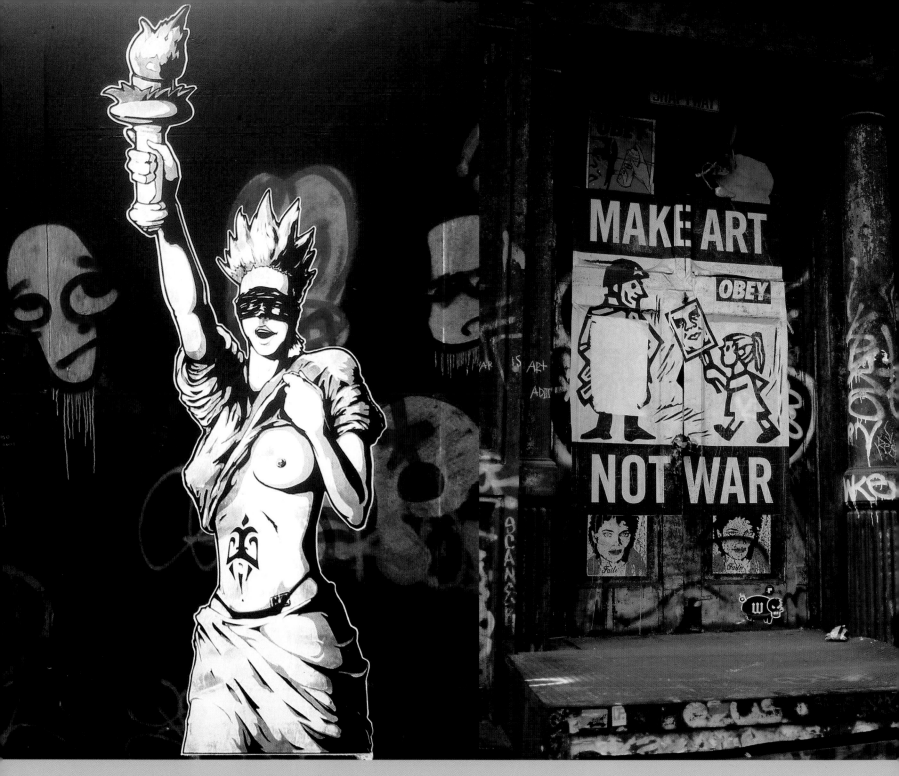

THIS PAGE FROM LEFT TO RIGHT BIG POSTER BY RÍPO (1). OBEY GIANT+ FAILE (2).

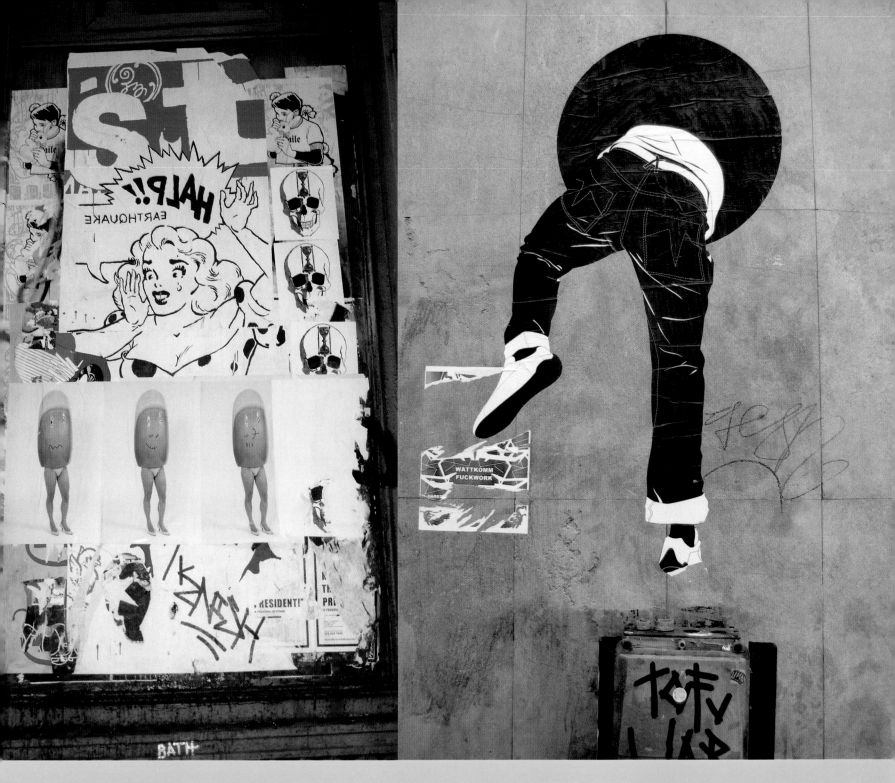

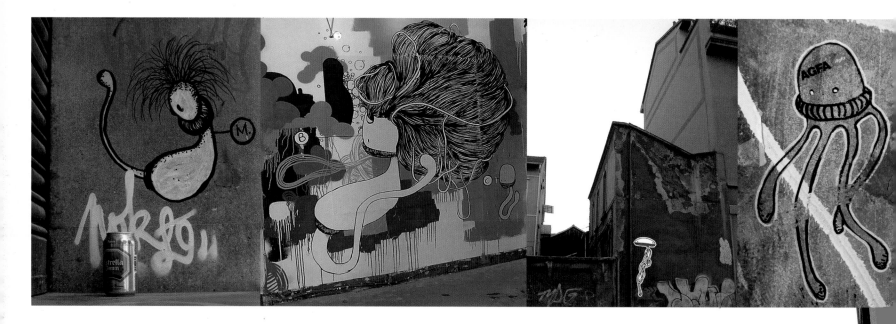

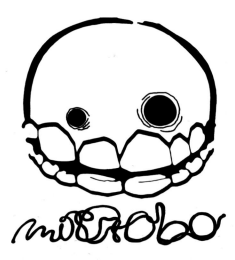

Although she was born in Sicily, this young artist thinks of herself as a citizen of Planet Earth. After studying in London, she decided to set up shop in Milan, where she now lives and works. She uses various tools and surfaces (canvas, cartoons, wall displays, posters, and so forth) to give life to her "microbes." In recent years she has exhibited throughout the world and has designed her own merchandising line. Don't forget to visit her website, but be very careful: it's infected with "microbes."

NAME MICROBO **CITY** MILAN **WORKING AREA** LIKELY UNDEFINITE **SPRAY FRIENDS** MORE THAN 1,000,000,000 PEOPLE **SPRAY ENEMIES** THE POLICE & ALBERTINI (MILAN MAYOR) **ARTIST YOU WOULD LIKE TO COLLABORTE WITH** ANY OCCASION TO COLLABORATE IT'S ALWAYS GOOD... WHEN THERE IS THE SPIRIT OF IT **YOUR FIRST GRAFFITI** AN ANT! **YOUR DEFINITION OF STREET ART** ANYTHING ON THE STREET LOOKS LIKE A PIECE OF ART, MEANS ANYTHING ON THE STREET GIVE ME AN EMOTION **FUTURE** WHO KNOWS? **FAME** I DON'T UNDERSTAND THE QUESTION **SURVIVAL KIT** I DON'T HAVE ANY IN PARTICULAR, IT DEPENDS ON PROJECT. ALWAYS I'VE GOT CIGARETTES AND MARKERS WITH ME: DAYTIME / NIGHTTIME

ON THESE PAGES SOME ARTWORKS BY MICRO BARCELONA, LONDON AND ITALY.

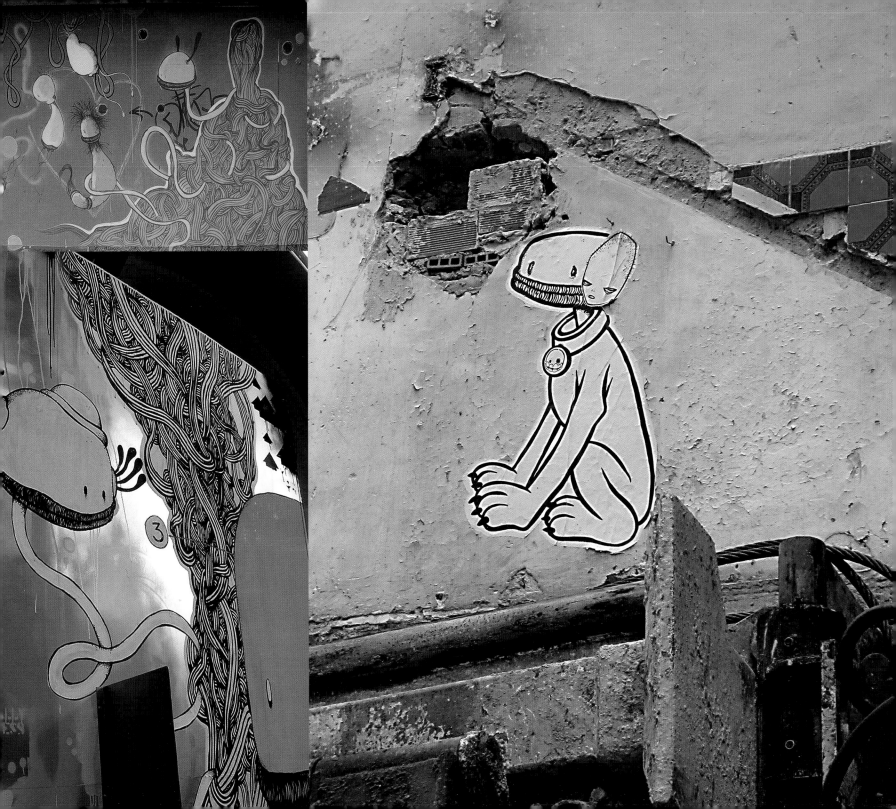

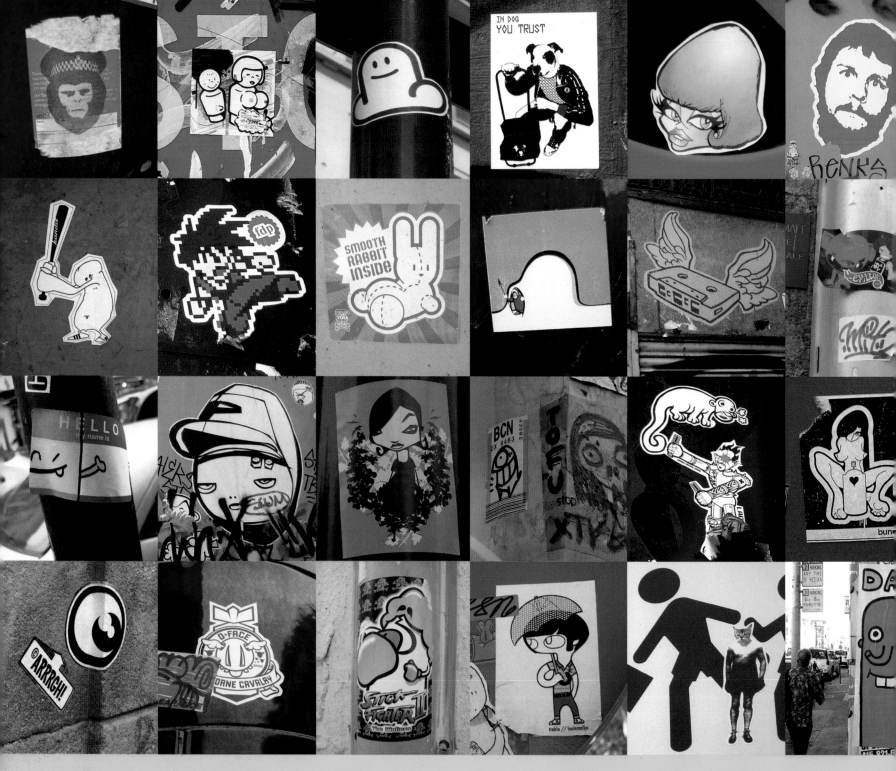

THIS PAGE FROM TOP LEFT TO RIGHT SARU (1). LIMBO (4). LADY MAGENTA (5). KANDIS (7). EVIL TOYS (12). MYSTERIOUS AL (14). PEZ + TOFU (16). BUNONE (18). ARRRGH! (19) D*FACE (20). DAVE (24).

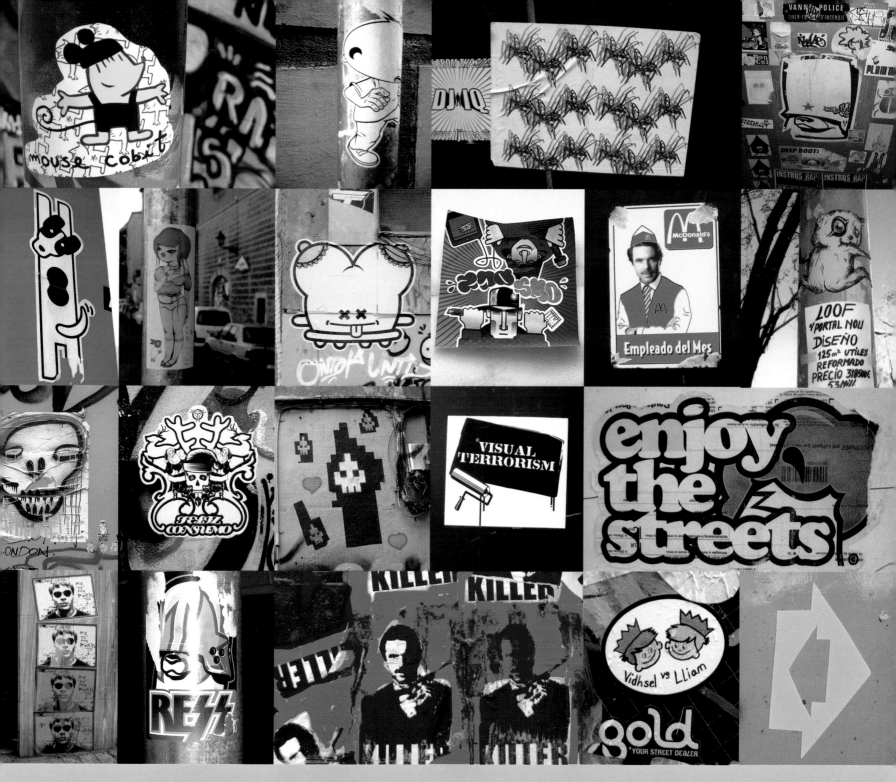

THIS PAGE FROM TOP LEFT TO RIGHT KARL TOON (2). FLYING FORTRESS (4+17). MISS VAN (6). BUFF MONSTER (7). TOFU (11).

67

Koralie invites us into her private world of color and fantasy, inhabited by small geishas surrounded by surrealist places and flowers.
This young French artist, who began painting on canvas at home, uses all her talent in the various genres of street art: stickers, graffiti, posters, and so forth. . . . Her work is closely allied with that of her boyfriend, Supakitch, with whom she has painted large murals all over the world.

NAME KORALIE **AGE** 27 **CITY** MONTPELLIER (FRANCE) **WORKING AREA** STREET, COMPUTER, CANVASES **SPRAY FRIENDS** MY BEST FRIEND FOR SPRAY IS MY SUPALOVER SUPAKITCH **SPRAY ENEMIES** RAIN, WIND, AND COLD **ARTIST YOU WOULD LIKE TO COLLABORATE WITH** I DON'T KNOW. I LIKE THE WORK OF MANY ARTISTS, BUT I WOULD PREFER TO COLLABORATE WITH ARTISTS WITH WHOM I HAVE AFFINITIES **YOUR FIRST GRAFFITI** 1999 IN TOULOUSE WITH THE TRUSCKOOL, FAFI, LUS, PLUME, KAT. . . . I'M HAPPY TO HAVE MET THEM. I PAINTED FOR A LONG TIME ON CANVASES AND IT'S THEM WHICH ENCOURAGED ME TO PAINT ON THE WALLS **YOUR DEFINITION OF STREET ART** IT'S LIKE USING STREETS AS SUPPORTS, CANVASES FOR ART (POSTERS, STICKERS, PAINTING, GRAFFITI, STENCIL, INSTALLATIONS). STREET ARTISTS ARE LESS OR MORE ENGAGED ABOUT POLICY BUT ACTING ILLEGALLY IN A PUBLIC PLACE, IT IS A KIND OF POLICY ACT! **FUTURE** I'M NOT A SOOTHSAYER **FAME** YES, LOVE, GLORY, AND BEAUTY !!! **SURVIVAL KIT** I HAVE A CASTOR BAG LIKE THE OLD WOMEN, WITH BRUSHES, PAINTING, POSTERS, PASTE. . . . AND MANY THINGS WHICH ARE USED FOR NOTHING!

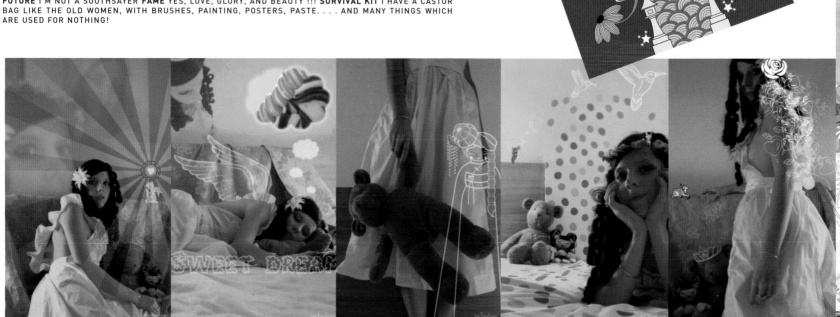

PHOTOGRAPHS BY KORALIE.

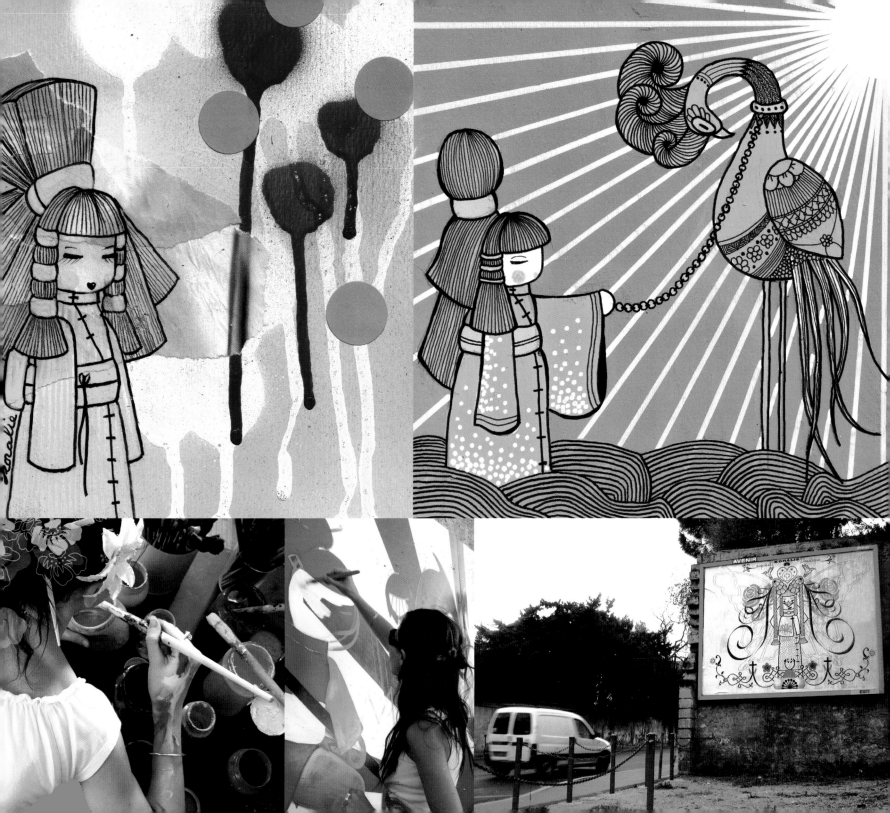

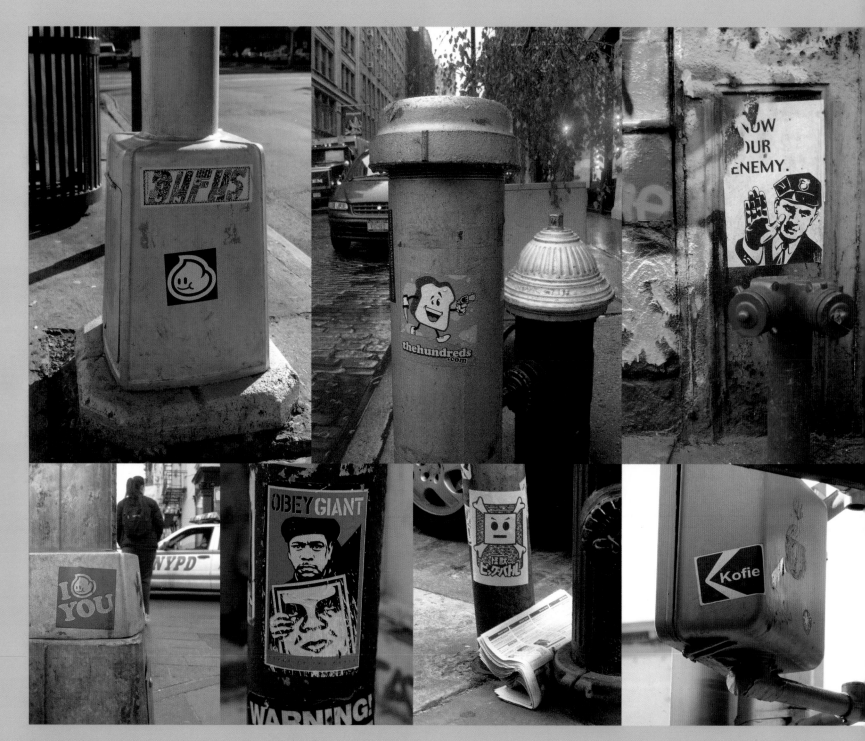

On these pages sticker action on the streets of New York. Obey Giant (5).

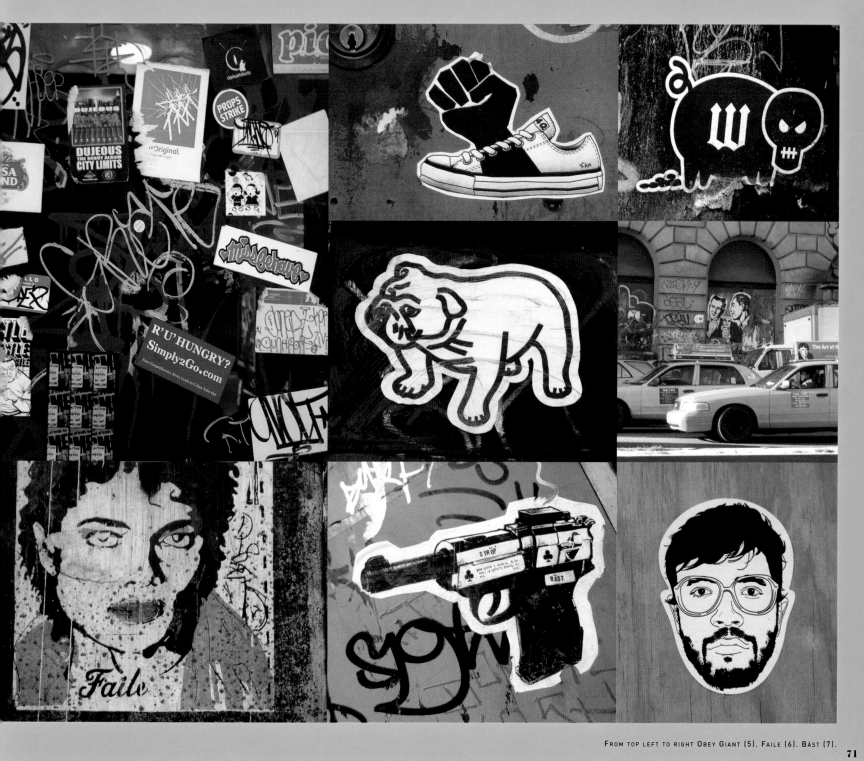

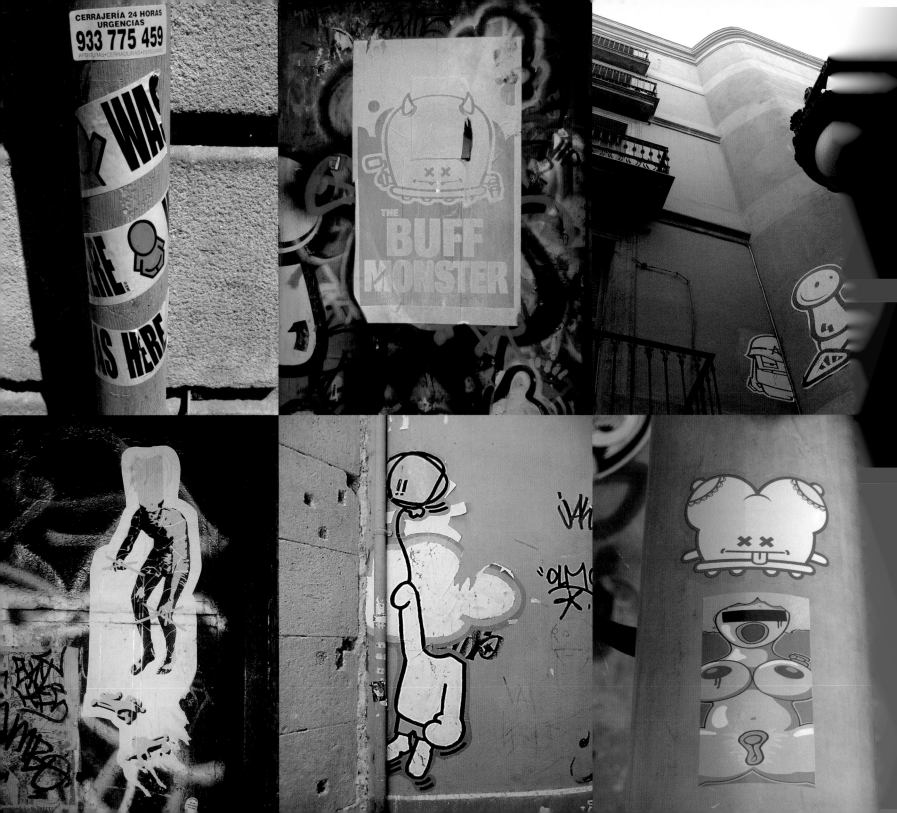

CERRAJERÍA 24 HORAS
URGENCIAS
933 775 459
APERTURAS·CERRADURAS·PERSIANAS

WAS

RE

S HERE

THE
**BUFF
MONSTER**

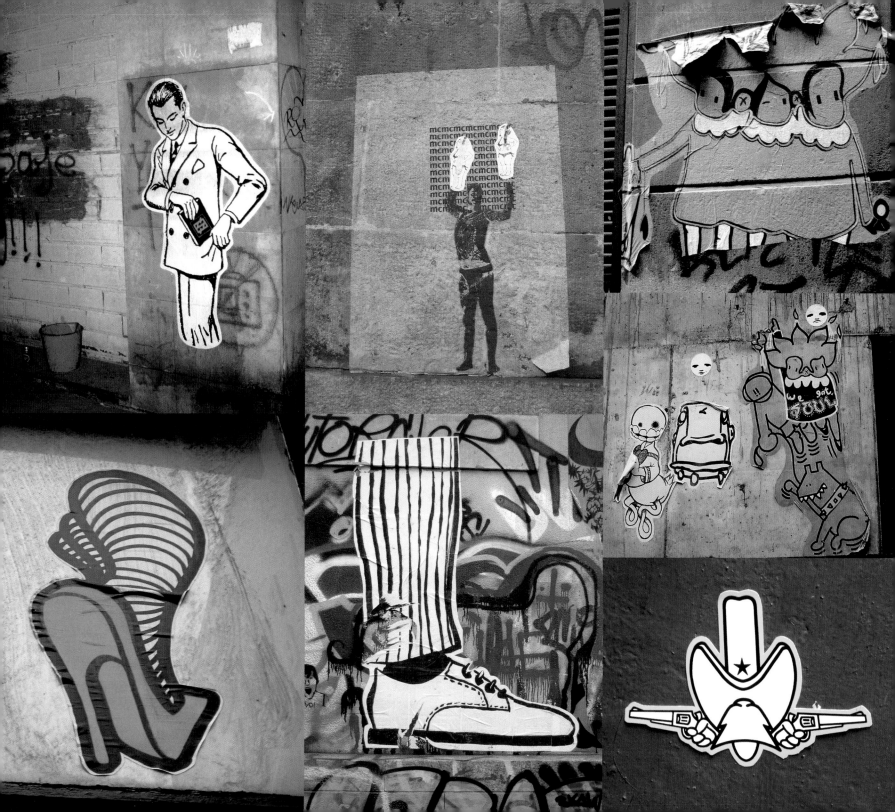

spray file 08

MATT SEWELL

UK-based artist MATT SEWELL's work can be described as romantic fantasy. He just sees it as the nicer side of life. Whether he's painting a canvas, wall, boutique interior, or the inside of a badger set, Matt will always try to bring a smile to your face.

NAME MATT SEWELL **AGE** SEVENTIES CHILD **CITY** AT THE MOMENT MANCHESTER, UK **WORKING AREA** ALL OVER THE PLACE **SPRAY FRIENDS** NO MISSION SEEMS POSSIBLE AT THE MOMENT WITHOUT THE HELP OF THE MIGHTY MIGHTY QNOTH WOMPER . . . **SPRAY ENEMIES** I'M A LOVER NOT A FIGHTER, BABY **ARTIST YOU WOULD LIKE TO COLLABORATE WITH** BILL WATERSON **YOUR FIRST GRAFFITI** UFO TAGS **YOUR DEFINITION OF STREET ART** STREET ART IS A BIT OF A DIRTY WORD AT THE MO . . . IN MY VIEW I WOULD SAY ITS STICKERING, STENCILS, POSTERS, AND DRAWING ILLEGALLY IN THE STREETS . . . PAINTING, TAGS, DUBS ETC IS GRAFF . . . TWO VERY DIFFERENT THINGS **FUTURE** LIVING BY THE SEA, BABIES, DOGS, CATS, VAN, MORE PAINT THAN NECESSARY, MY OWN HIDE, BADGERS RAIDING BINS, TIME TRAVEL, BARCELONA, AND GOOD HEALTH **FAME** THE WORK SPEAKS FOR ITSELF . . . IF IT'S GOOD IT'S GOOD **SURVIVAL KIT** RUCKSACK, NEW YORK FAT CAPS, GOOD TIMES, AND SKILLS

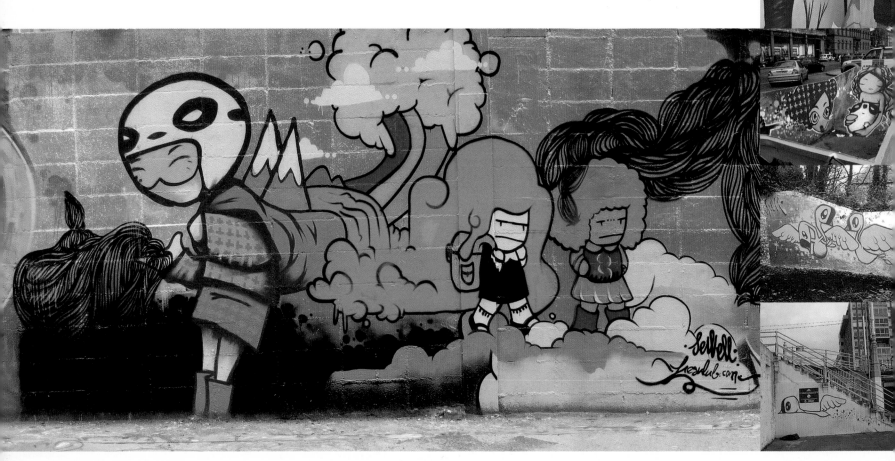

BIG MURAL PAINTED IN BARCELONA WITH FREAKLÜB.

PHOTOGRAPH ON THE NEXT PAGE BY KEVIN M

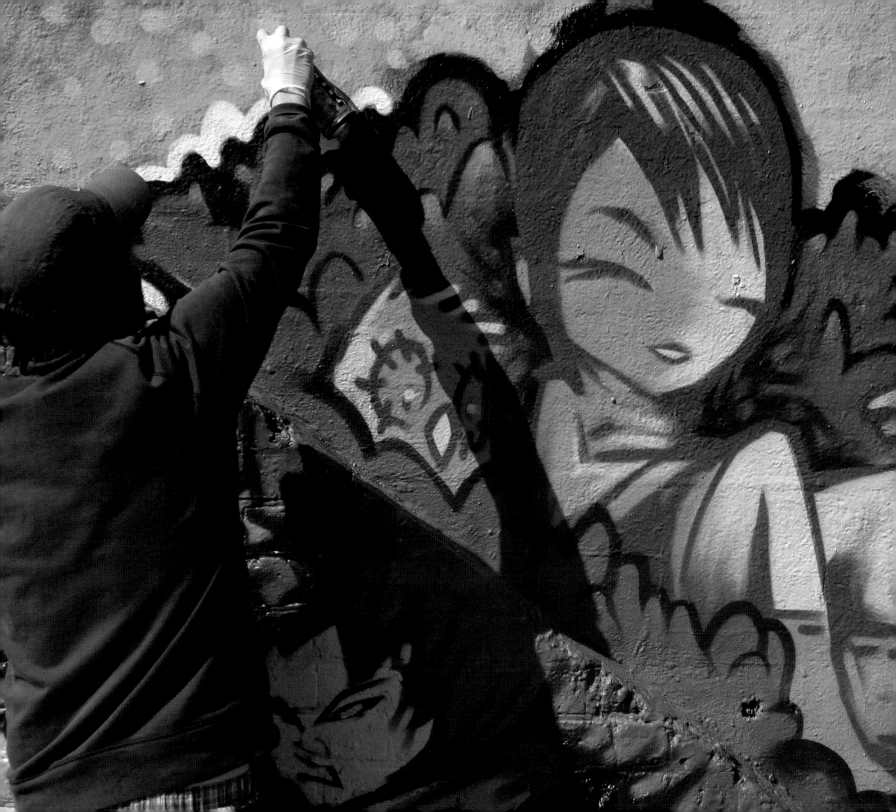

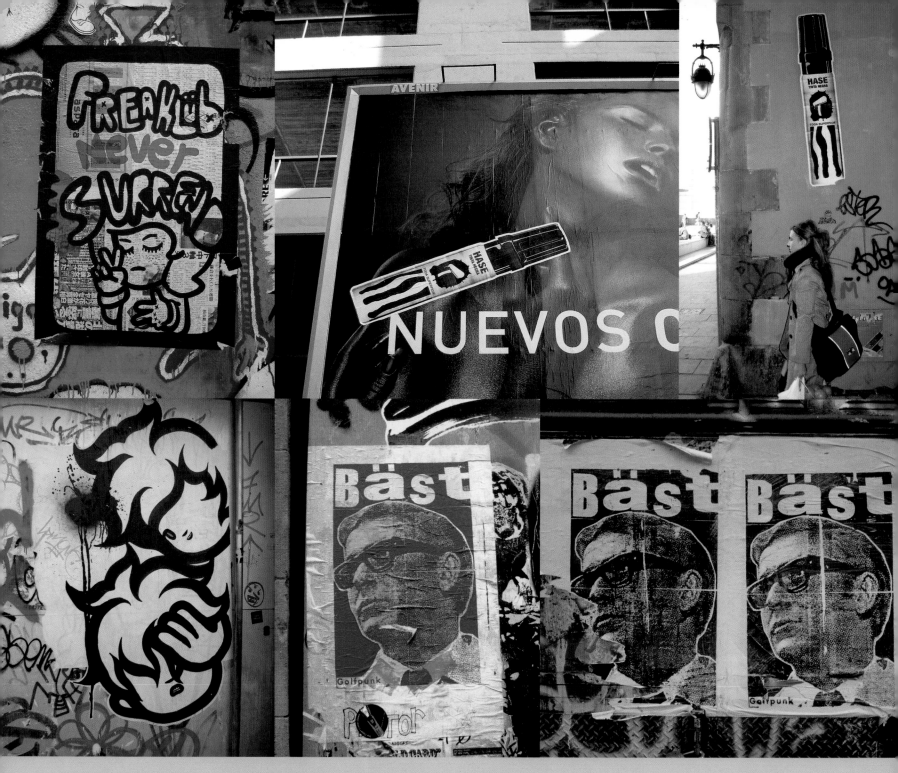

THIS PAGE FROM TOP LEFT TO RIGHT FREAKLÜB (1). LOLO (4). BÄST (5+6).

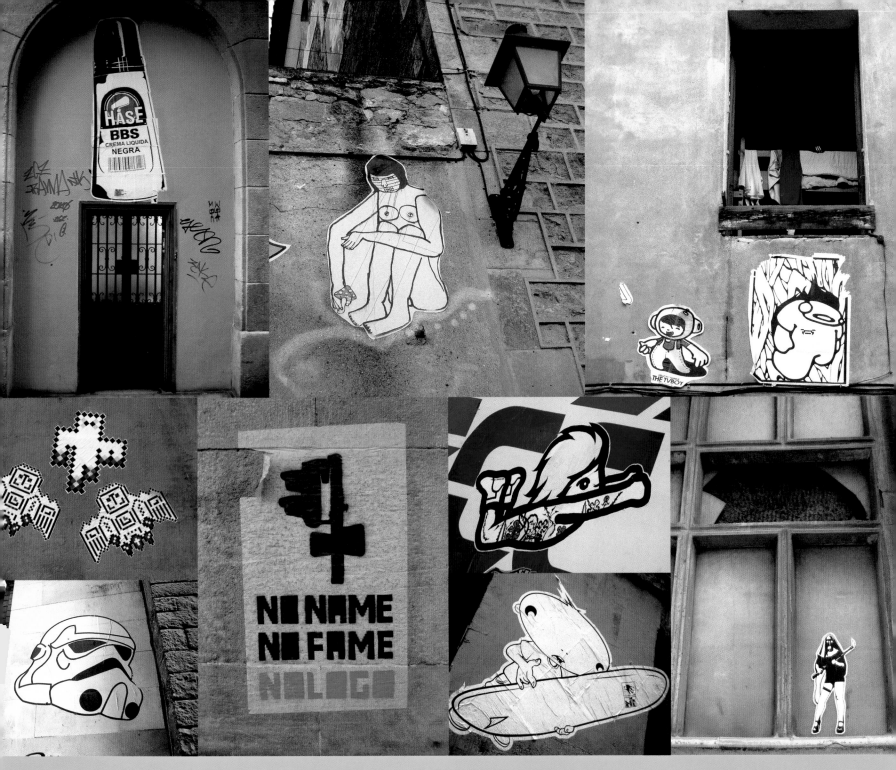

THIS PAGE FROM TOP LEFT TO RIGHT KAMIKAZE CREW (2). CASTRO+BO130 (3).LOLO (6). AMOAMIAMO (8). KARL TOON (9).

77

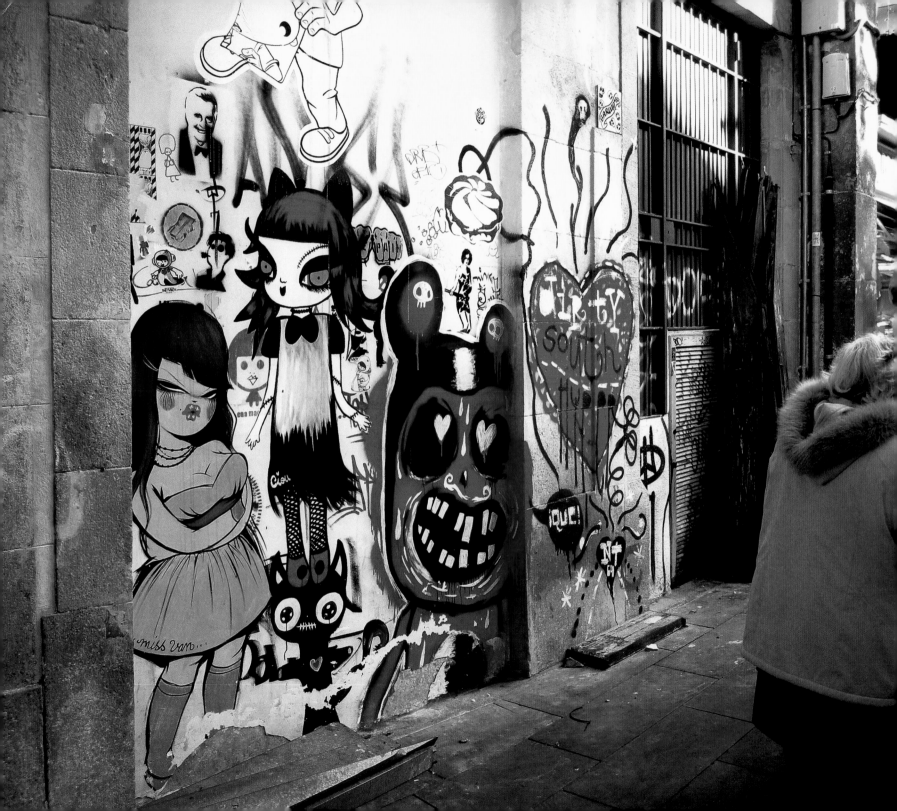

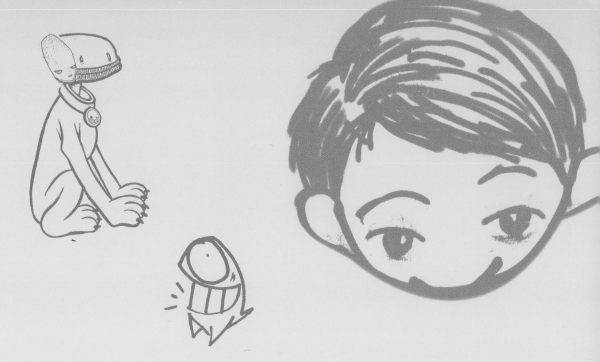

CHARACTERS

Characters have been a fundamental component of contemporary graffiti since the mid-1980s. Caricatures drawn with spray, acrylic, chalk, charcoal, and felt-tip marker invade the city until they become recognizable and permanently emblazoned on our retinas.

Animals, monsters, comic book characters, villains, heroes, celebrities, politicians, and self-portraits of the artists live with us on the walls of our cities.

Many artists use one or several characters as emblems or trademarks, making them their signature or tag, which is the essence of the graffiti culture.

We can find everything from very elaborate pieces, such as those by MISS VAN, FLAN, or SKUM, to the simplest, such as those by

FREAKLÜB, CHANOIR, and BORIS HOPPEK or the unforgettable iconographic characters of the late American artist, KEITH HARING. The simpler the character the easier it will be for the artist to repeat the motif ad nauseam, because it does not need to be accompanied by a background or text, and its purpose is none other than to disseminate his or her tag or logo.

Artists such as FAFI and FLYING FORTRESS, for example, use their characters as their company banners, registering them as trademarks, creating their own merchandising and product lines (T-shirts, skateboards, clothing, stickers, badges, caps, vinyl figures, comics, and so on) that can be purchased online through their websites or in specialty stores.

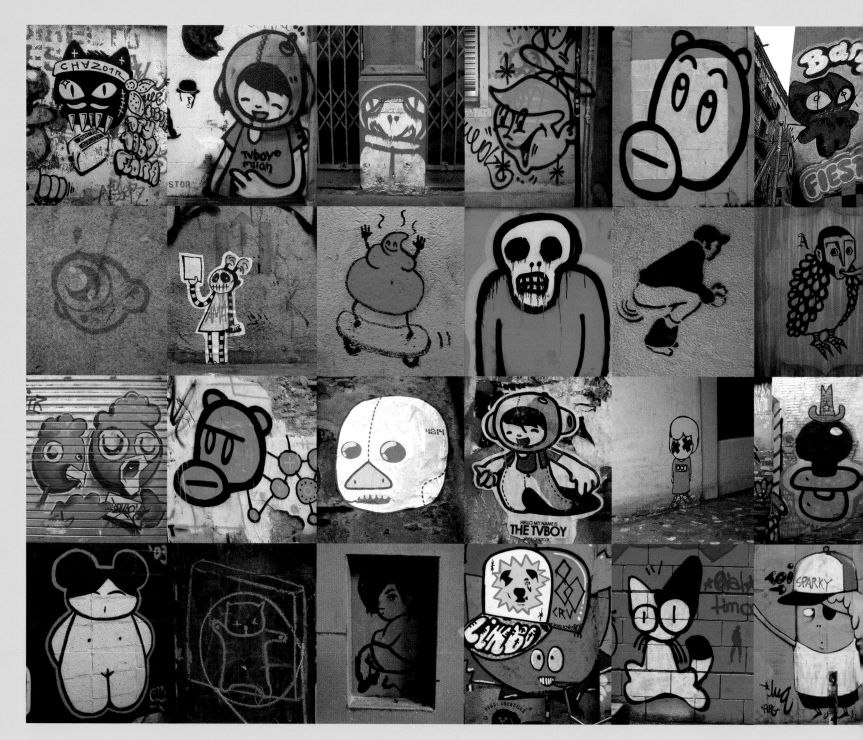

THIS PAGE FROM TOP LEFT TO RIGHT CHANOIR (1+22). CASTRO (2+16). NYLON (4). THE APE (5+14). ETRON (9). CALAVERO (10). CALMA (12). NANO 4814 (15). FUERA DE SERIE (17). EL XUPET NEGRE (18). LOLO (21).

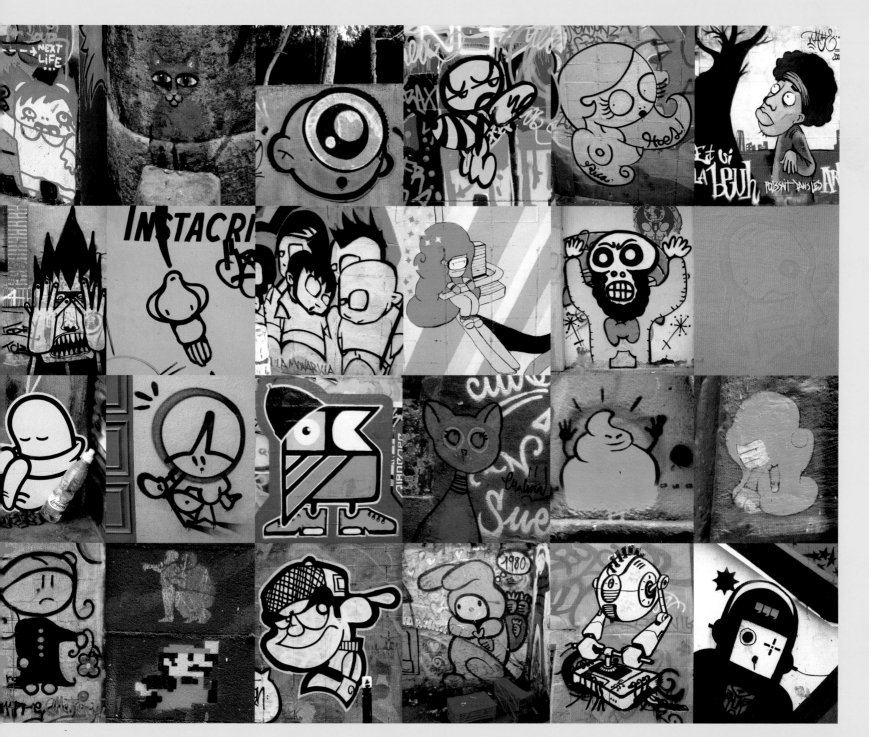

THIS PAGE FROM TOP LEFT TO RIGHT RICA (5). FLAN (7). NANO 4814 (8). FREKLÜB (10+18). CALAVERO (11). DAVE THE CHIMP (13). ETRON (17). SUEI (19). 1980 CREW (22). PUNKYPOW (23).

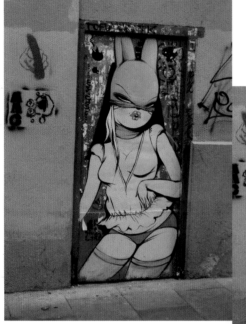

MISS VAN is one of the first women to break onto the street art scene, making it perfectly clear that graffiti is not just the domain of men (with all respect to the mythical LADY PINK). Born in Toulouse, she began painting her dolls with acrylics in the early 1990s, eventually developing her own highly recognizable style.

Sex, glamour, fantasy, and a large dollop of imagination have earned MISS VAN's art international recognition. She has exhibited in major cities such as Paris and New York.

ON THE FOLLOWING PAGES ARTWORKS BY MISS VAN ON THE STREETS OF BARCELONA.

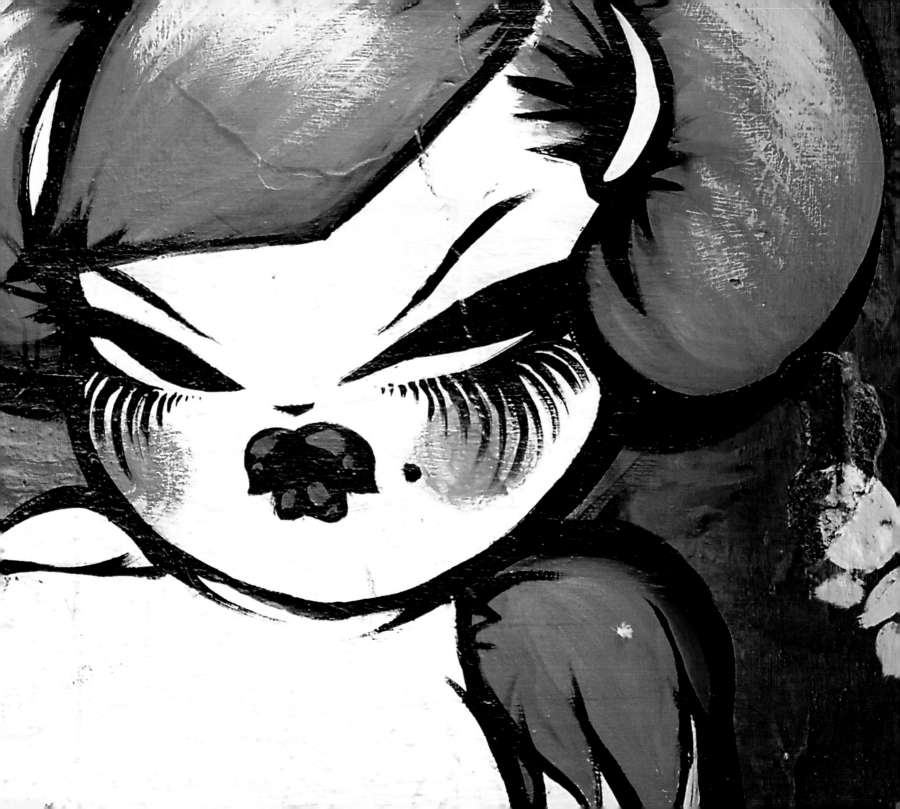

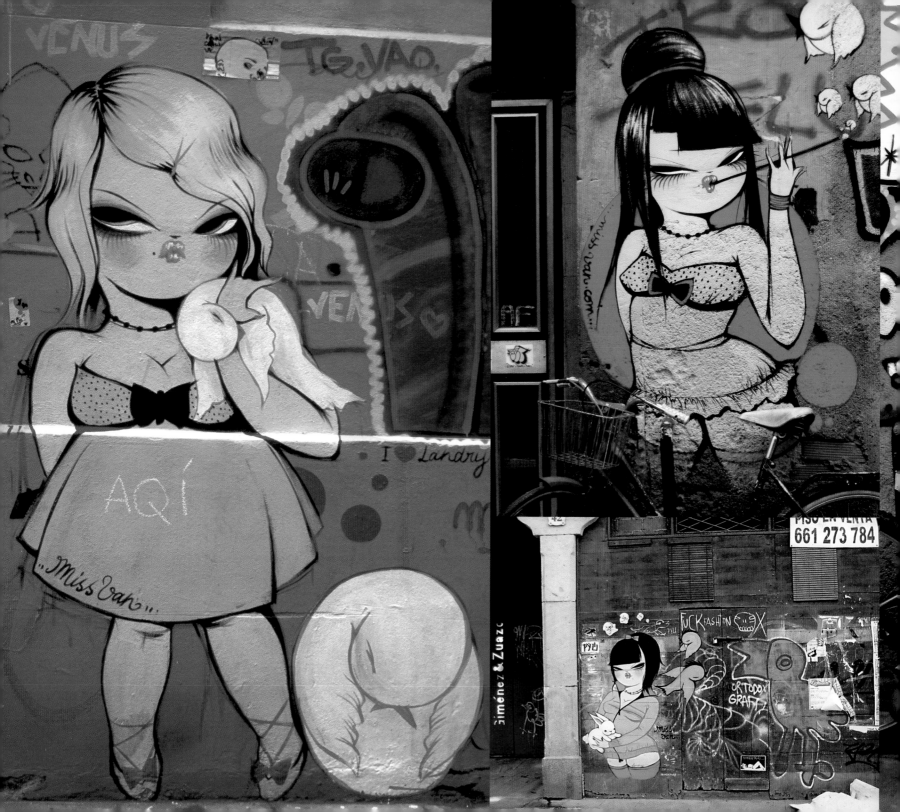

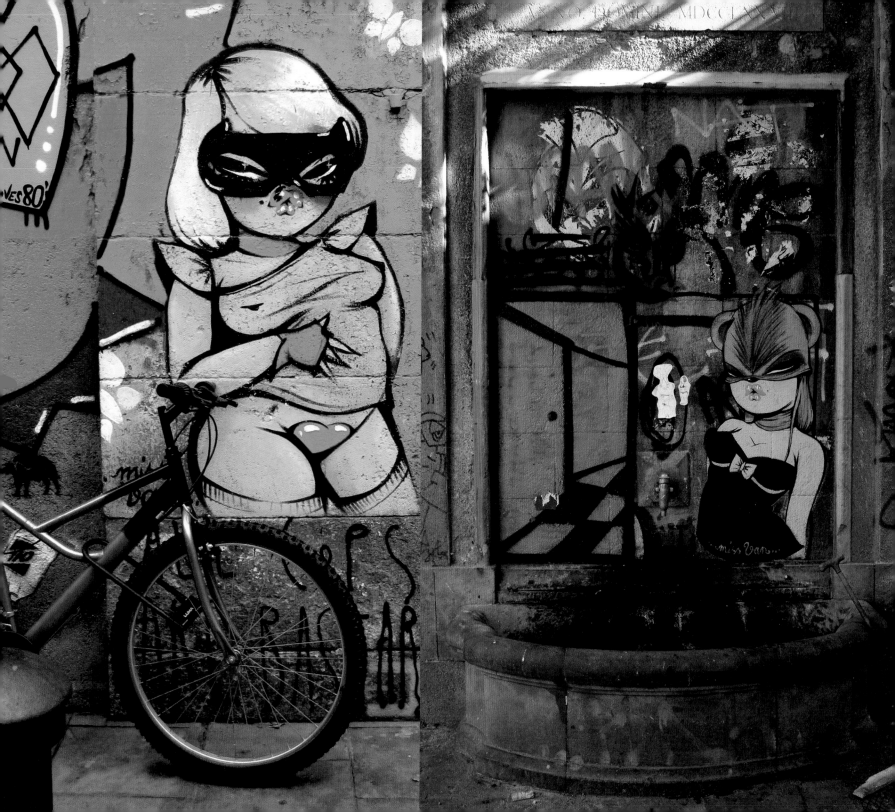

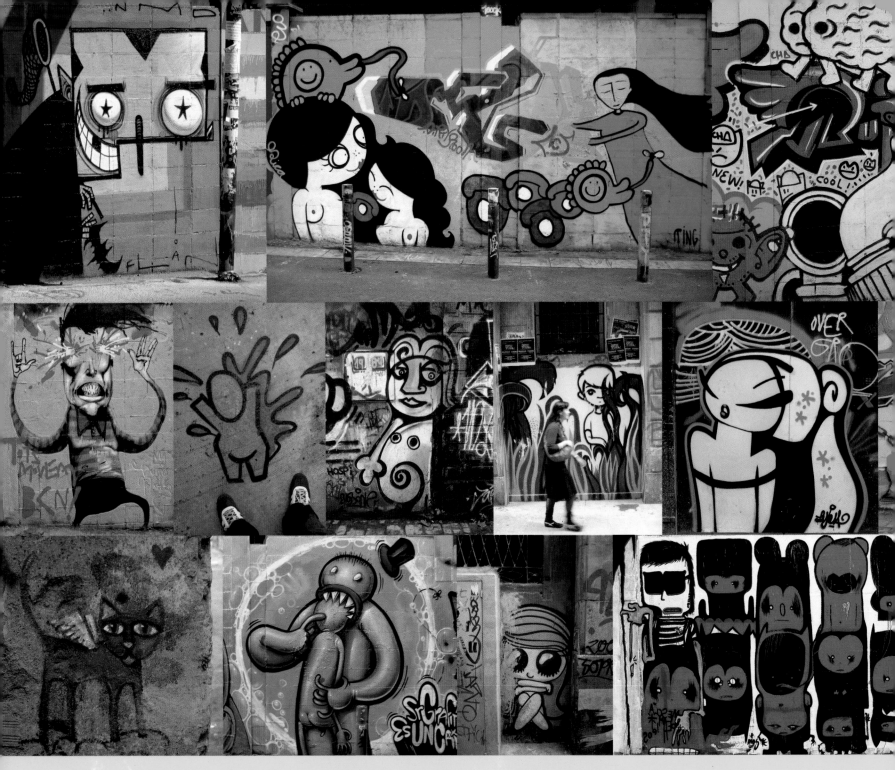

THIS PAGE FROM TOP LEFT TO RIGHT FLAN (1). RICA+RING (2). CHANOIR+PEZ+PELUCAS (3). JACE (5). BLOB (6). LOLO (7). LYLEA (8). NINA (11). SIXE (12).

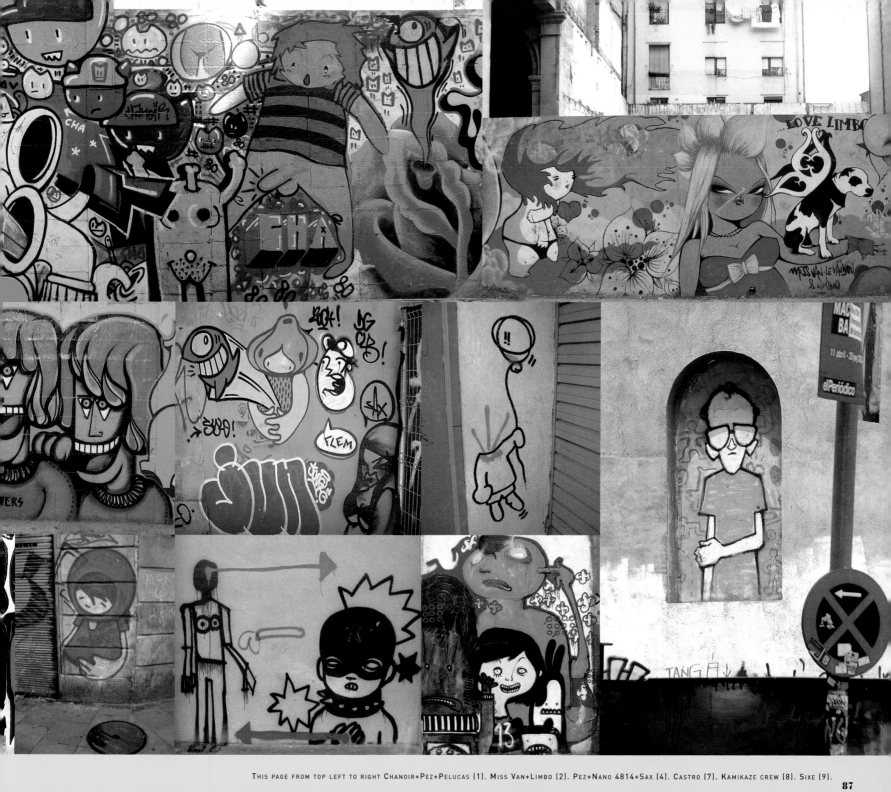

THIS PAGE FROM TOP LEFT TO RIGHT CHANOIR+PEZ+PELUCAS (1). MISS VAN+LIMBO (2). PEZ+NANO 4814+SAX (4). CASTRO (7). KAMIKAZE CREW (8). SIXE (9).

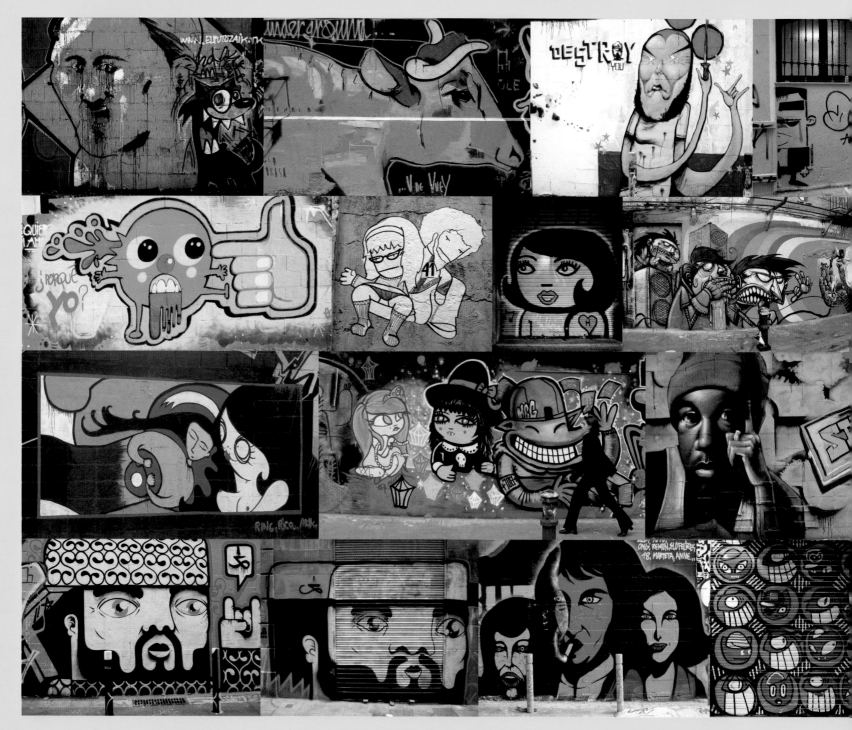

THIS PAGE FROM TOP LEFT TO RIGHT EL PUTO ZAIK (1). KETÓDICO & LE_JAIA (4). FREAKLÜB (6). MALICIA, 1980 CREW (7). FLAN (8). RING+RICA+MILK (9). 1980 CREW (14). CHANOIR+PEZ (15).

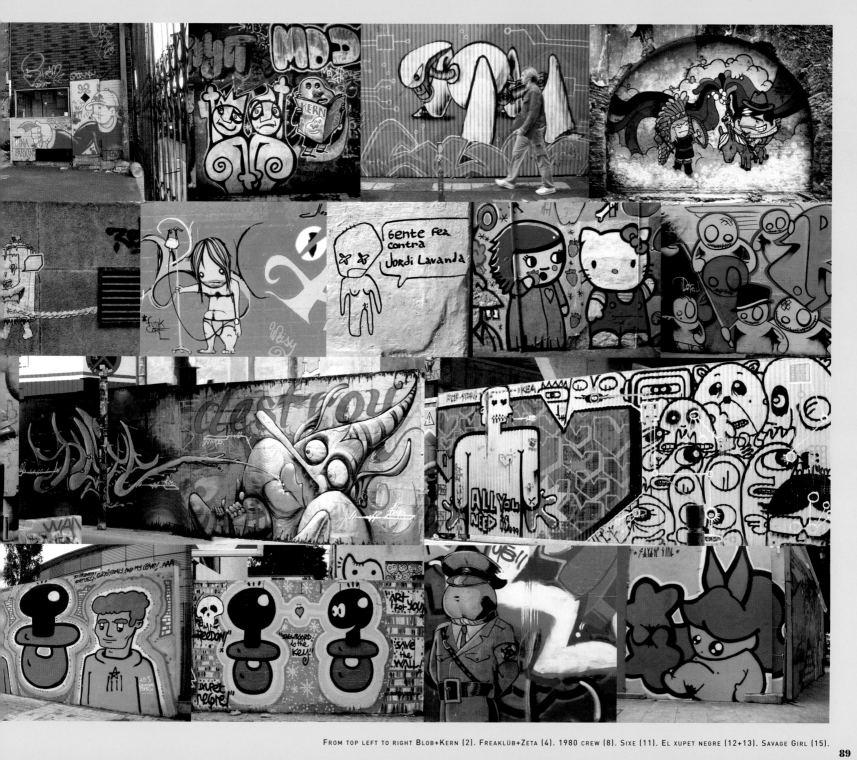

From top left to right Blob+Kern (2). Freaklüb+Zeta (4). 1980 crew (8). Sixe (11). El xupet negre (12+13). Savage Girl (15).

89

FLYING FORTRESS

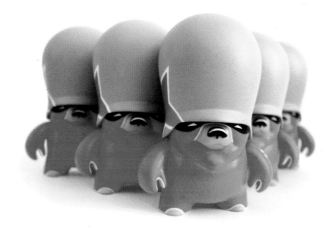

NAME: FLYING ✱ FÖRTRESS
AGE: LET'S SAY: NOT REALLY TWENTY-NINE ANYMORE...
CITY: BEER'N' SAUSAGES CAPITAL: MÜNICH
WORKING AREA: AS HIGH AS MY ARMS REACH...
SPRAY FRIENDS: LOOMIT ✱ BURNS ✱ EMKA ✱ TUMOR ✱ BEAST&HEMS ✱ CHIMP ✱ 243 ✱ 123K ✱ ...
SPRAY ENEMIES: COLD WEATHER! GOOD PARTY'N'BEER! CHICKS WITH DICKS... AND YOUR MOTHER!
WICH ARTIST YOU WOULD LIKE TO DO A COLLECTIVE WORK WITH:
JIM PHILLIPS - THE GODFATHER OF SKATE-ART ✱
YOUR FIRST GRAFFITI: ... WAS PRETTY CRAP! MUST HAVE BEEN AROUND 1988 OR SO...
YOUR DEFINITION OF STREET ART:
A LITTLE BIT LIKE GRAFFITI BUT WITHOUT ALL THIS GRAFF-REALNESS RULES

FUTURE: NOT BEING LIKE PEOPLE ARE EXSPECTING ME TO BE!

FAME: EVERYBODY HUNTS FOR FAME BUT NONE IS ACCEPTING TO ANYBODY... ENVY!

SURVIVAL KIT: MY ELECTRIC RUBBER FOR MY SHITTY PENCIL FIRSTLINES... PROST!

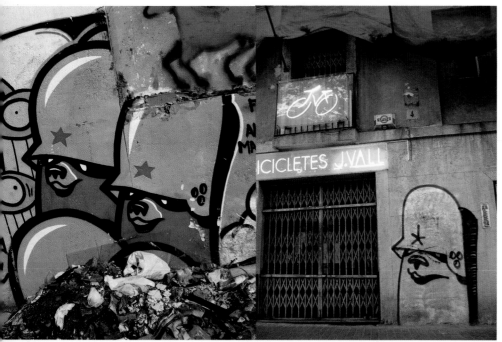

An army of bear soldiers is the FLYING FORTRESS banner. Based in Munich (Germany), its private army occupies public space with the same power as the armed forces themselves, but in the form of stickers, posters, and, of course, works painted with spray or acrylic. FLYING FORTRESS also has a collection of vinyl figures that can be found in specialty stores throughout the world, but can also be purchased directly through their attractive website.

PAGE 92 ANDY WARHOL'S HOMAGE BY SKUM.
PAGE 93 MONKEY BY KRAM.

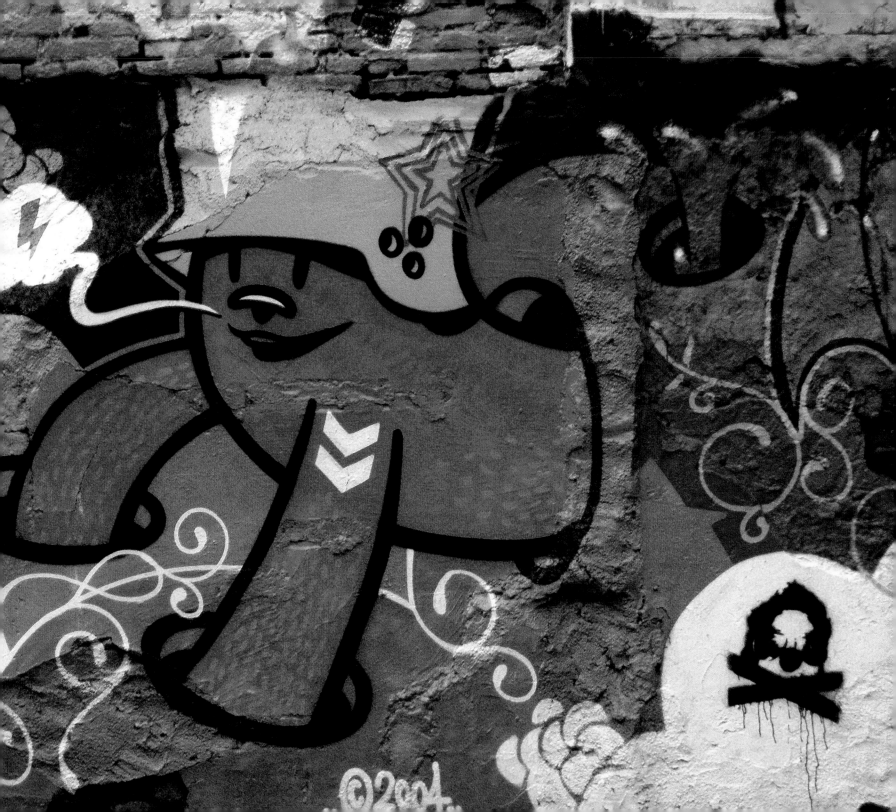

©2004

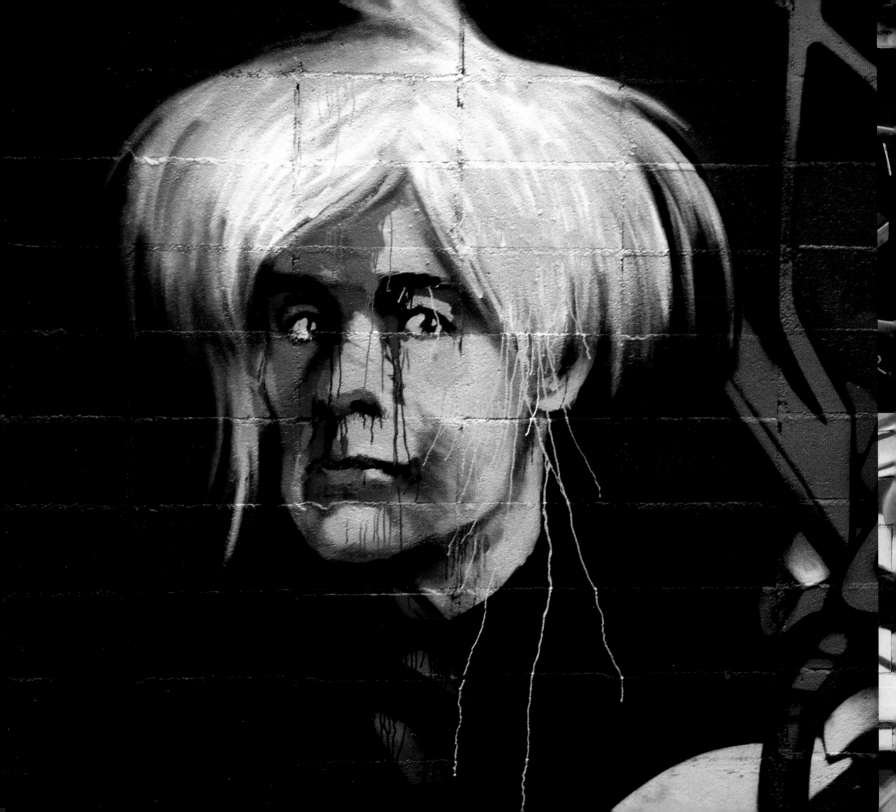

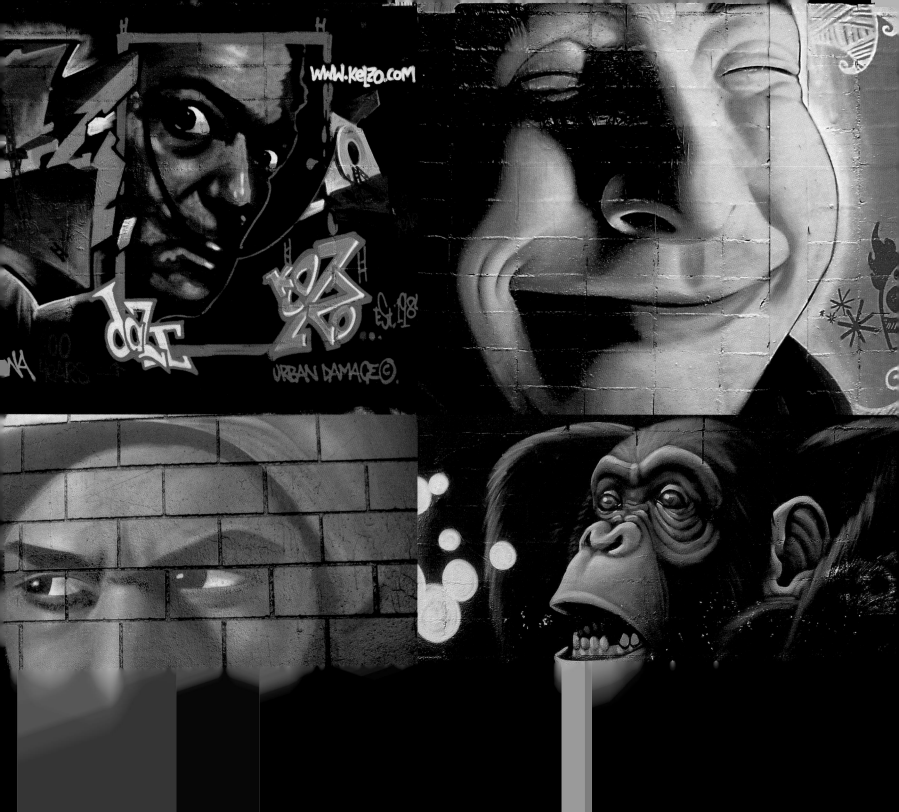

www.kelzo.com

URBAN DAMAGE ©

PEZ TRIBUTE / FREAKLUB

PEZ (Fish) started painting tags on the streets at the end of the 1990s. Little by little his tags turned into the shape of a smiling blue fish, and he became a celebrity throughout Barcelona. If you're planning to visit that city in search of PEZ graffiti, you will find his fish, "diving," from the airport to the most unexpected corners.

We can get PEZ on T-shirts, badges, canvases, bath curtains, walls, tags, stickers, and so on. A lot of experience under his belt and a recent exhibition, "Under Water," consolidate PEZ's name as one of the most creative and genuine artists on the Spanish graffiti scene.

Long live the FISH!

NAME PEZ **AGE** 28 **CITY** SANT ADRIÀ DEL BESÒS (BARCELONA) **WORKING AREA** BARCELONA AND SUBURBS, I ALSO LIKE TO PAINT IN THE VARIOUS CITIES I TRAVEL TO. **SPRAY FRIENDS** ZOSEN, MASH, KENOR, CHANOIR, BLOB, MORGAN, ROVERS, CHAN, CRANEO, EL CHUPET NEGRE, LAMANO, SIXE DIOS, SKUM, KRAM, NADOS, TECK, SEYD, BIRDIE, AMH CREW, ONG CREW, RN1CREW, 1980 CREW, MAUS, NIRSE, LEGO, LEINA, RING, EKOS, TOR, HAT, AEEC, ENTE, TIME, TECH, PILON, JOE, MODS, HUE, OGRO, ZOE, BUNI, DENO, SINS, EL TONO, NANO, TIÑAS, PELUCA, EL NIÑO DE LAS PINTURAS, SEAK, MISS VAN, OS GEMEOS, ALEXONE, NYLON, SICKBOY, PONK, THE LONDON POLICE, SUPAKITCH, OSTA, POPAI, KRISPOLLS, KASP, FINDERKREPERSCREW, FLYING FORTRESS, MR. CROOK, ABBOMINEVOLE, OZMO, BO130, MICROBO, TVBOY, PAO, KIEV, BORDEL, JAGDISH, REMON, EASTERIC, BLOND, SAIGON, SEIN, MARLA, SHE, BUJIA, OVAS, HOCK, OASEI, NOSOLOGRIS, DARLITA, ELEDU, JLOCA, PIGS, SUSO33, DISOP, ANDER, LUXE, DEBONE, FAST, SOOH, ZINK, HOW, DEST, DEBRA, KADER, AND OTHERS I'VE SURELY FORGOTTEN. **SPRAY ENEMIES** BETTER NOT TO HAVE ANY, ALTHOUGH I THINK THE WORST ENEMIES WILL BE THE SECURITY FORCES **ARTIST YOU WOULD LIKE TO COLLABORATE WITH** I WOULD LIKE TO COLLABORATE WITH ARTISTS WHOSE STYLE IS SIMILAR TO MY OWN, WITH PEOPLE FROM ALL OVER THE WORLD, IT WOULD BE FANTASTIC. FOR EXAMPLE, LONDON POLICE, SUPAKITCH, CHANOIR, MISS VAN, ALEXONE, D*FACE, DAVE THE CHIMP, LAMANO, BUFFMONSTER, NANO, SUSO, EL CHUPET NEGRE, FLYING FORTRESS, HOCK, VORE **YOUR FIRST GRAFFITI** AT AGE 14, TWO FRIENDS AND I PAINTED SOME GRAFFITI WITH TWO CANS OF CAR SPRAY PAINT WE HAD STOLEN FROM A SUPERMARKET. BUT THE FIRST SERIOUS GRAFFITI WAS IN 1999 AT THE CASAL DEL NORD IN SAN ADRIÀ DE BESÒS (BARCELONA) **YOUR DEFINITION OF STREET ART** IT'S A LABEL THAT SOMEONE'S INVENTED AND THAT HAS BEEN VERY FASHIONABLE LATELY, DIFFERENTIATING THE MORE CLASSICAL AND TRADITIONAL GRAFFITI FROM THE NEW TRENDS THAT HAVE BEEN DEVELOPING IN RECENT YEARS **FUTURE** YOU HAVE TO WORK VERY HARD NOW TO REAP THE FRUITS OF YOUR LABOR IN THE FUTURE **FAME** IT WAS AN AMERICAN TV SERIES, RIGHT? **SURVIVAL KIT** CORROSIVE INK FELT-TIP MARKER, WHITE OR SILVER INK FELT-TIP MARKER, STICKERS. IF I HAVE A BACKPACK I ALSO GENERALLY CARRY SPRAYS.

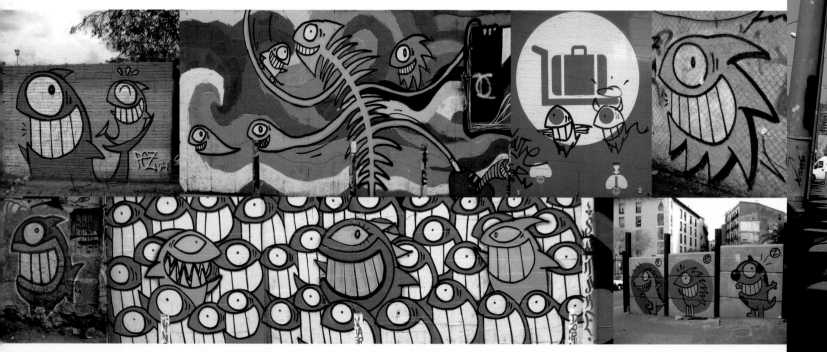

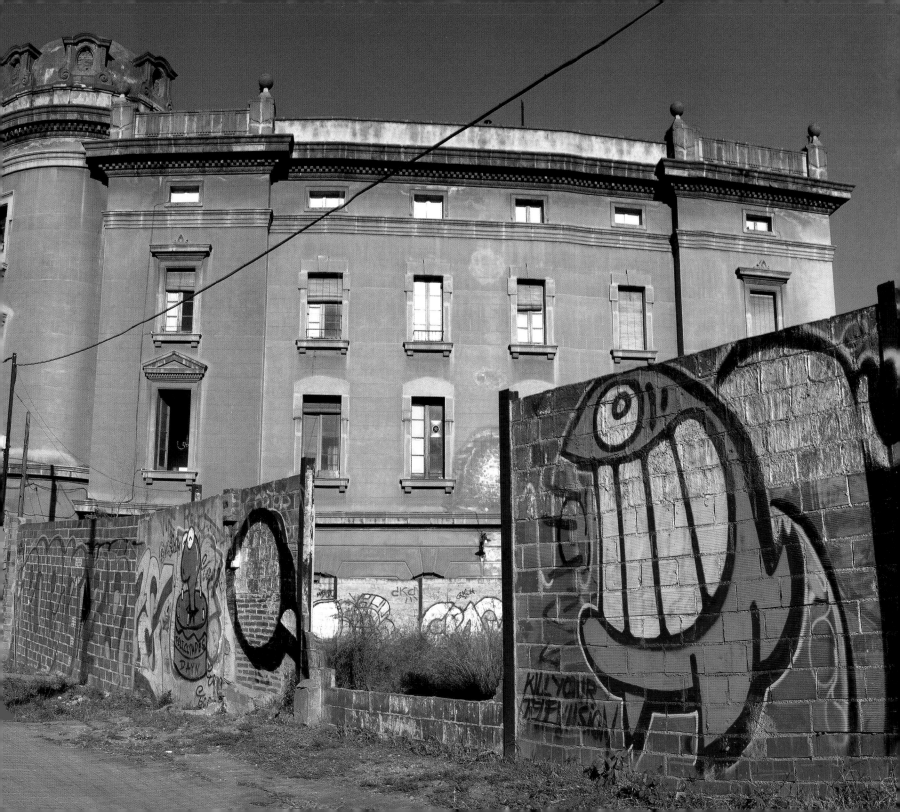

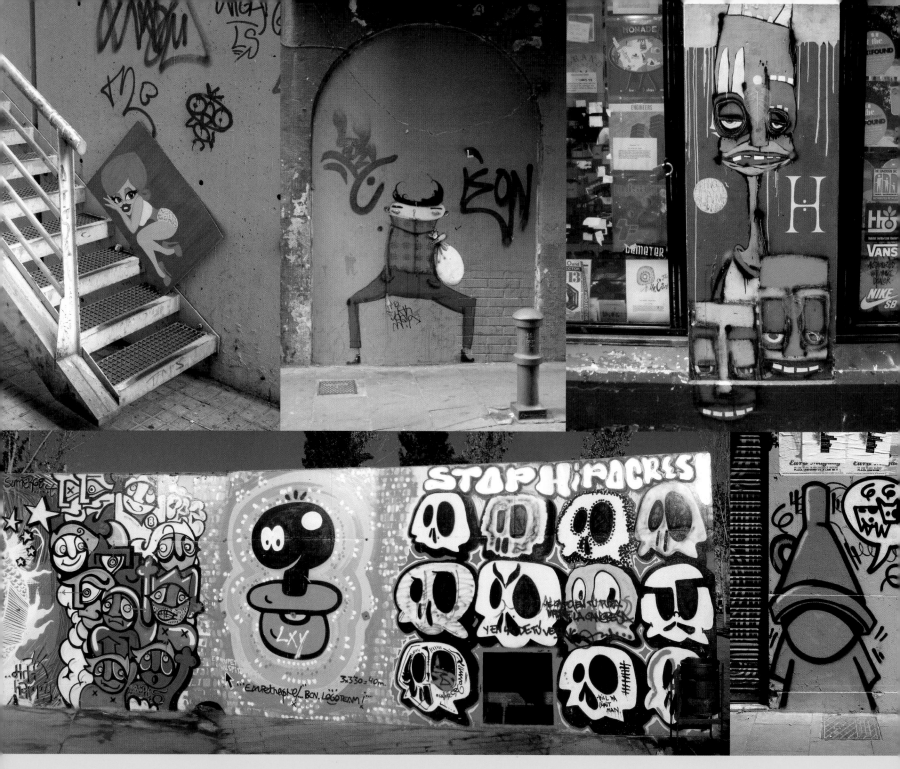

THIS PAGE FROM TOP LEFT TO RIGHT LADY MAGENTA (1). OS GEMEOS (2). BLOB+EL XUPET NEGRE+CRANEO (4). JACE (5).

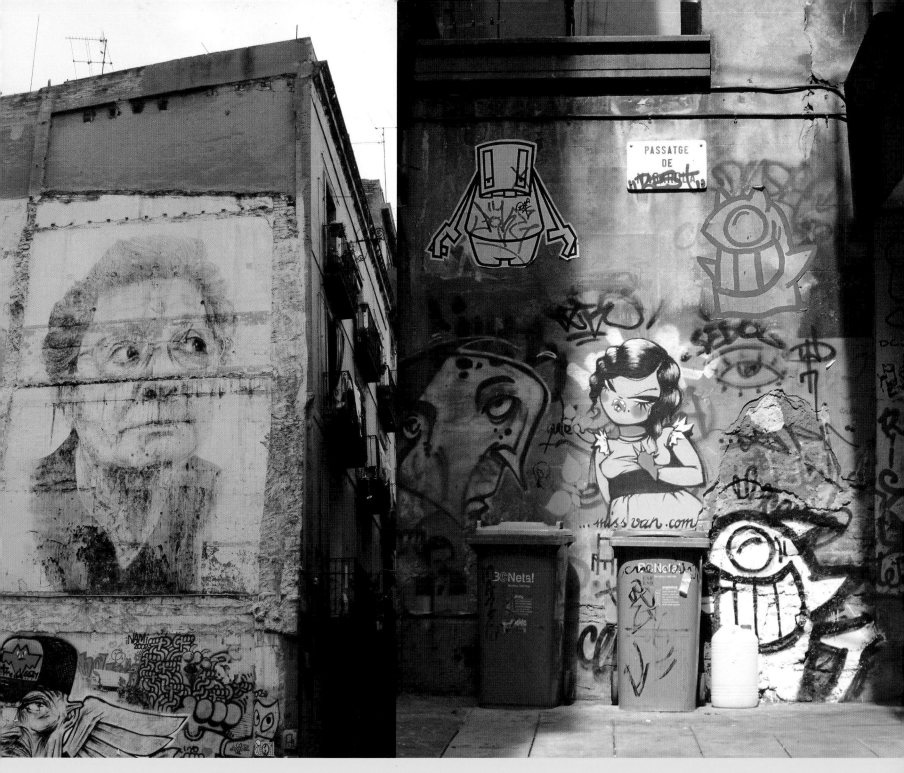

FROM LEFT TO RIGHT JORGE RODRÍGUEZ GERADA (1). MISS VAN+PEZ+D*FACE (2).

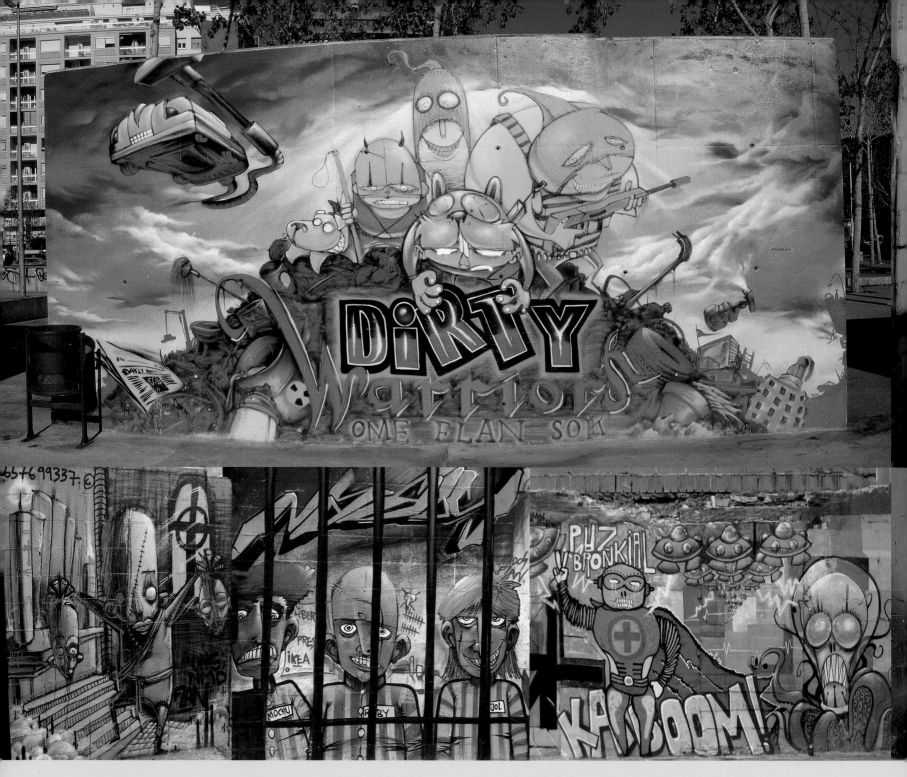

Clockwise OME+Flan+SOK (1). Ong (2). Flan (3+4).

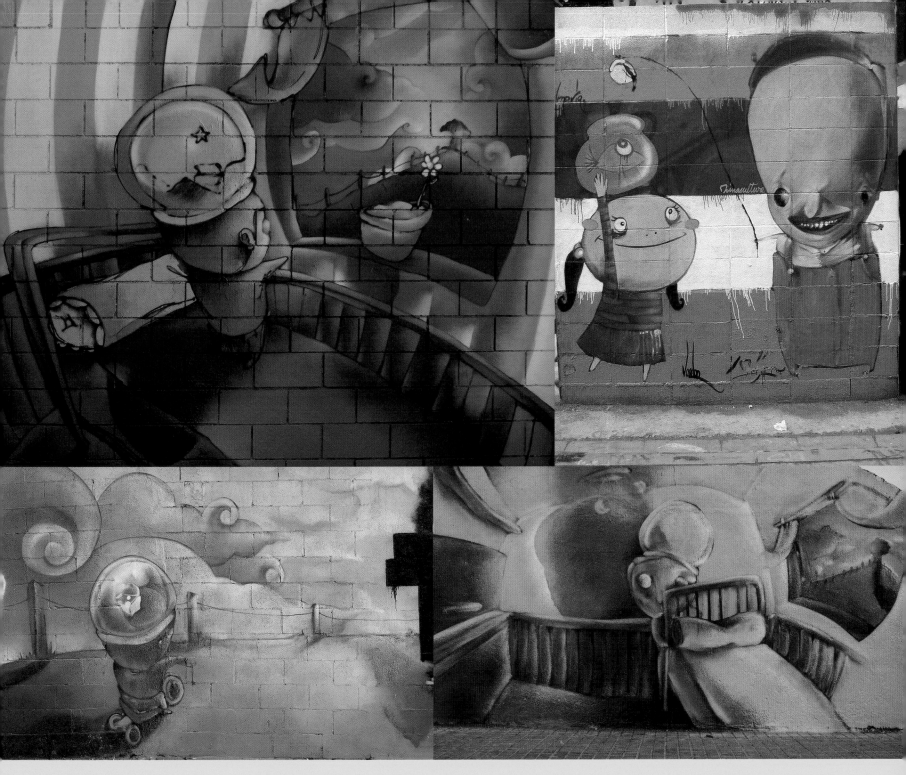

The inspiration for his characters comes from the Dragon Ball TV series and the films of Hayao Miyazaki. Influenced by the cartoons and puppets of his childhood, he began creating his characters unconsciously, never dreaming that soon he would be participating in exhibitions of urban art along with other great artists. He generally works and paints alongside his girlfriend, KORALIE. His passion for drawing and graphic design led him to paint on the streets using graffiti as a means of creative expression.

NAME SUPAKITCH **AGE** 00 **CITY** MONTPELLIER (FRANCE) **WORKING AREA** ANYWHERE **SPRAY FRIENDS** KORALIE MY GIRLFRIEND **SPRAY ENEMIES** POLICE **ARTIST YOU WOULD LIKE TO COLLABORATE WITH** I DON'T KNOW. 3 THINGS FOR A COLLABORATION WITH ME: 1-I LIKE THE WORK OF THE ARTIST. 2-A GOOD FEELING. 3-A GOOD IDEA FOR THE COLLABORATION **YOUR FIRST GRAFFITI** 1842 **YOUR DEFINITION OF STREET ART** POST GRAFFITI **FUTURE** YES **SURVIVAL KIT** MY BRAIN, MY HANDS, MY EYES, AND COLORS

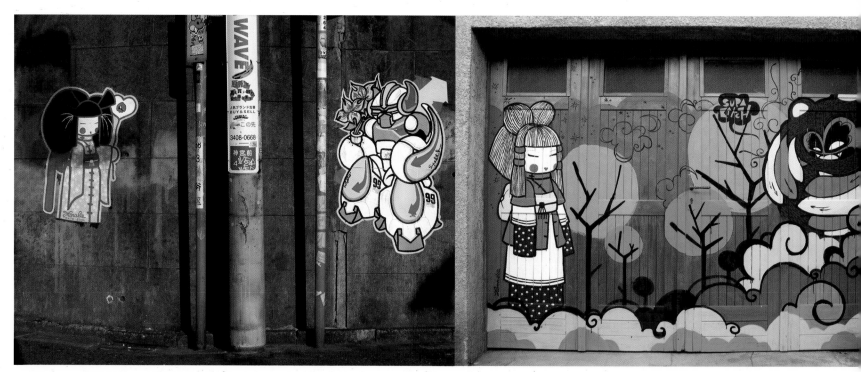

ABOVE POSTERS BY KORALIE AND SUPAKITCH IN JAPAN. PHOTOGRAPHS BY SUPAKITCH.

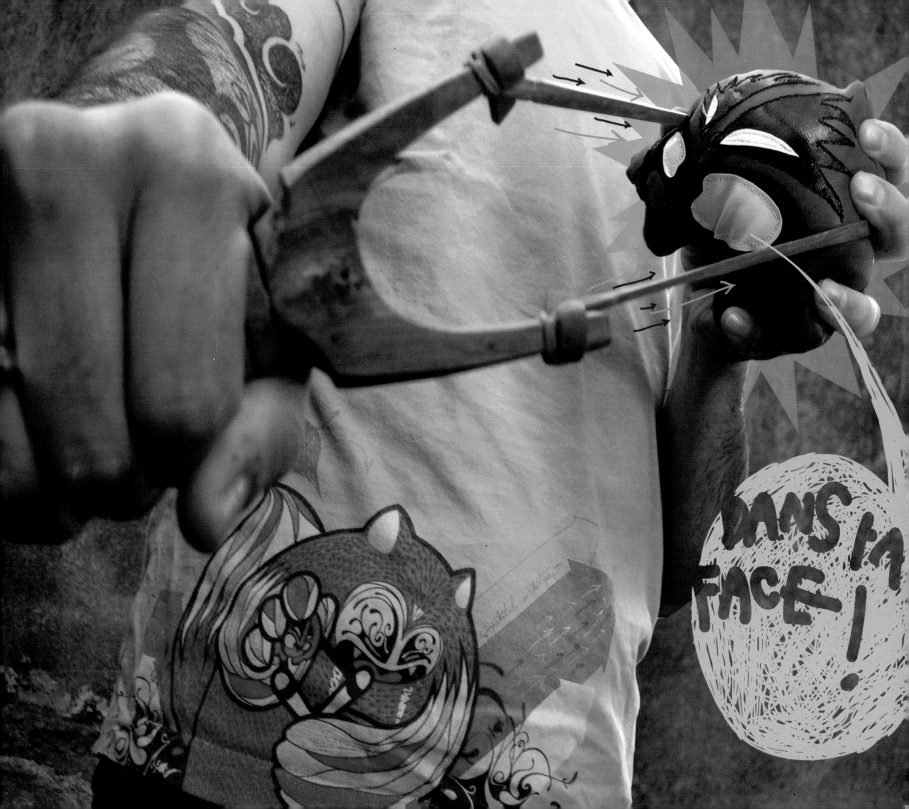

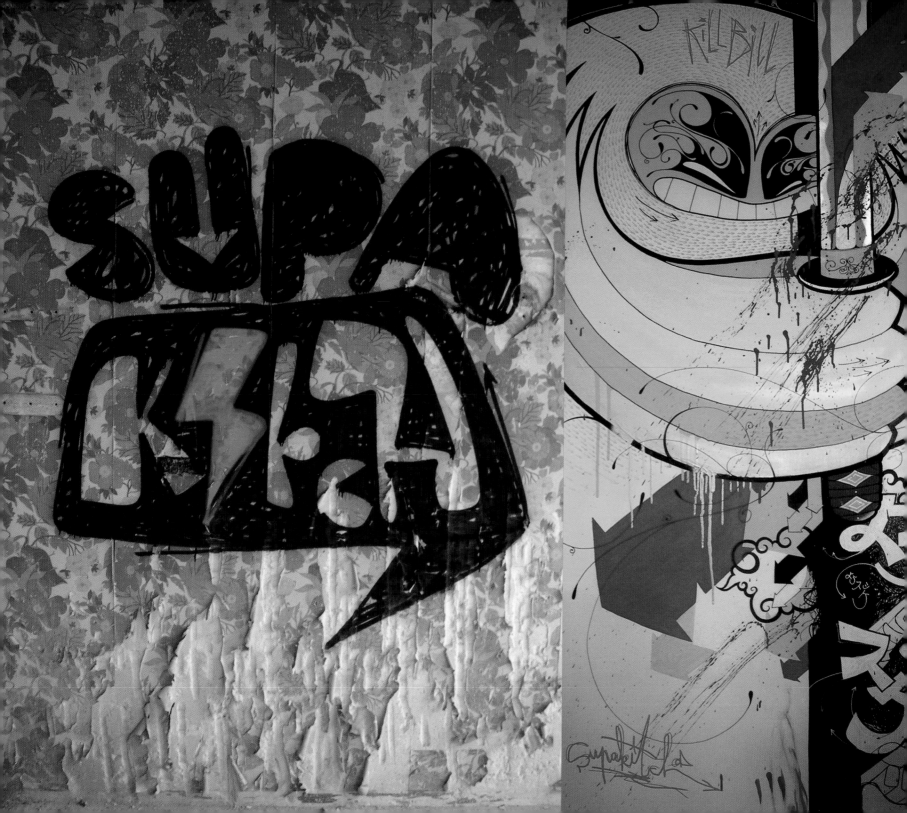

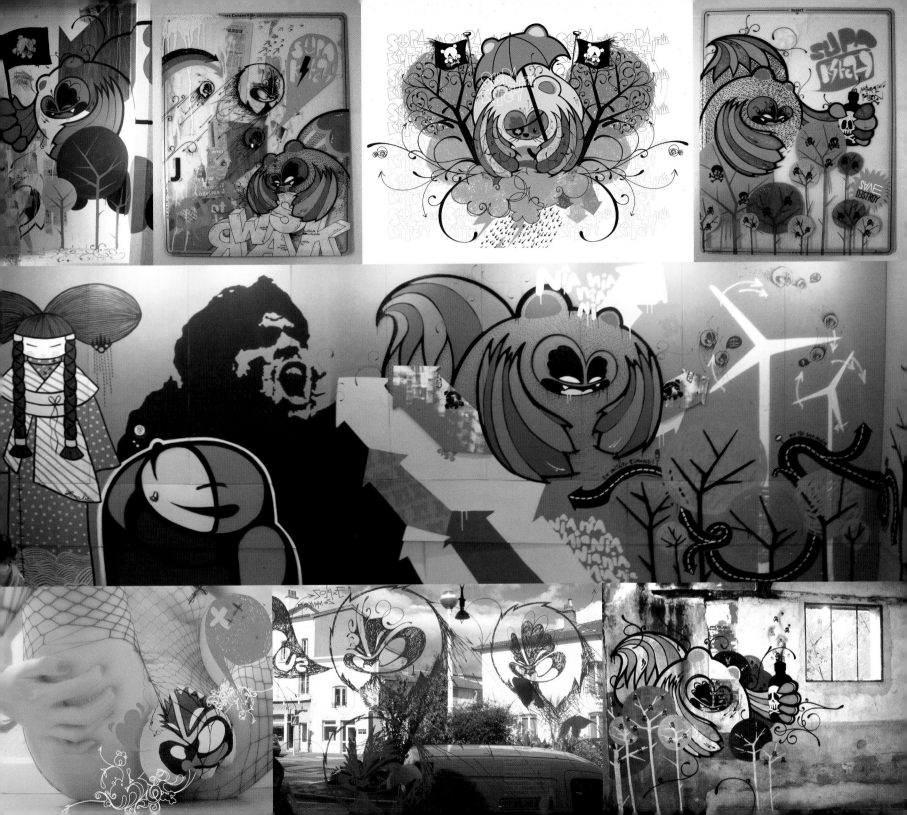

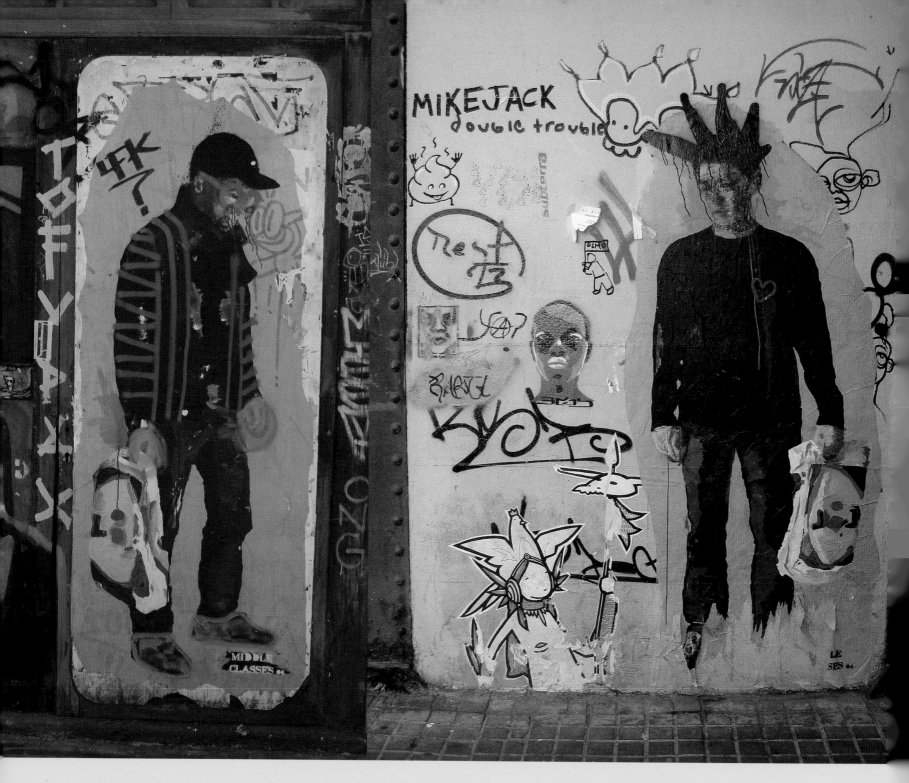

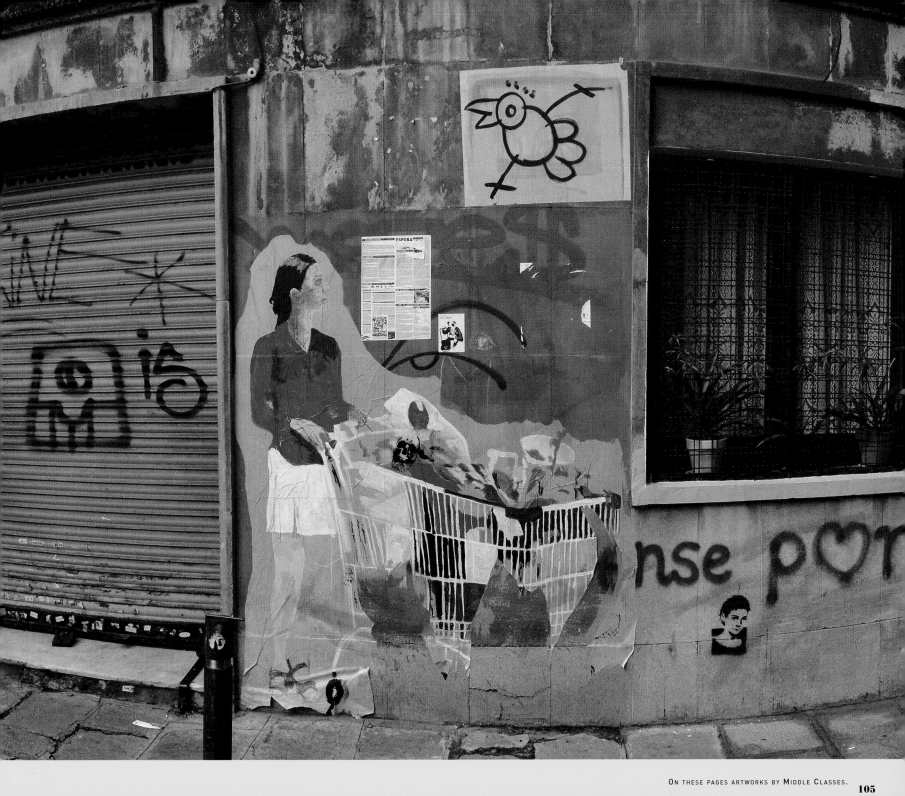

Graffiti and street art have turned big cities all over the planet into a third dimension . Citizens have learned to coexist with the big invasion of characters made of spray and acrylic or perhaps stuck on any surface. Provoking smiles, love, and hate among the population, graffiti interacts with the passerby who is surprised in every corner of the big city.

The city has infinite supports in which artists can create their own works, transforming furniture and urban scenery into a cauldron of ideas and messages full of irony.

Ordinary things like trash containers, semaphores, traffic signs, doors, blinds, sidewalks, asphalt, windows, roofs, corners, stairs, bars, markets, vehicles, park benches, telephone boxes, sculptures, shop windows, and, obviously, the walls of any street or square serve as bases for the "miracle" of creation.

As in a fairy tale , characters, icons, and drawings take on their own life, turning the city into some kind of wonderland in which everything is possible. Let's take a walk and see!

Wonderland

"The King and Queen of Hearts were seated on their throne when they arrived, with a great crowd assembled about them—all sorts of little birds and beasts, as well as the whole pack of cards: the Knave was standing before them, in chains, with a soldier on each side to guard him; and near the King was the White Rabbit, with a trumpet in one hand and a scroll of parchment in the other. In the very middle of the court was a table, with a large dish of tarts upon it: they looked so good that it made Alice quite hungry to look at them—'I wish they'd get the trial done,' she thought, `and hand round the refreshments!' But there seemed to be no chance of this, so she began looking at everything about her, to pass away the time."

Alice in Wonderland. Lewis Carroll.

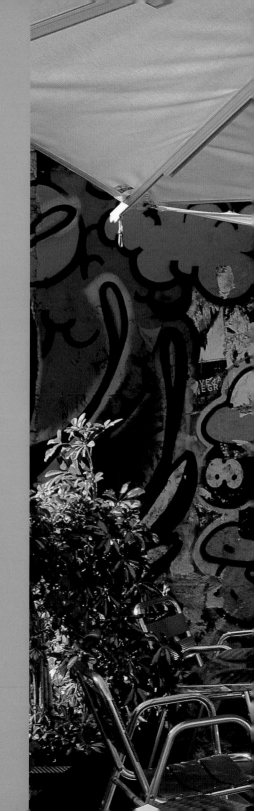

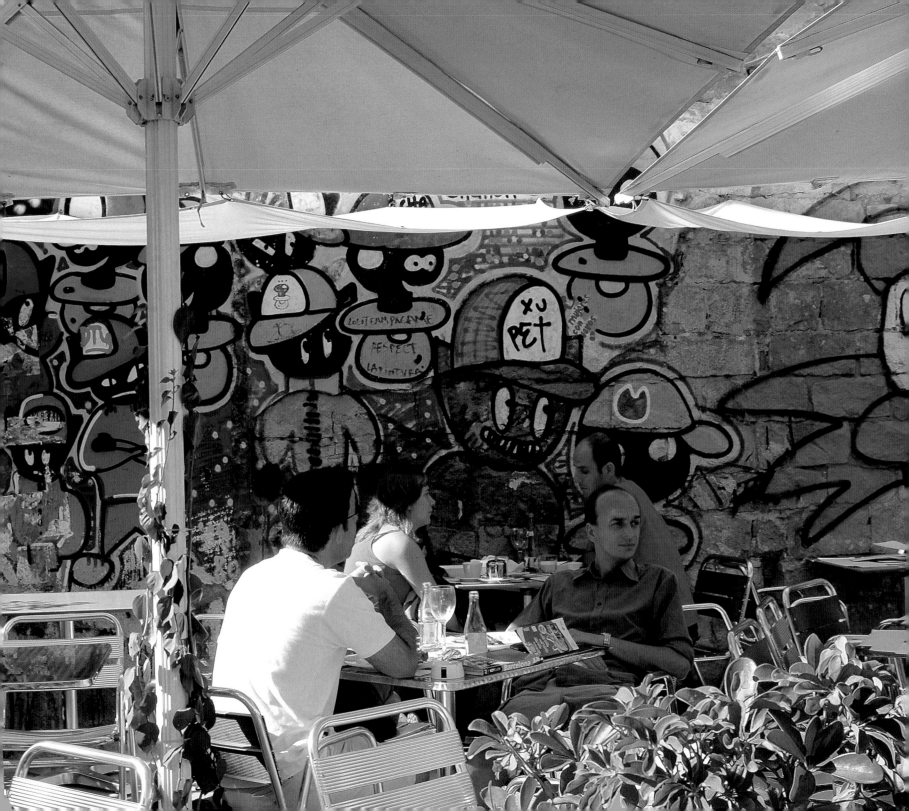

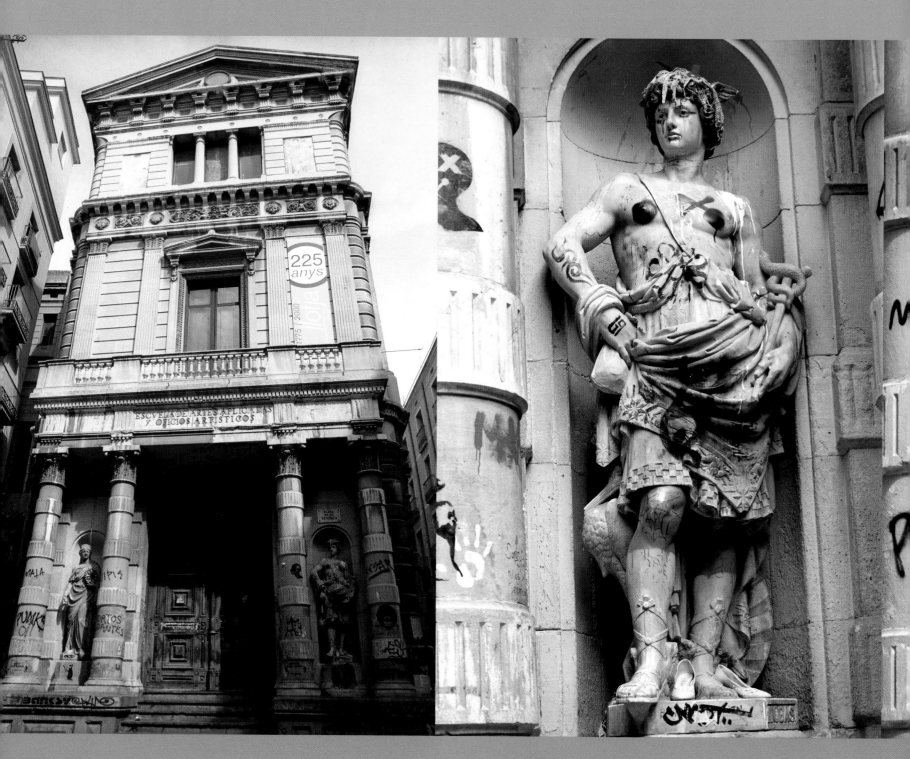

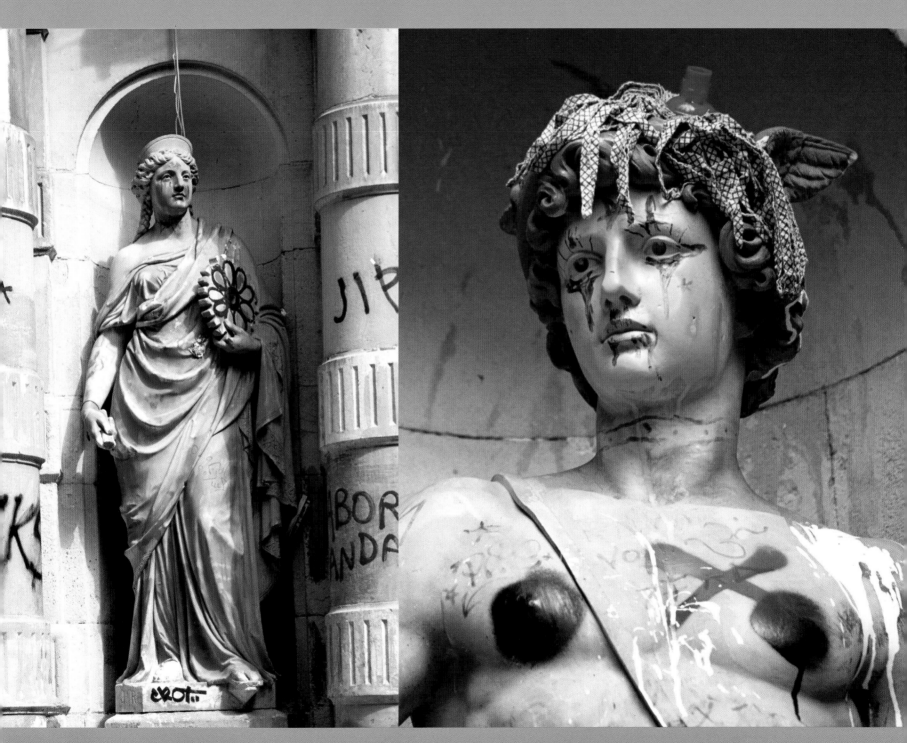

On these pages "Art attack" in La Llotja , an old school of art in Barcelona.

109

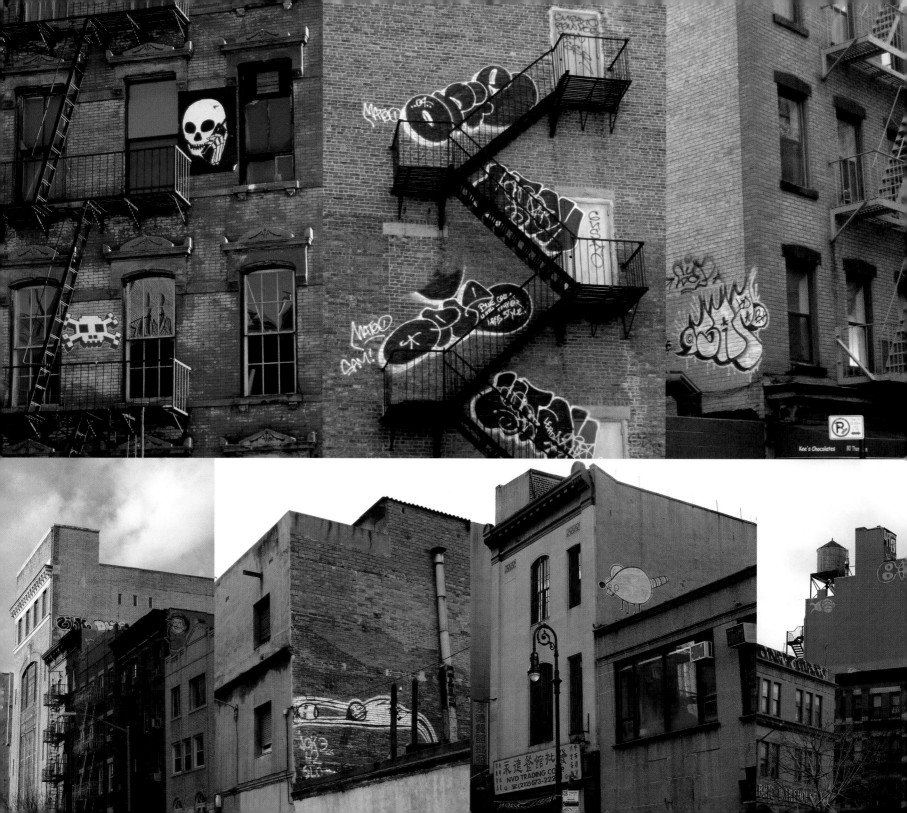

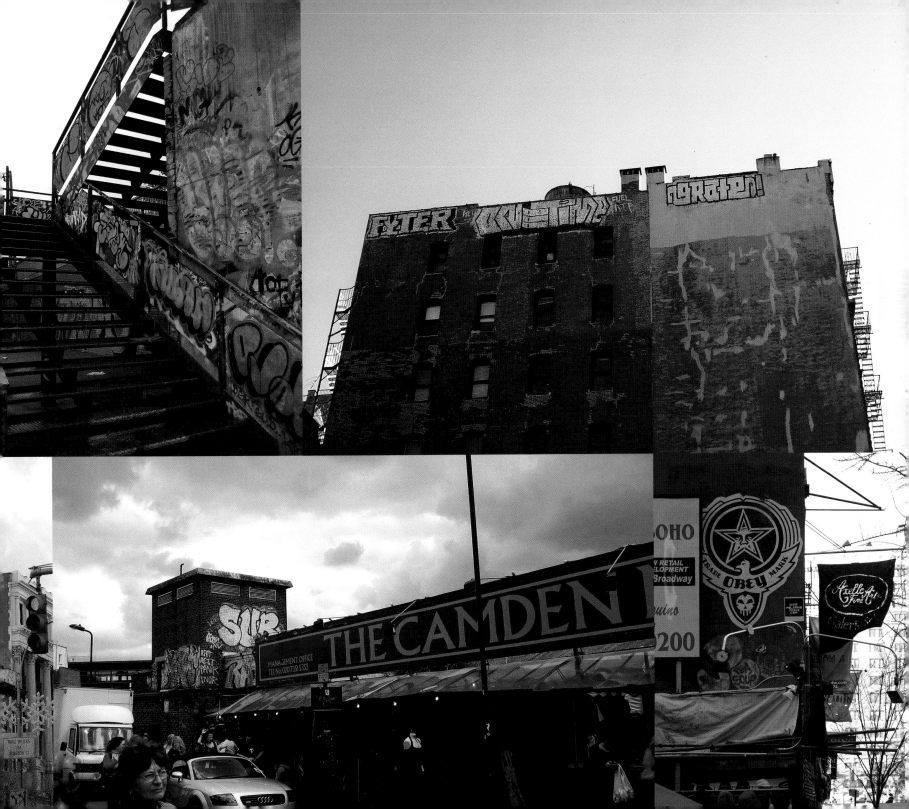

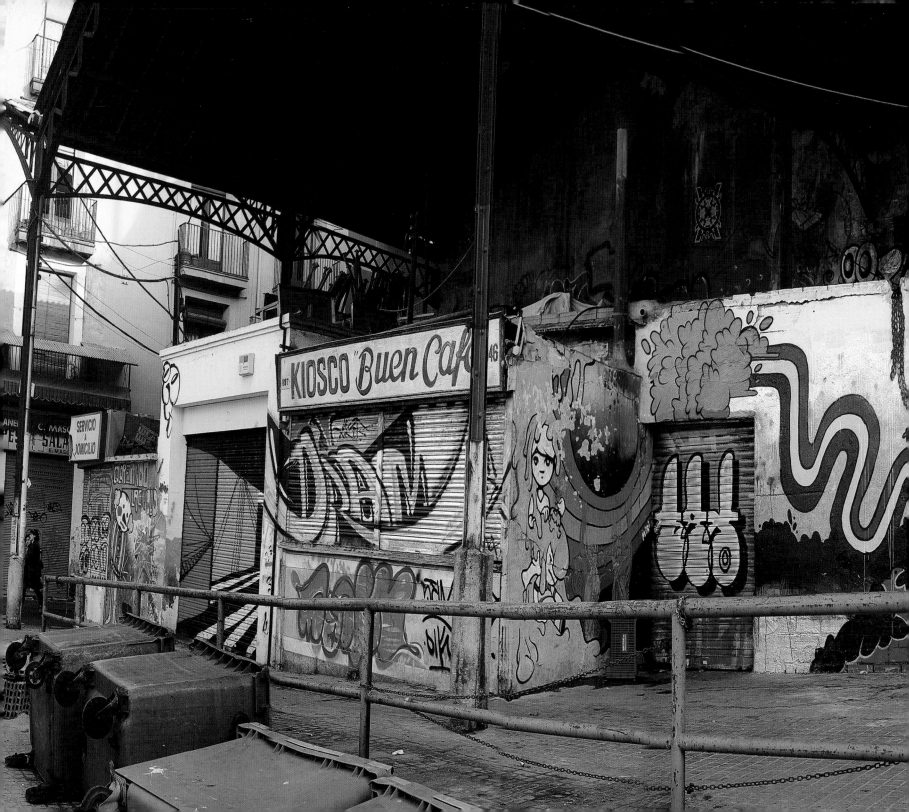

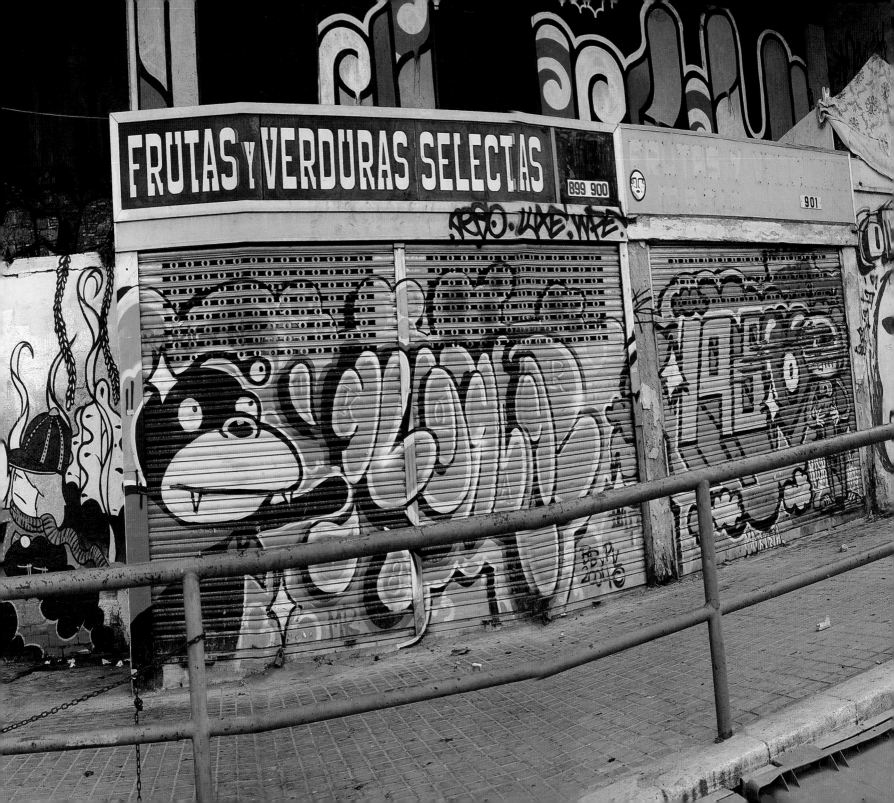

BORIS HOPPEK

This German based in Barcelona began his artistic incursions into the street almost a decade ago. Although his art is reminiscent of Keith Haring's, Boris has a well-defined style that is all his own. Like Haring, he loves to draw his characters in chalk, since he feels that it's like a journey through time, a return to the roots of art. His "bimbos" can be found on walls, drawn using various techniques and different media. Although he prefers to work alone, we can sometimes see his collaborations with MISS VAN and FREAKLÜB. In addition to selling his hand-painted coasters, some specialty stores sell characters hand-sewn by the artist himself.

NAME BORIS HOPPEK **AGE** 33 **CITY** BCN **WORKING AREA** I WORK A LOT IN MY HEAD. I AM NOT ALWAYS HAPPY WITH MY BRAIN, BUT SOMETIMES IT SURPRISES ME . . . **SPRAY FRIENDS** XAVI, ELISA, GREGORY, STEVE, DANIELE, NUNO, FRANK **SPRAY ENEMIES** NO **ARTIST YOU WOULD LIKE TO COLLABORATE WITH** GOLDSWORTHY **YOUR FIRST GRAFFITI** 1989 **YOUR DEFINITION OF STREET ART** I WAS VERY LATE WITH GIRLS, I DONT KNOW, I HAD A CAR ALREADY. SO IN THIS CAR I WAS SITTING NEXT TO THIS GIRL. BLONDE, NICE, AND AFTER HOURS I TOUCHED HER HAND ...IT WAS LIKE A FLASH! A SLOW FLASH, A BIG INFUSION OF ILLEGAL STUFF. YES ILLEGAL BECAUSE SHE HAD A FRIEND . . . I WAS SURE AFTER THIS SHE HAD TO QUIT WITH HIM . . . ALL MINE NOW. THIS WAS THE POINT WHERE I LEARNED A LOT ABOUT COMPLEX SITUATIONS IN LIFE . . . **FUTURE** I DONT KNOW **FAME** YES, MONEY, NO... **SURVIVAL KIT** MY HANDS, AND CHALK.

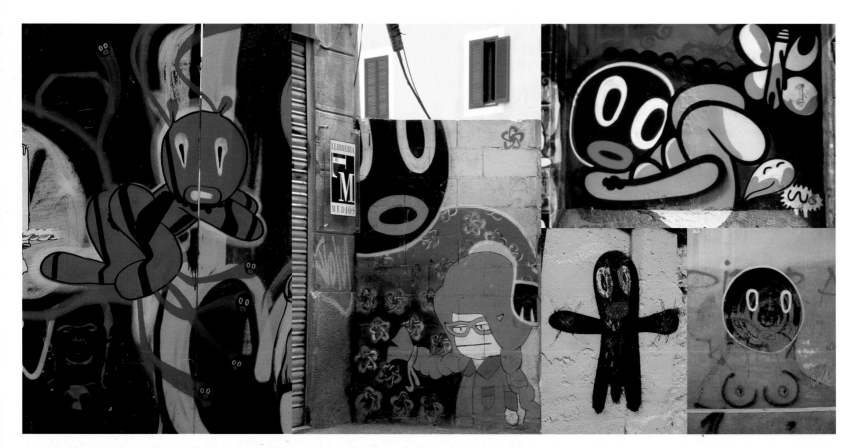

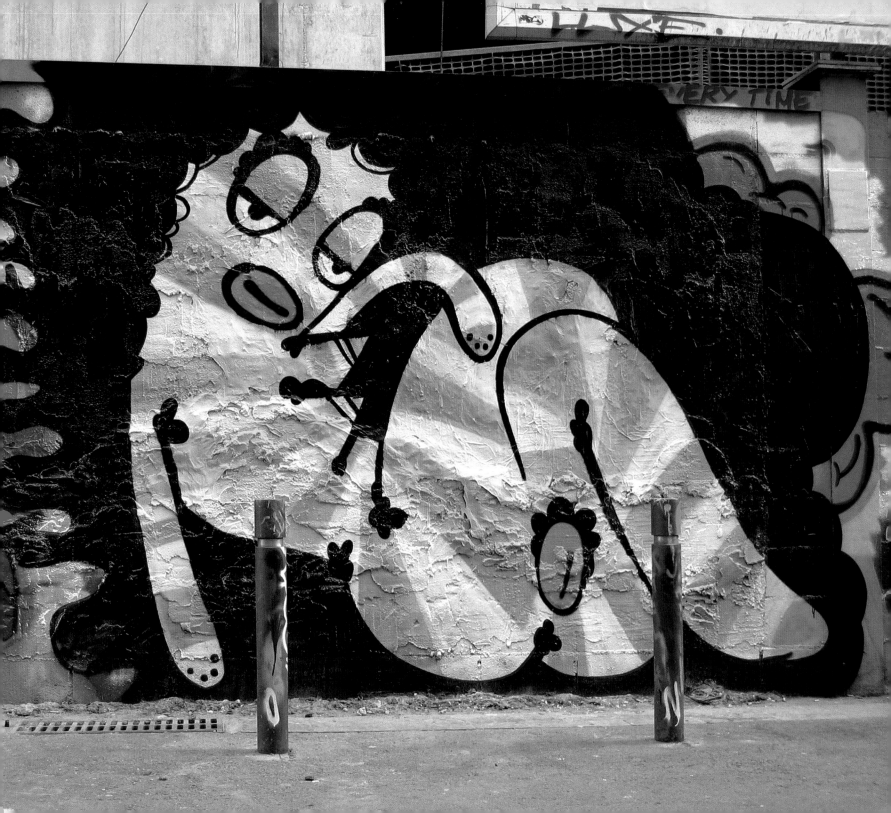

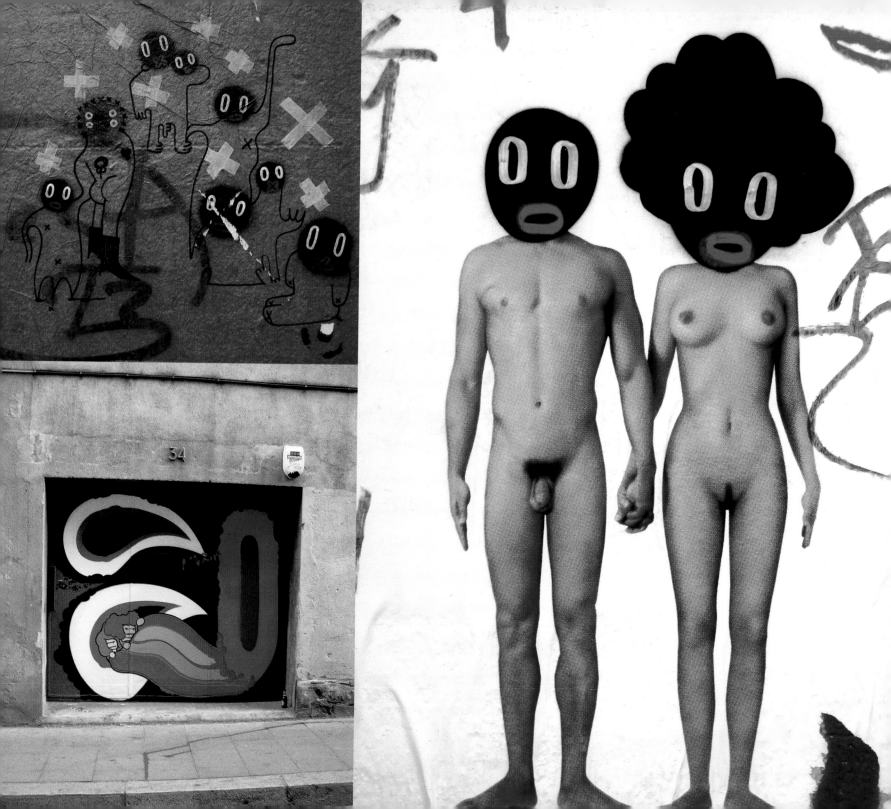

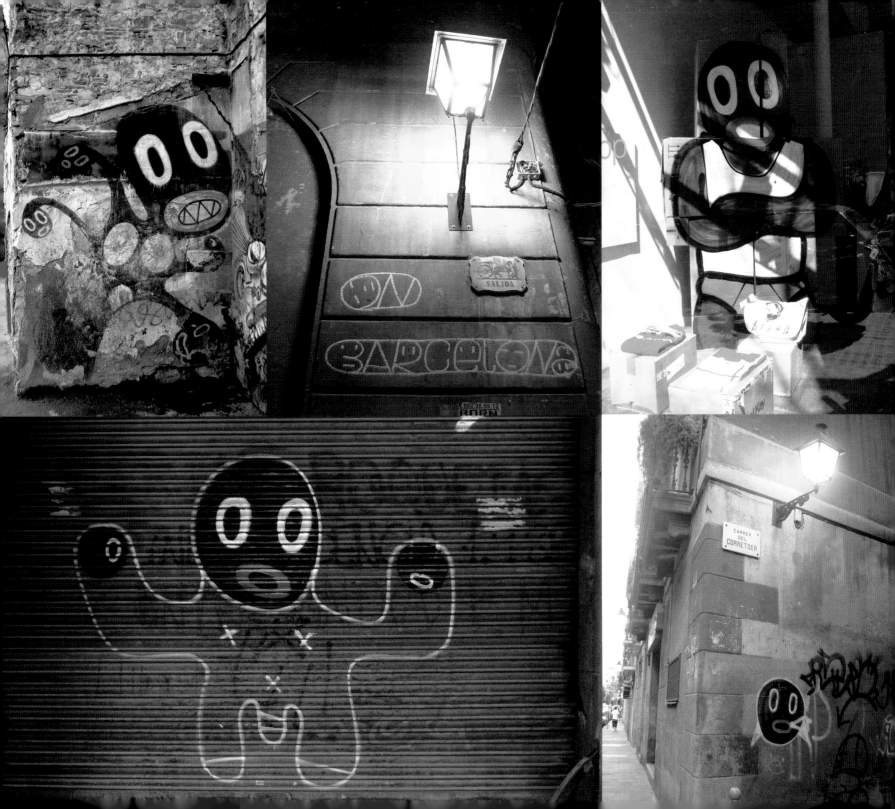

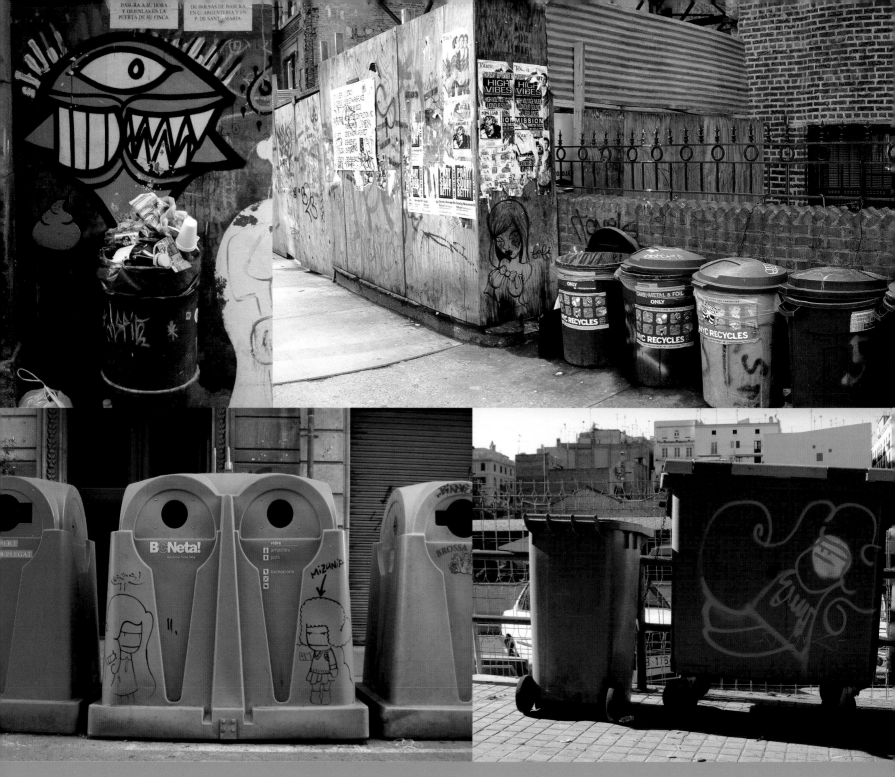

This page from top left to right Pez+Etron (1). Fafi (2). Freaklüb (3+4).

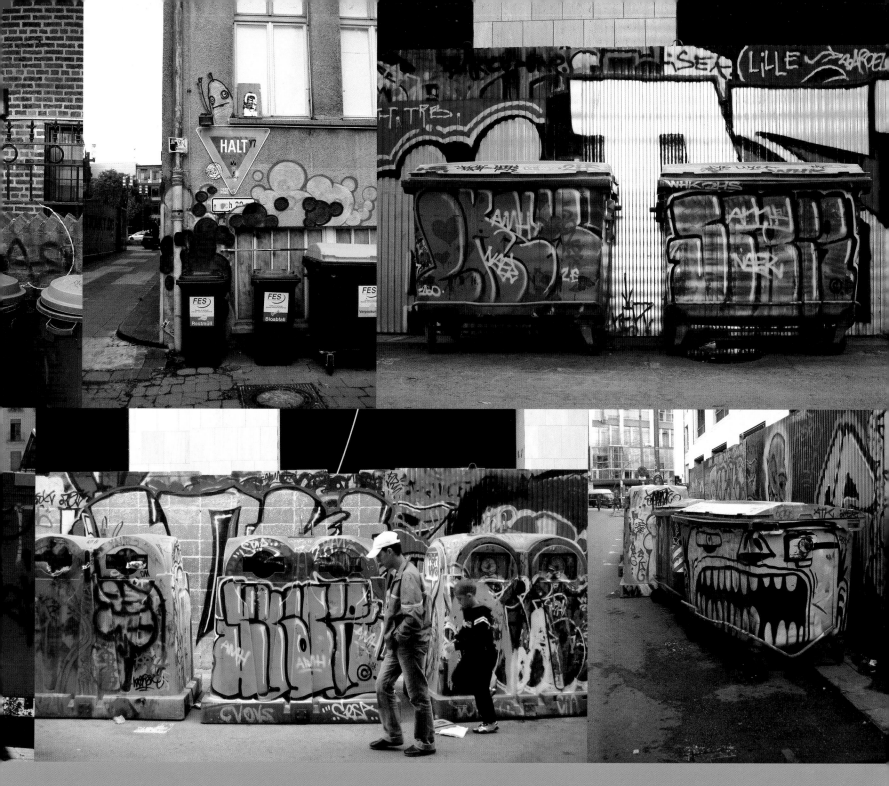

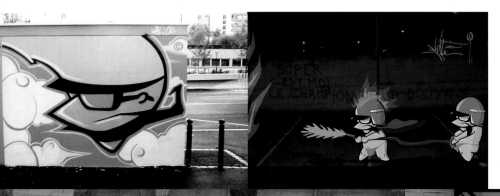

KEFLI's characters have become omnipresent throughout France. He usually uses stickers and posters, but he really enjoys painting big murals. As do many other artists, he uses characters transformed into personal logos.

NAME KEFLI **AGE** 21 **CITY** RENNES (FRANCE) **WORKING AREA** OLD WAREHOUSES OR FACTORIES, COMPUTER **SPRAY FRIENDS** . . . **SPRAY ENEMIES** . . . **ARTIST YOU WOULD LIKE TO COLLABORATE WITH** TOO MANY . . . EVERY COLLABORATION IS INTERESTING **YOUR FIRST GRAFFITI** UGLY! **YOUR DEFINITION OF STREET ART** EVERYBODY CAN SEE IT; NO NEED TO ENTER GALLERIES TO SEE IT **FUTURE** BEING A COP SUPA-SUPASTAR? HUMMERS, GIRLS, AND PAINT . . . **FAME** I'M SO FAMOUS IN MY BEDROOM . . . COPS LOVE ME, ME TOO . . . **SURVIVAL KIT** RIGHT POCKET FULL OF STICKERS, POSTERS, AND GLUE, OR MONTANA

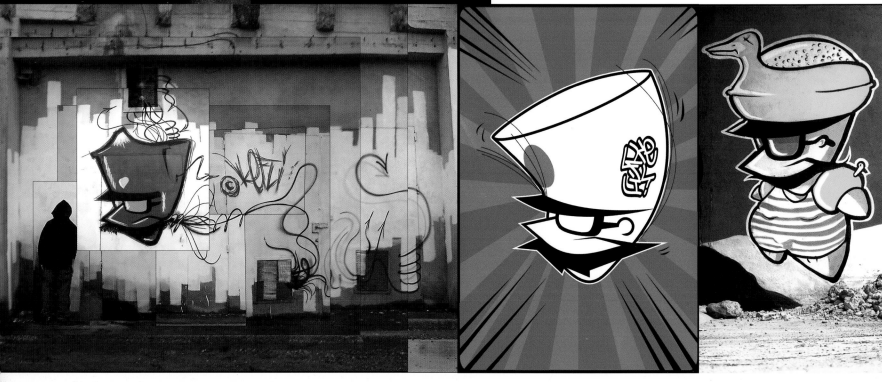

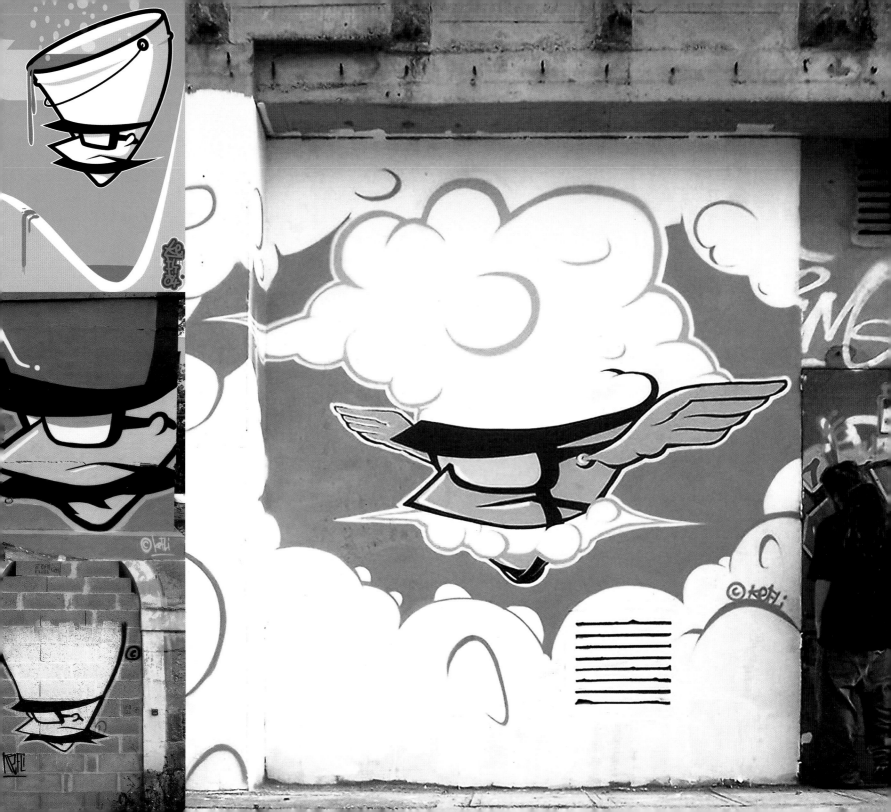

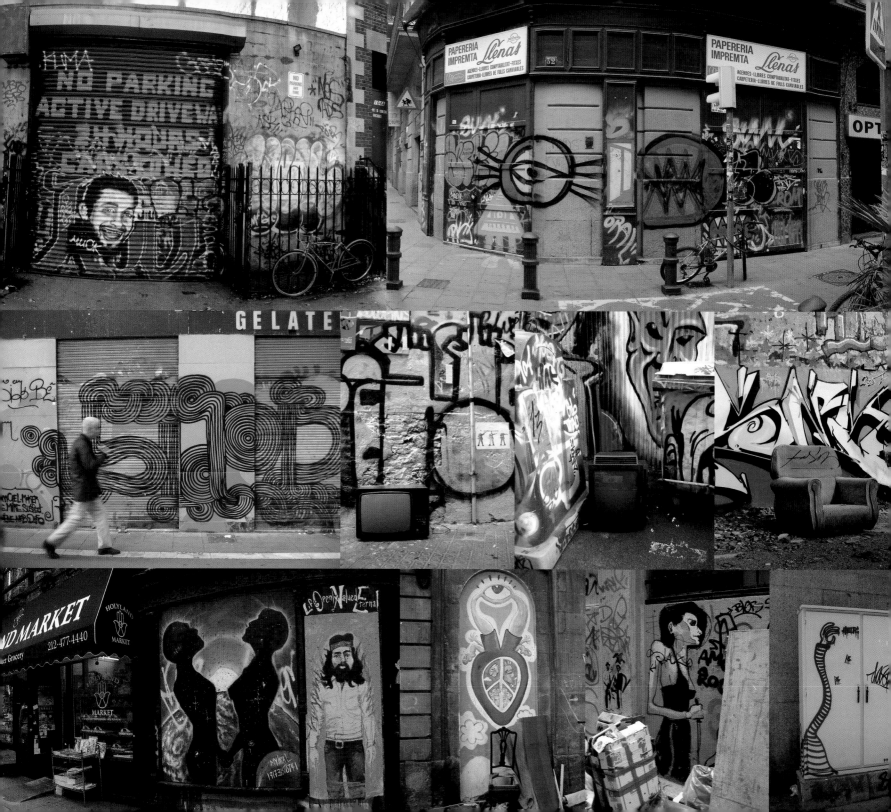

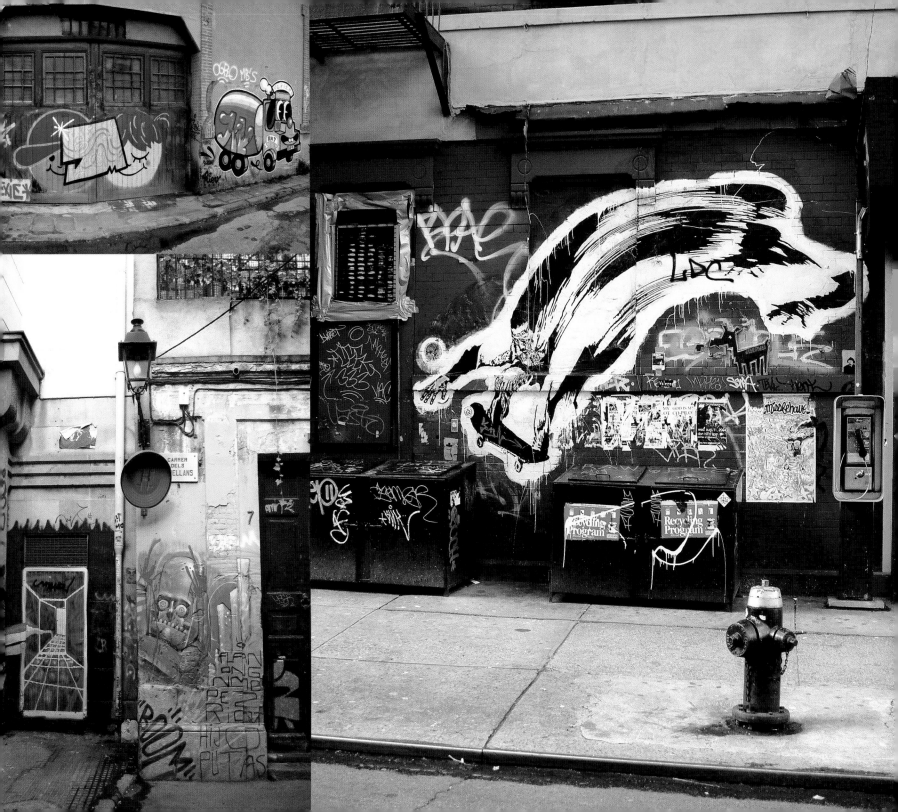

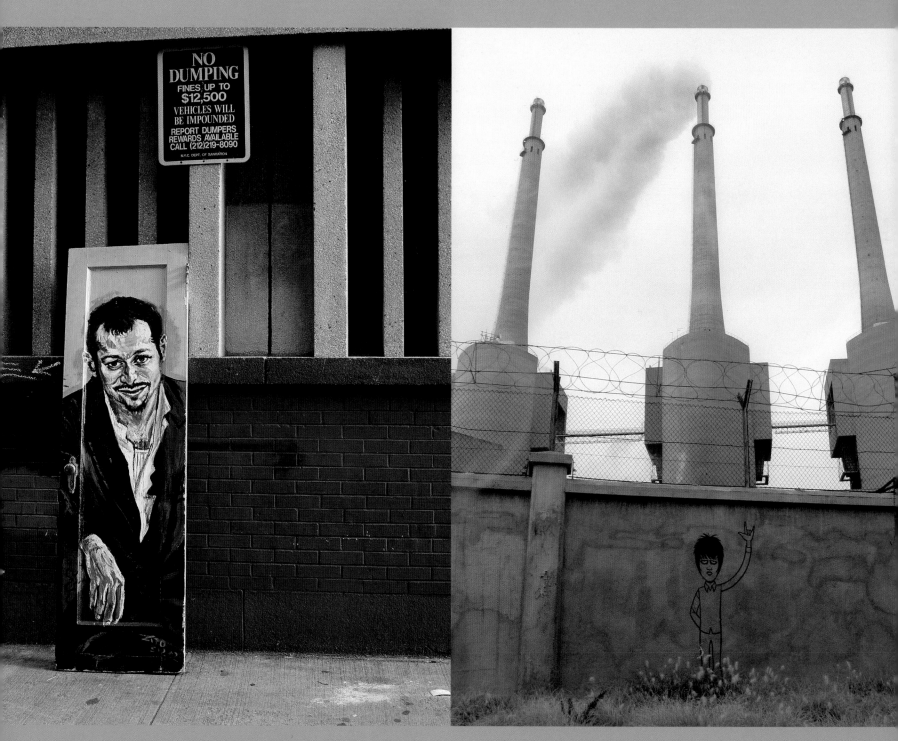

THIS PAGE ON THE RIGHT CHARACTER BY BERNART LLITERAS.

124

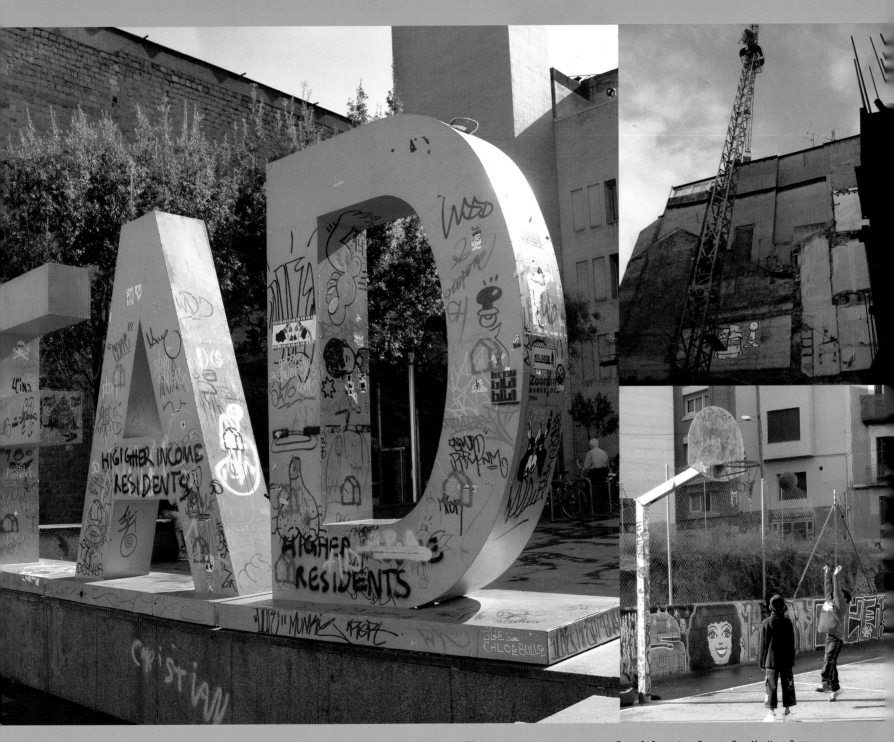

CLOCKWISE "ART ATTACK" AT THE FAD , BARCELONA (1). D*FACE+THE LONDON POLICE (2). CHARACTER BY MALICIA FROM 1980 CREW (3). ON THE FOLLOWING TWO PAGES CHARACTERS BY ETRON+OS GEMEOS+LOLO+FREAKLÜB+BTOY+MISS VAN IN BARCELONA.

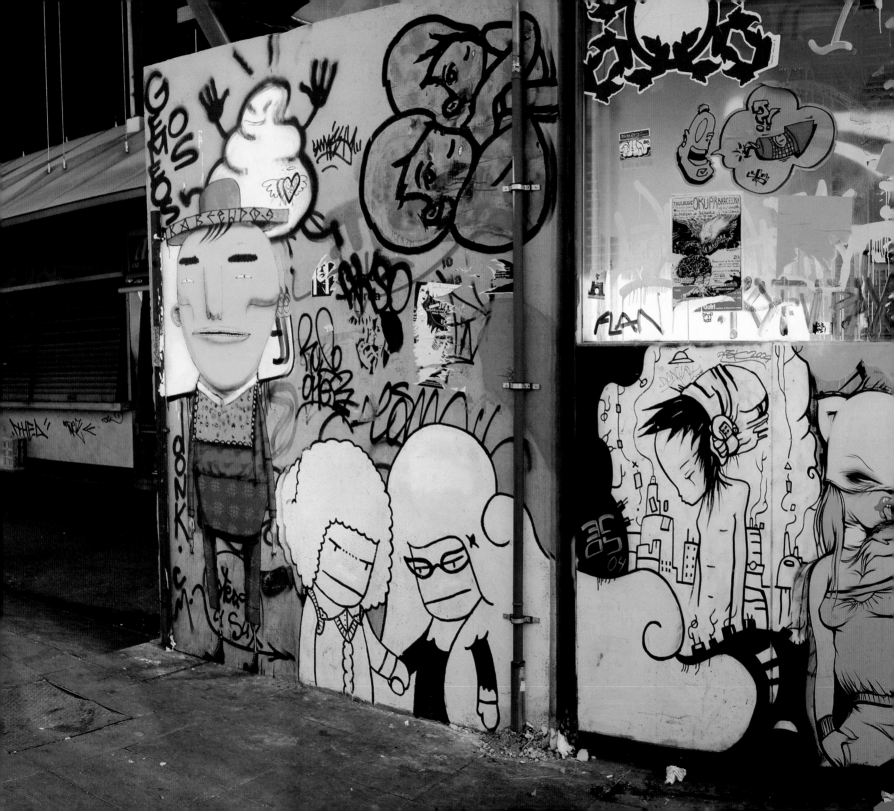

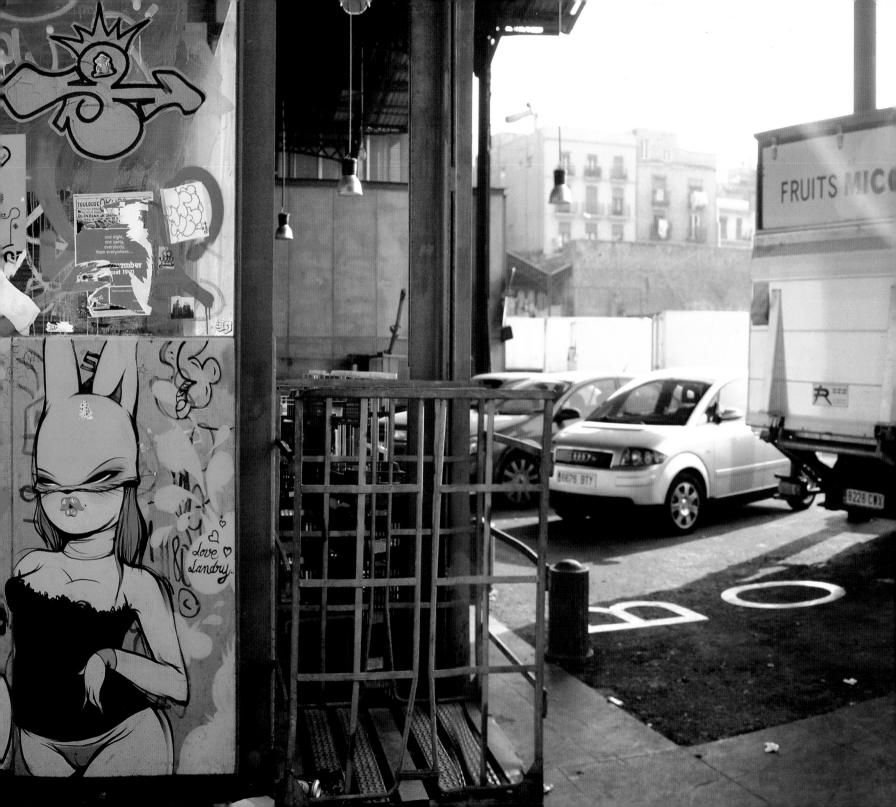

The 1980 CREW are based in Barcelona, one of the big capitals of street art and graffiti. Its members are RODRIGONE, MISTER, MALICIA, FLAN, KOAR, CHANOIR, TROTTER, and IBON, to mention a few. Their artworks are full of color and imagination, engaging our senses in many ways. They like to experiment with big murals in public places, mixing their own special sign language with comic-inspired characters.

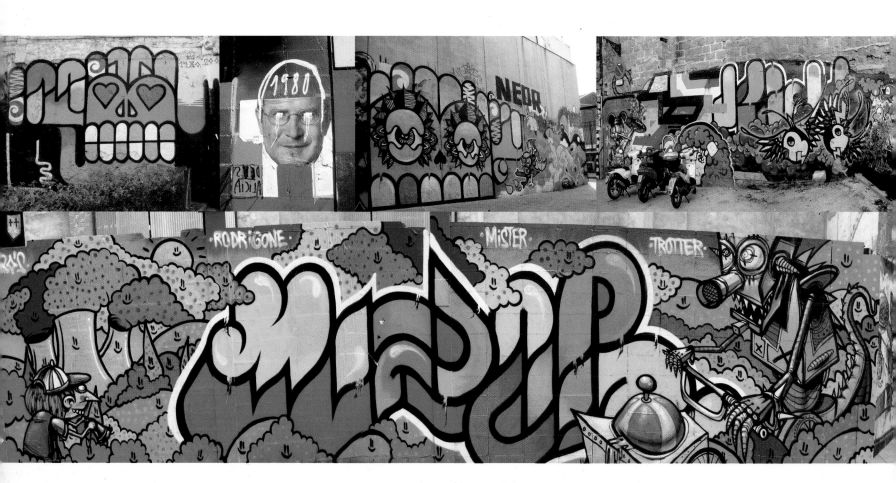

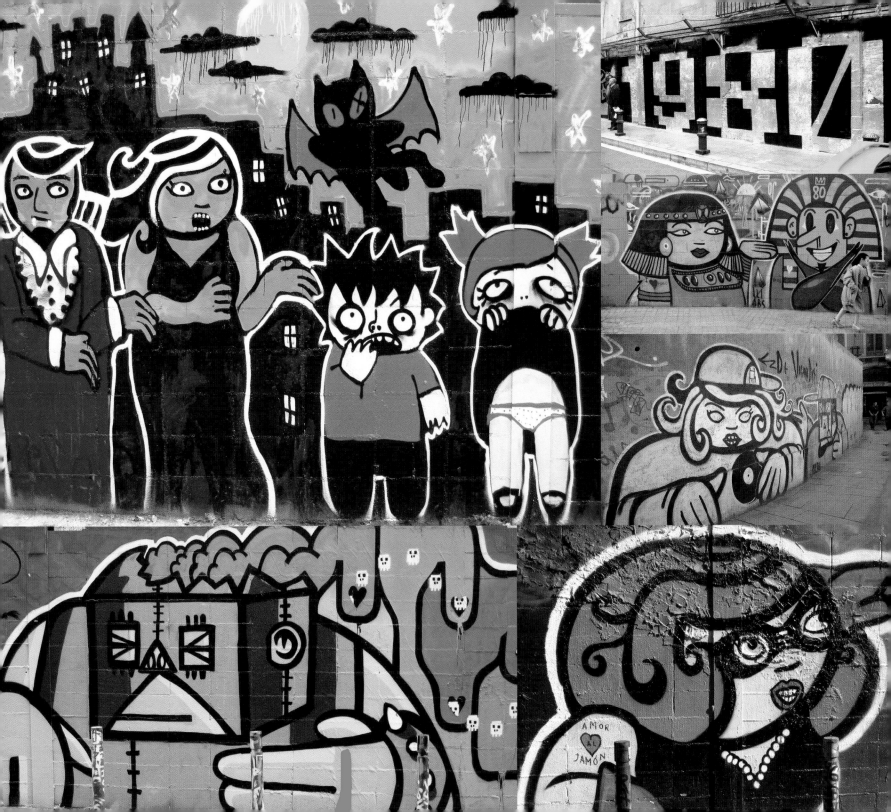

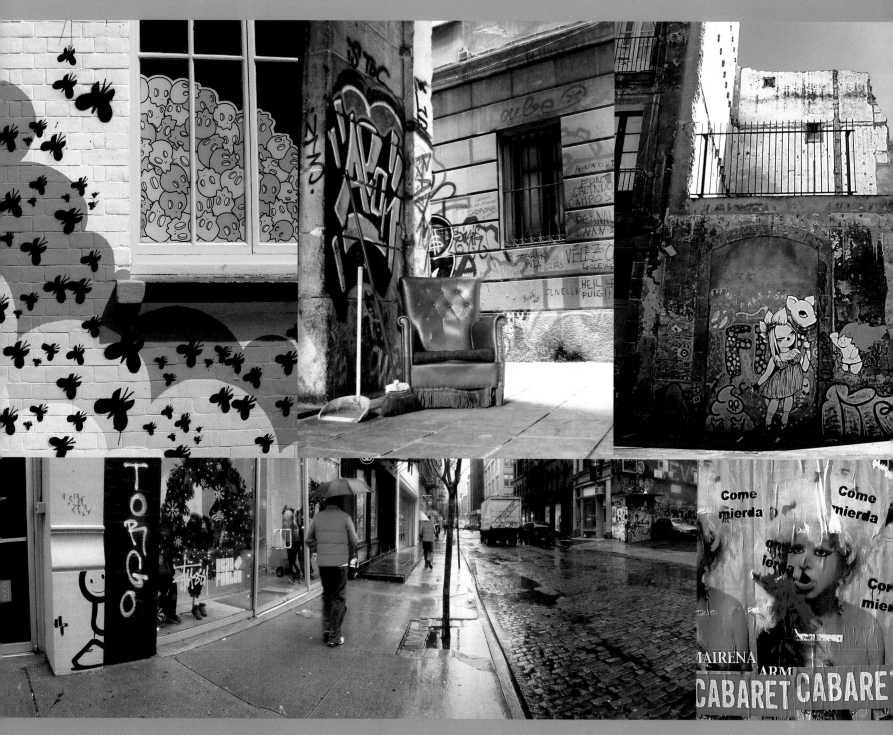

THIS PAGE FROM TOP LEFT TO RIGHT MYSTERIOUS AL (1). BIRDIE+ETRON+MISS VAN+FREAKLÜB (3). THE LONDON POLICE (4).

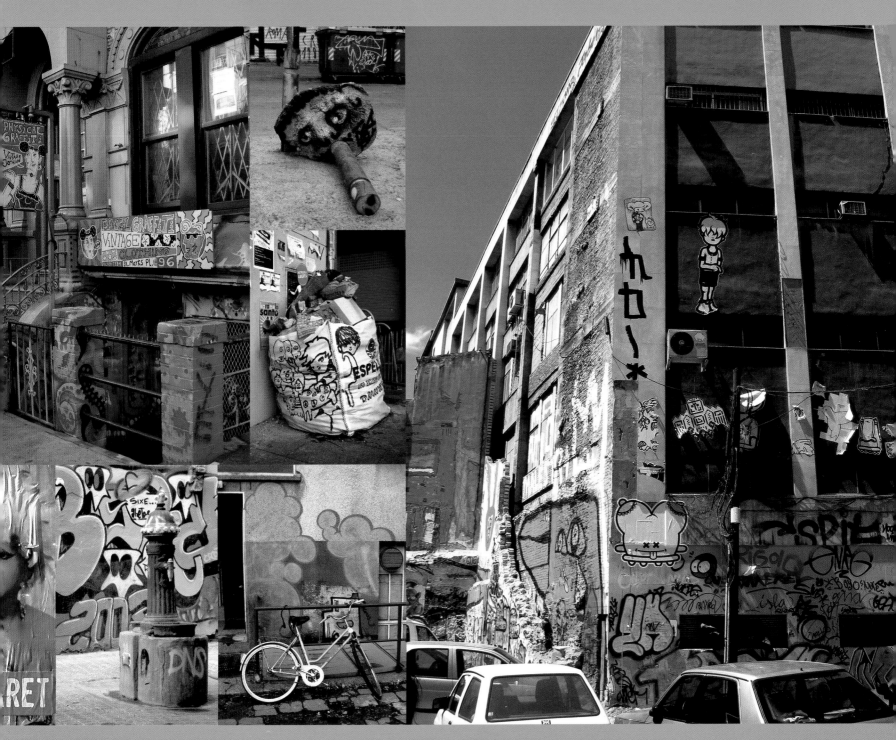

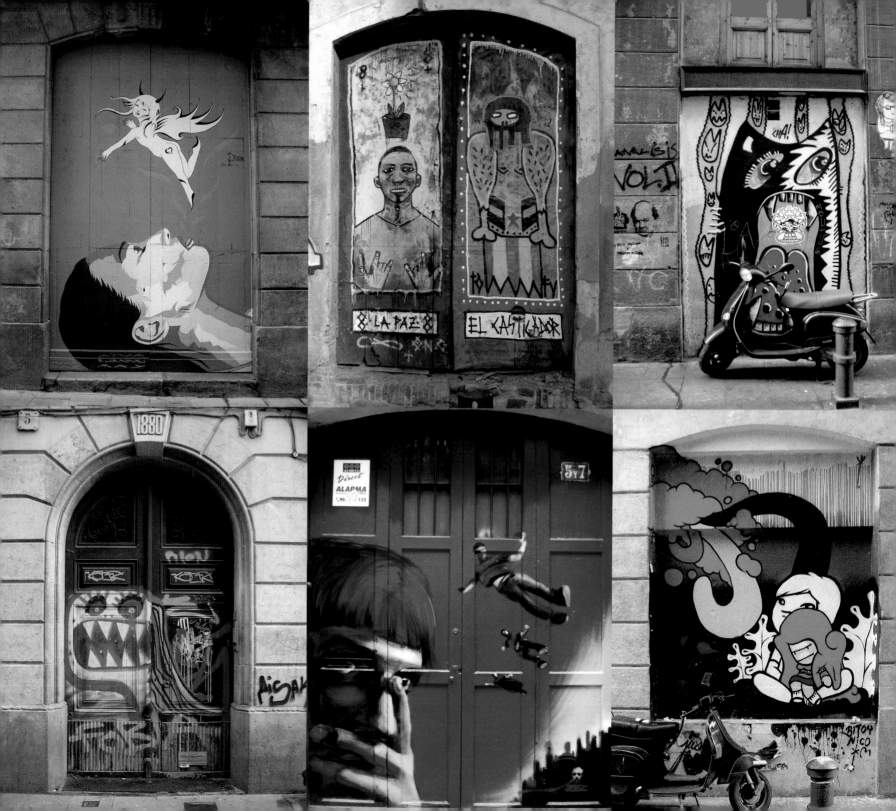

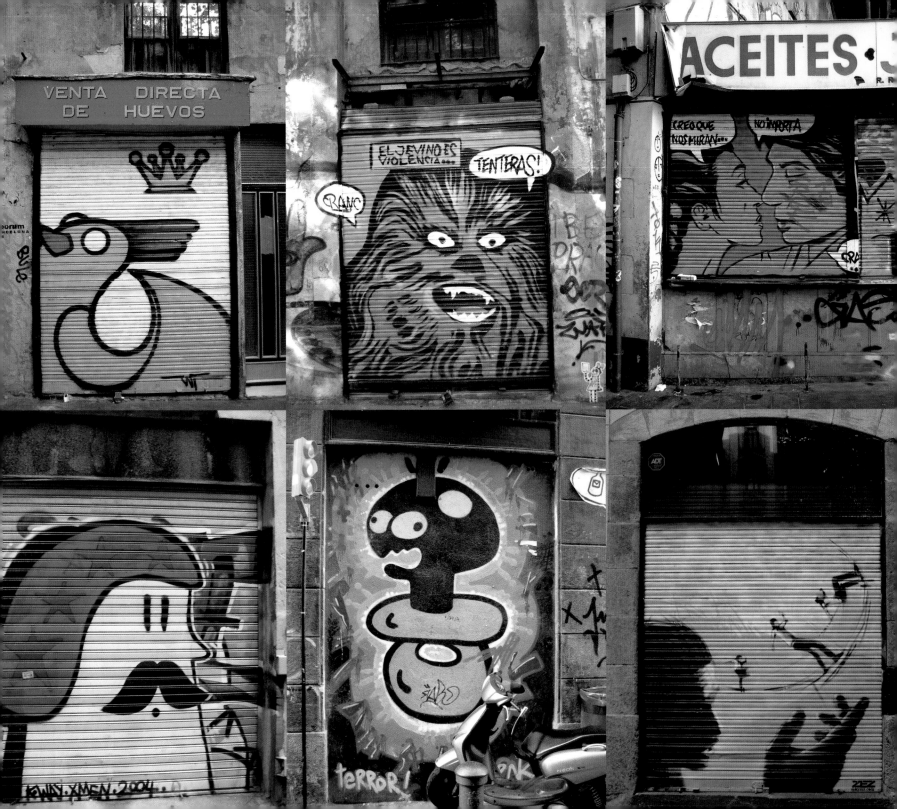

Traffic signs and signals are the preferred space for urban artists to place their stickers, since they're very accessible and, one way or another, we all tend to look at them. They are very good for protecting the stickers from rain and severe weather, although they are right in the line of sight of municipal cleaning staffs. Cities the world over are filled with signs and pictograms that have served as inspiration and media for graffiti artists, who have often changed their sense and meaning, making them, for a short time, works of art.

The commercial logos that invade big-city streets are a legal way to disseminate a message or trademark, which is precisely what almost every artist tries to do: advertise him- or herself, but in this case, at no cost.

JACE and BORIS HOPPEK are among the artists who use advertising billboards as media for creating their works.

TRAFFIC SIGNS

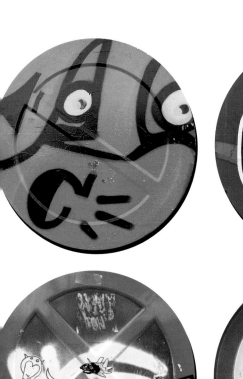 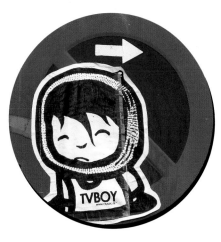 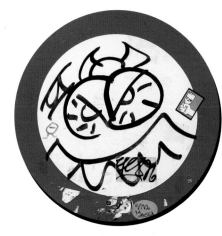

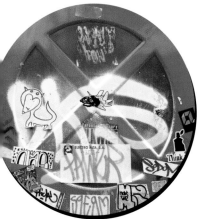 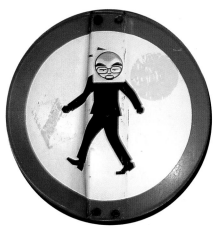 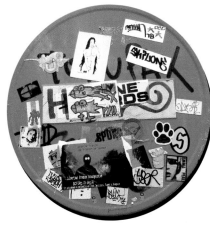

 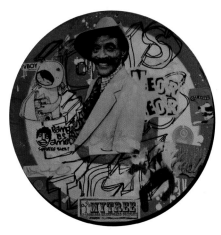

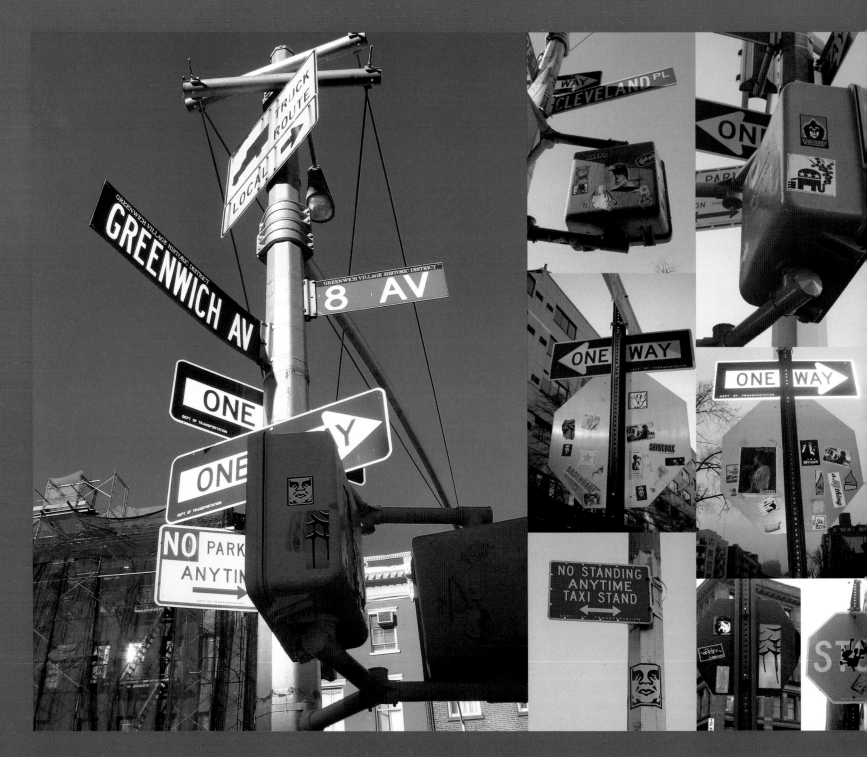

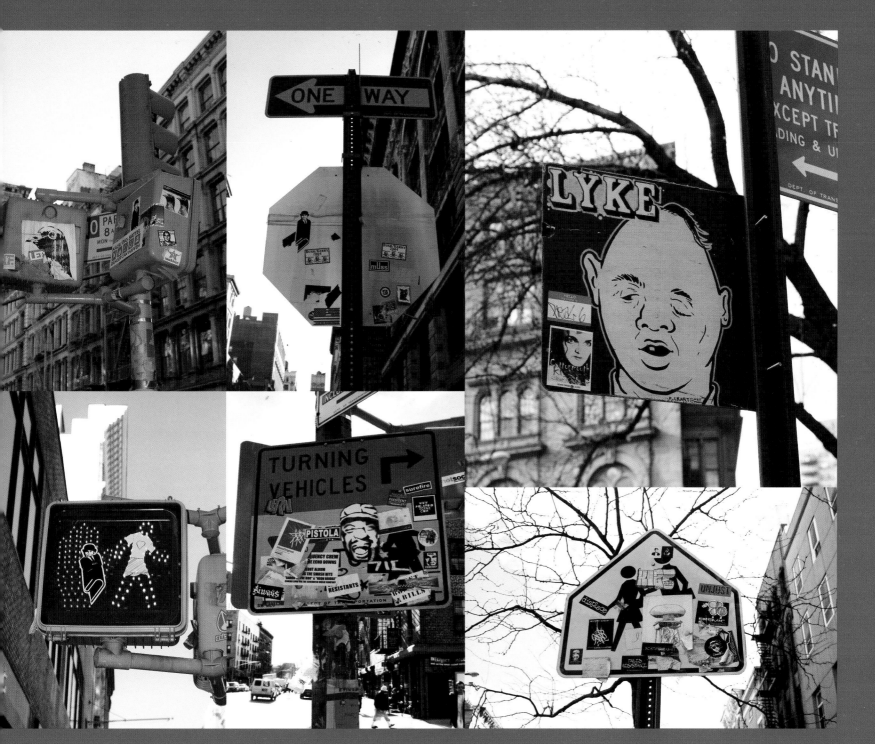

HÔTEL D'A

Collège St

 HÔTEL

 LA MUETTE

Laborables
de dilluns a divendres
de 8-14h i 16-20h

Excepte càrrega
descàrrega
s màxim 30 min.

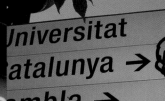
Universitat
atalunya →
ambla →

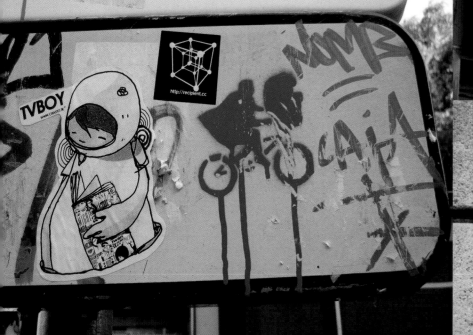

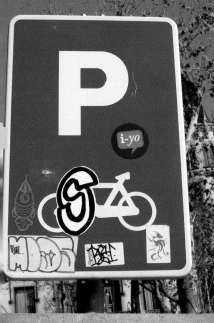

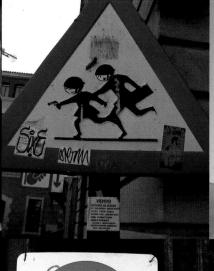

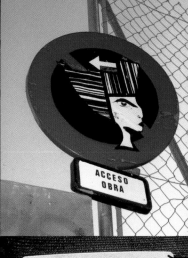

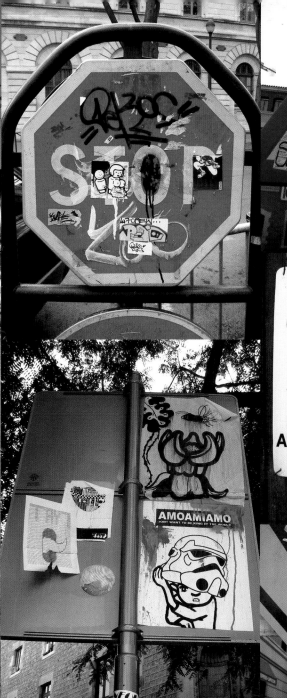

ACCESO OBRA

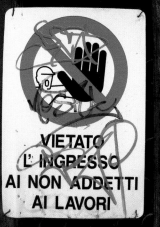

VIETATO L'INGRESSO AI NON ADDETTI AI LAVORI

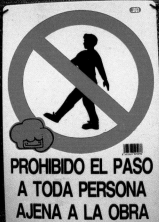

PROHIBIDO EL PASO A TODA PERSONA AJENA A LA OBRA

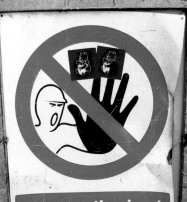

No unauthorised persons allowed beyond this point

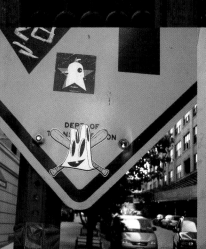

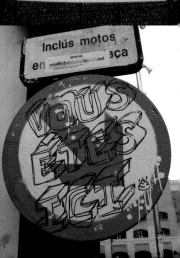

spray file 16 D*FACE

www.dface.co.uk

Stickers, posters, stencils, and spray, no technique goes
unnoticed by this London artist.

D*FACE's works are on display in cities such as New York,
Barcelona, and, of course, London, his customary center of
operations. His unmistakable graphic style, with black and
white as base colors, has made him unique and recognizable in
the world of urban art.

He often shares the spotlight with THE LONDON POLICE, whose
technique and style are similar to his.

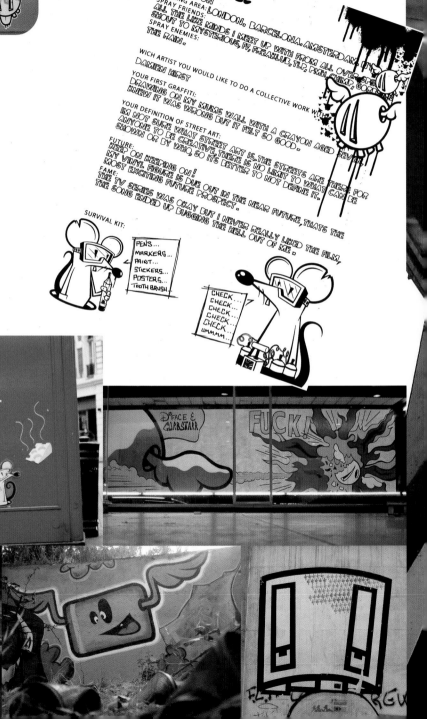

NAME: D*FACE
AGE:
CITY: LONDON
WORKING AREA: LONDON, BARCELONA, AMSTERDAM ETC.
SPRAY FRIENDS: ALL THE LIKE MINDS I MEET UP WITH FROM ALL OVER, SHOUT TO MYSTERIOUS, FE FREAKLUB, TLP, PMH, CHIMP, GOMA
SPRAY ENEMIES: THE RAIN.

WICH ARTIST YOU WOULD LIKE TO DO A COLLECTIVE WORK WITH: DAMIEN HIRST

YOUR FIRST GRAFFITI: DRAWING ON MY MUM'S WALL WITH A CRAYON AGED SEVEN, I KNEW IT WAS WRONG BUT IT FELT SO GOOD.

YOUR DEFINITION OF STREET ART: IM NOT SURE WHAT STREET ART IS, THE STREETS ARE THERE FOR ANYONE TO BE CREATIVE THERE IS NO LIMIT TO WHAT CAN BE SHOWN OR BY WHO, SO IT'S BETTER TO NOT DEFINE IT.

FUTURE: KEEP ON KEEPING ON! MY VINYL FIGURE IS DUE OUT IN THE NEAR FUTURE, THATS THE MOST EXCITING FUTURE PROSPECT.

FAME: THE TV SERIES WAS OKAY BUT I NEVER REALLY LIKED THE FILM, THE SONG ENDED UP BUGGING THE HELL OUT OF ME.

SURVIVAL KIT:

PENS...
MARKERS...
PAINT...
STICKERS...
POSTERS...
TOOTH BRUSH

CHECK...
CHECK...
CHECK...
CHECK...
CHECK...
UMMM...

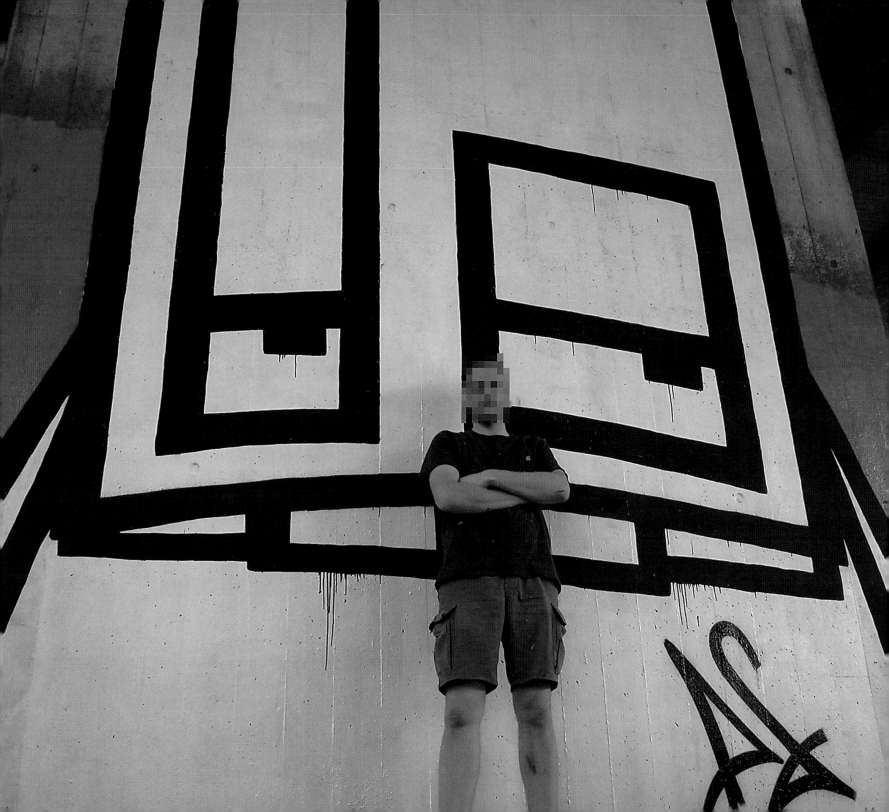

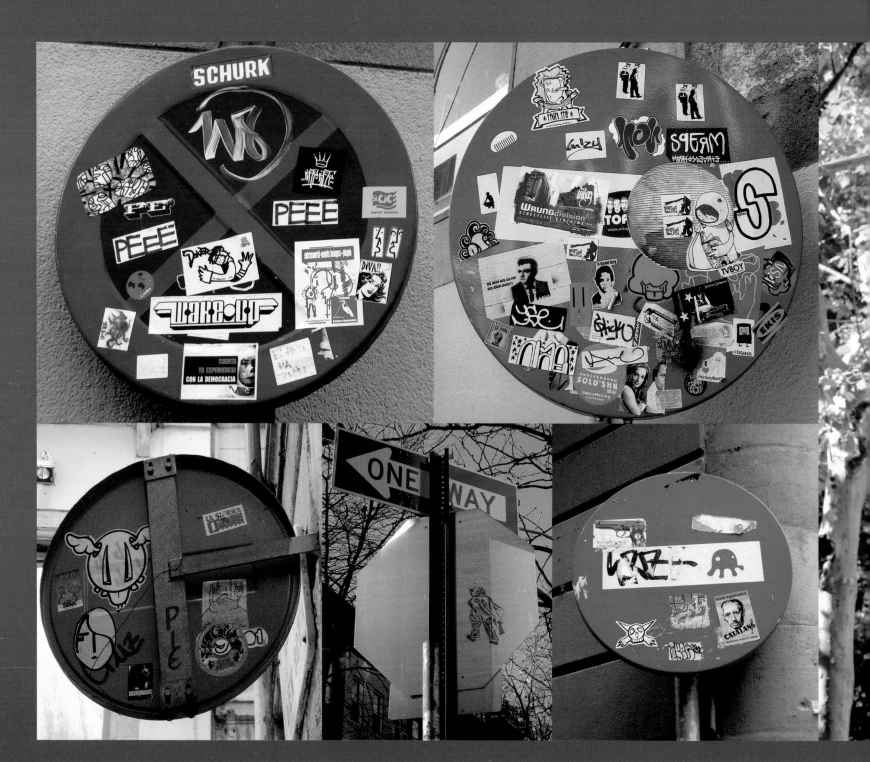

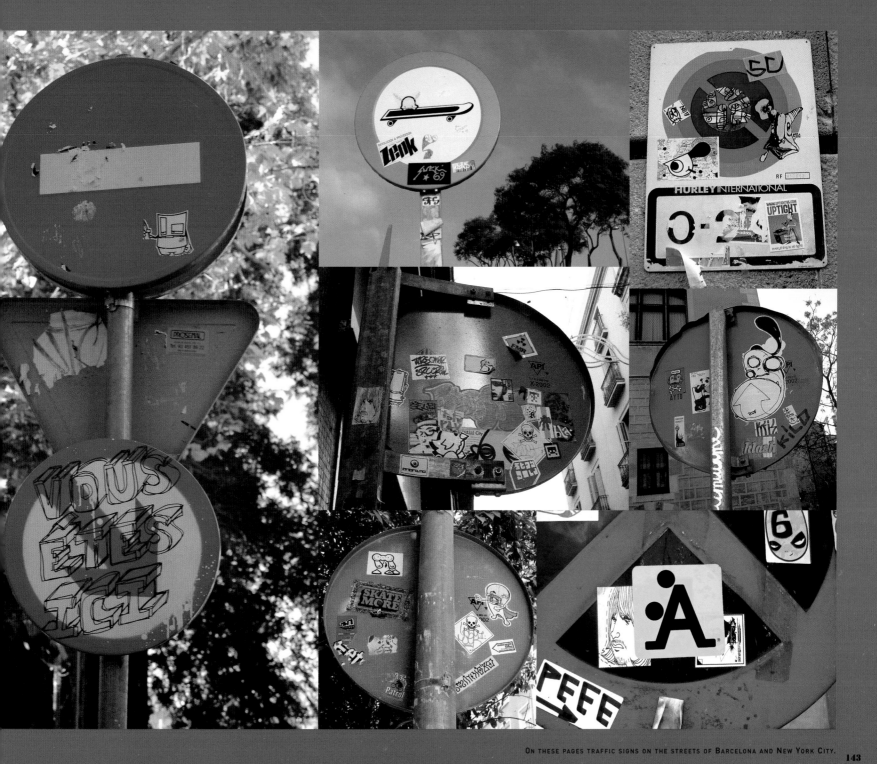

ON THESE PAGES TRAFFIC SIGNS ON THE STREETS OF BARCELONA AND NEW YORK CITY.

SAVAGE GIRL

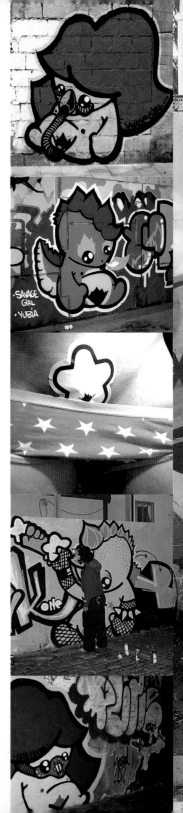

This young artist began painting her star-shaped logo an dpunk girls several years ago. SAVAGE GIRL can be spotted mainly on the streets of Bilbao and Barcelona, forming part of a community of artists called KREATIZIDES (FRIK+YUBIA+LE PUZLE), with whom she has painted large murals. The stickers with her logo, a star with a pubis, appear around cities on walls and traffic signs.

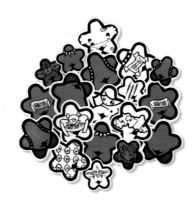

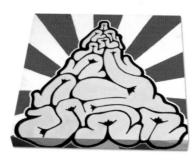

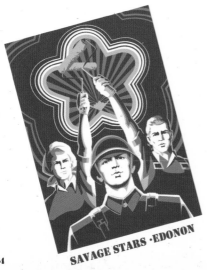

SAVAGE STARS ·EDONON

NAME SAVAGE . . . GIRL! **AGE** 21 **CITY** BILBAO (SPAIN) **WORKING AREA** GENERALLY BILBAO AND SUBURBS. BUT THERE ARE ALWAYS GETAWAYS TO BARCELONA AND WHEREVER! **SPRAY FRIENDS** KREATIZIDES (FRIK+YUBIA+LE PUZLE+SAVAGEGIRL) **SPRAY ENEMIES** MY ONLY ENEMIES ARE WHOEVER DOES NOT RESPECT THE OTHERS' WORK. **ARTISTS YOU WOULD YOU LIKE TO COLLABORATE WITH** NOW MY REGULAR GROUP IS: YUBIA, FRIK, LE PUZLE, AND ME. BUT I WOULD LOVE TO COLLABORATE WITH OTHERS, IT'S VERY ENRICHING. I ADORE THE WORK OF ARTISTS SUCH AS SUPA, RESS, CHIMP, MISS VAN, TXAPELPIXEL, SUMO, DIPS, TITIFREAK, SEA CREATIVE, FREAKLÜB, NANO4814, ERONAI, HOMBRES GRISES, AKIRO, . . . **YOUR FIRST GRAFFITI** JUNE 2003 . . . BUFF . . . HORRIBLE! **YOUR DEFINITION OF STREET ART** STREET ART IS A FORM OF ARTISTIC EXPRESSION THAT USES THE STREET TO MAKE A STATEMENT AND TO REFLECT **FUTURE** I WOULD LIKE TO CONTINUE WITH THE SAME LINE, GETTING TO KNOW MORE PEOPLE AND GROWING AND CHANGING!!! SAVAGE DON'T STOP! **FAME** IT'S NOT SOMETHING THAT INTERESTS ME A GREAT DEAL, BUT I ADMIT I LIKE IT WHEN PEOPLE RECOGNIZE ME BECAUSE OF MY ICONS **SURVIVAL KIT** WELL, MY KIT IS NEVER WITHOUT STICKERS, FELT-TIP MARKERS, SPRAYS, AND BEER!!

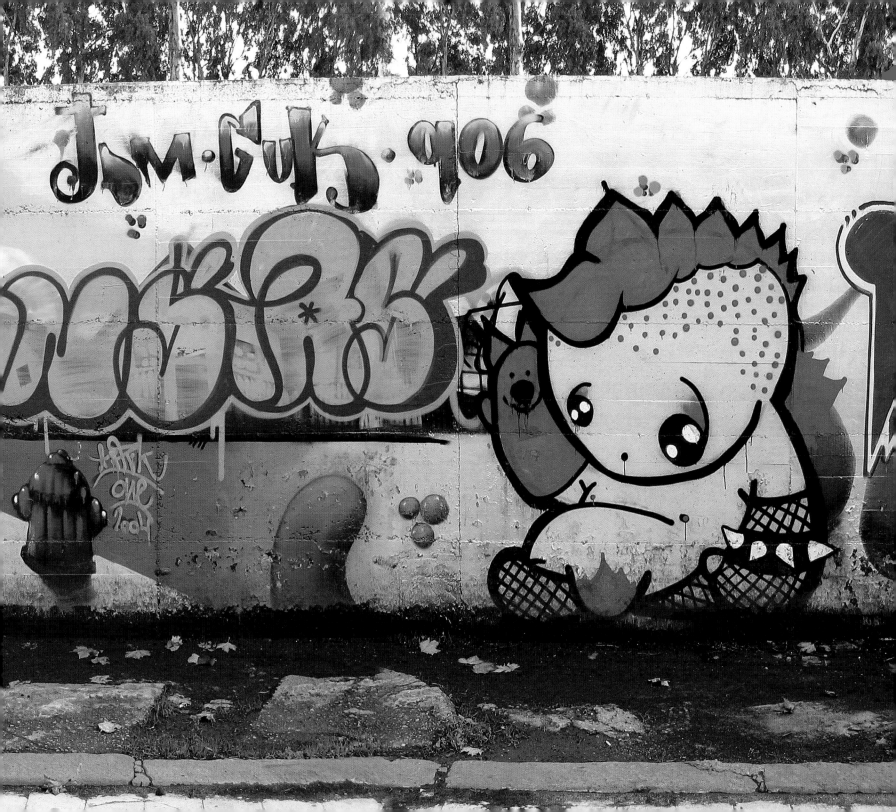

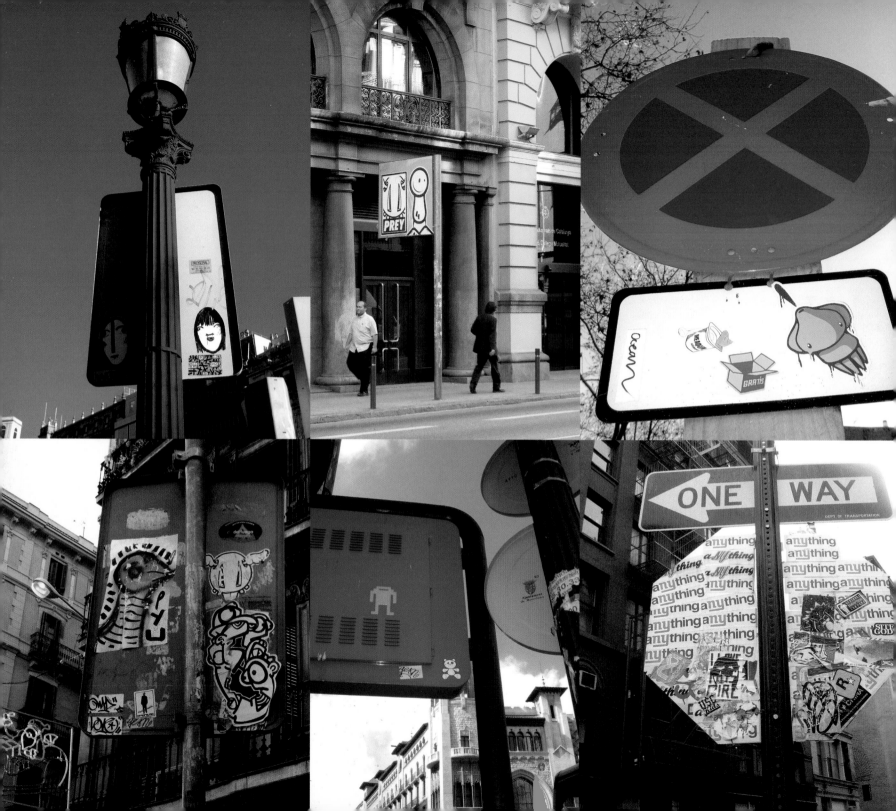

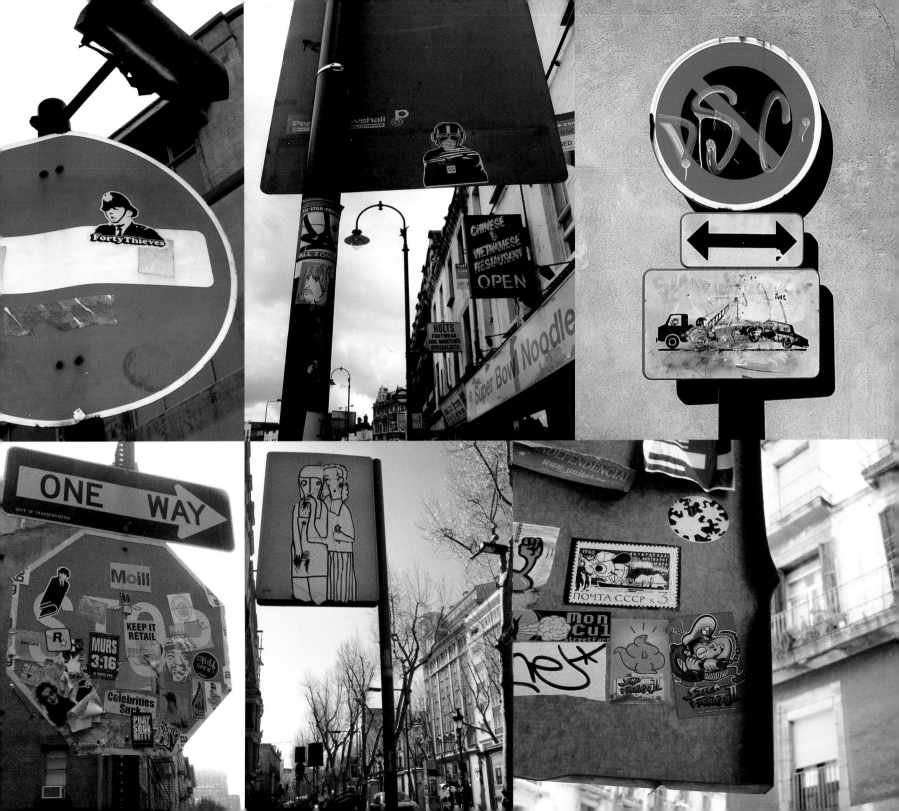

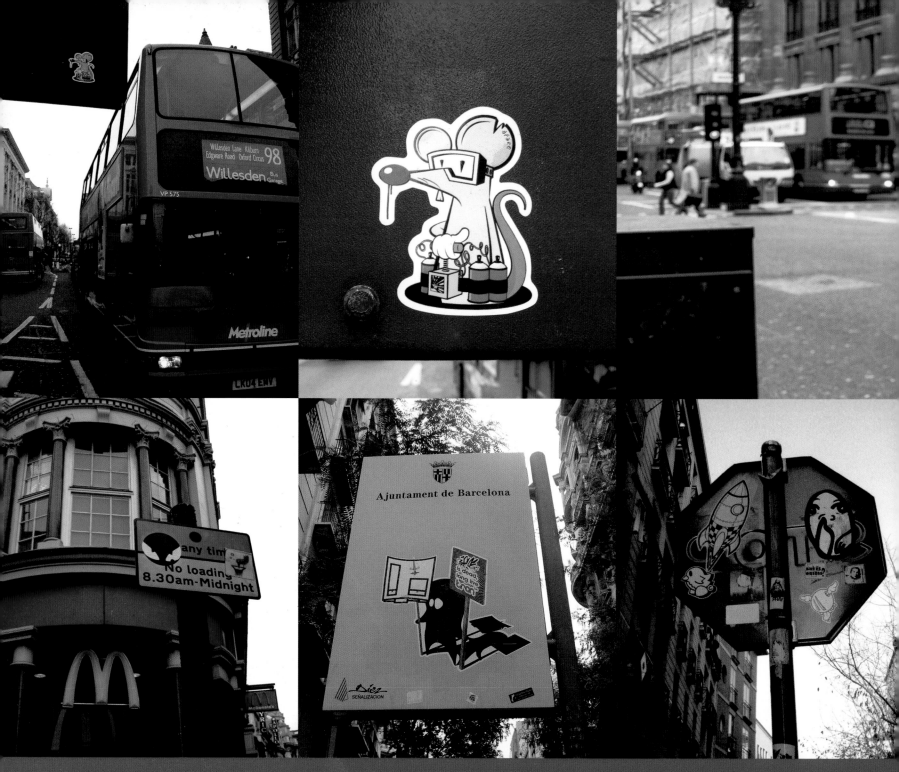

THIS PAGE TRAFFIC SIGNS OVER THE STREETS OF LONDON AND BARCELONA, FROM TOP LEFT TO RIGHT D*FACE (1+2+5), KAMIKAZE CREW (6).

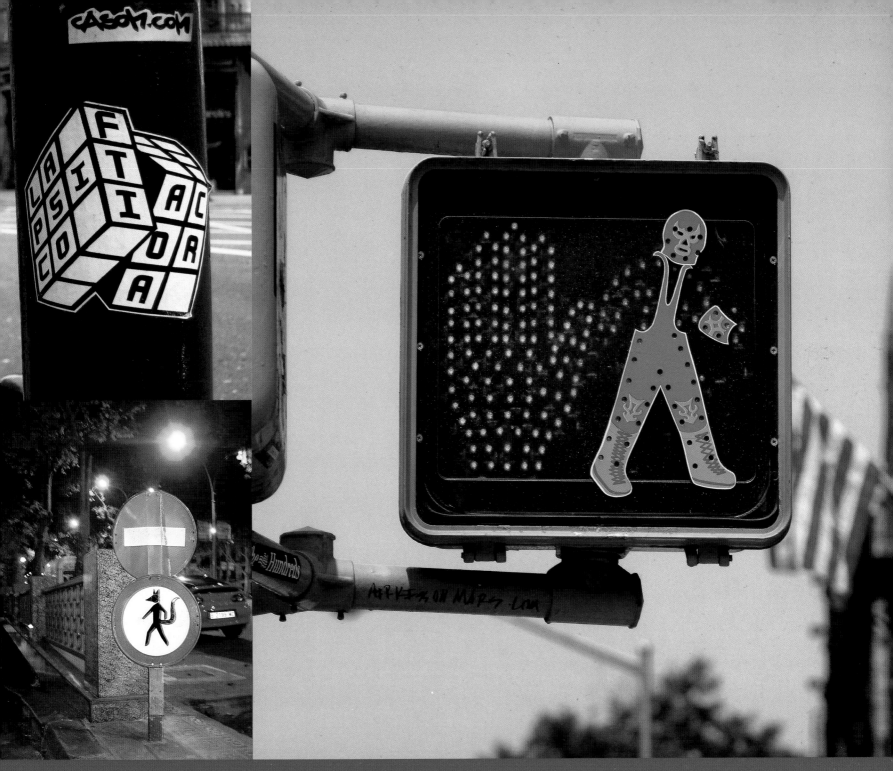

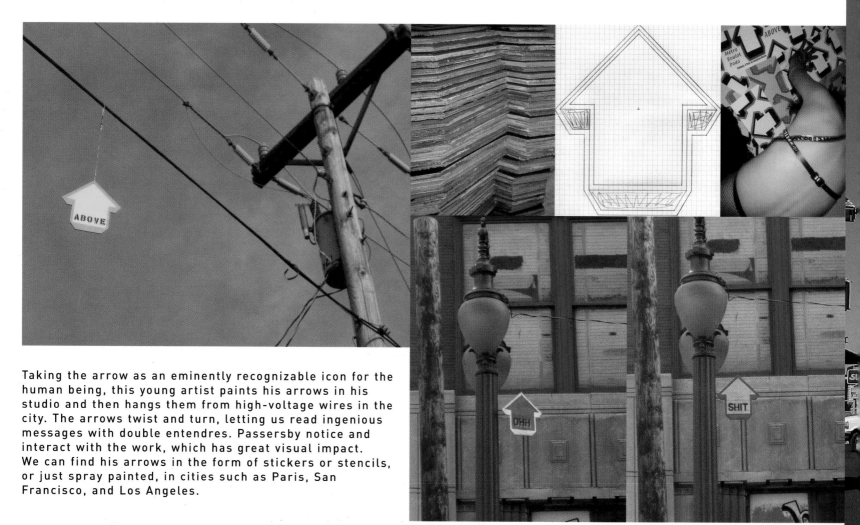

Taking the arrow as an eminently recognizable icon for the human being, this young artist paints his arrows in his studio and then hangs them from high-voltage wires in the city. The arrows twist and turn, letting us read ingenious messages with double entendres. Passersby notice and interact with the work, which has great visual impact. We can find his arrows in the form of stickers or stencils, or just spray painted, in cities such as Paris, San Francisco, and Los Angeles.

PHOTOGRAPHS BY ABOVE.

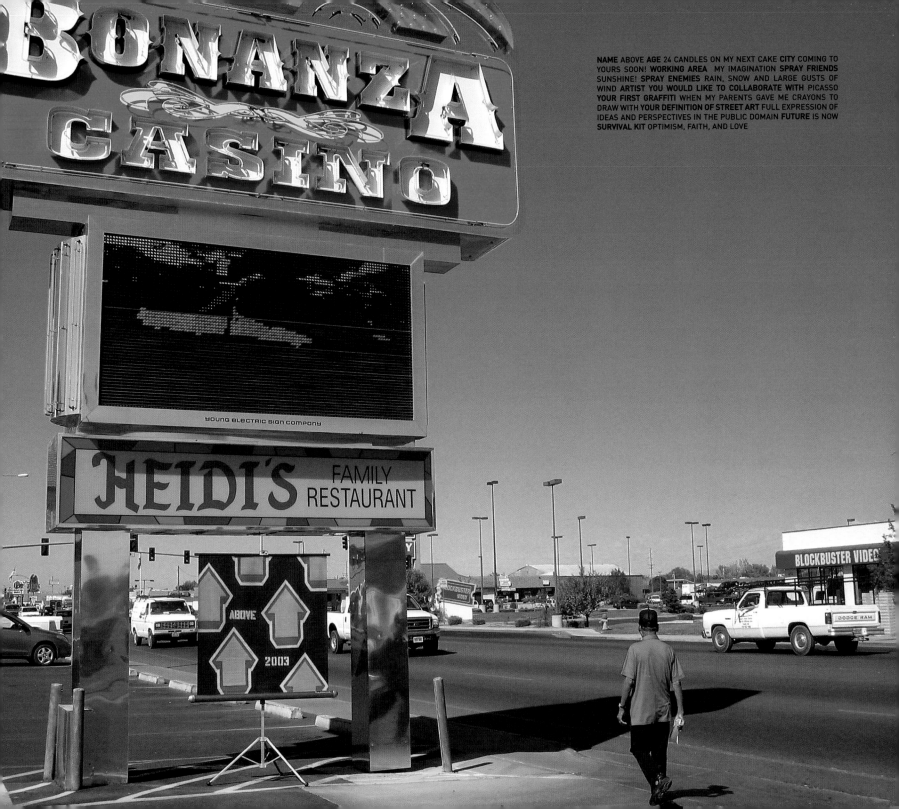

NAME ABOVE AGE 24 CANDLES ON MY NEXT CAKE CITY COMING TO YOURS SOON! WORKING AREA MY IMAGINATION SPRAY FRIENDS SUNSHINE! SPRAY ENEMIES RAIN, SNOW AND LARGE GUSTS OF WIND ARTIST YOU WOULD LIKE TO COLLABORATE WITH PICASSO YOUR FIRST GRAFFITI WHEN MY PARENTS GAVE ME CRAYONS TO DRAW WITH YOUR DEFINITION OF STREET ART FULL EXPRESSION OF IDEAS AND PERSPECTIVES IN THE PUBLIC DOMAIN FUTURE IS NOW SURVIVAL KIT OPTIMISM, FAITH, AND LOVE

ON THESE PAGES ARROWS BY ABOVE ON THE STREETS OF LOS ANGELES, ST.LOUIS, DETROIT, AND PARIS.

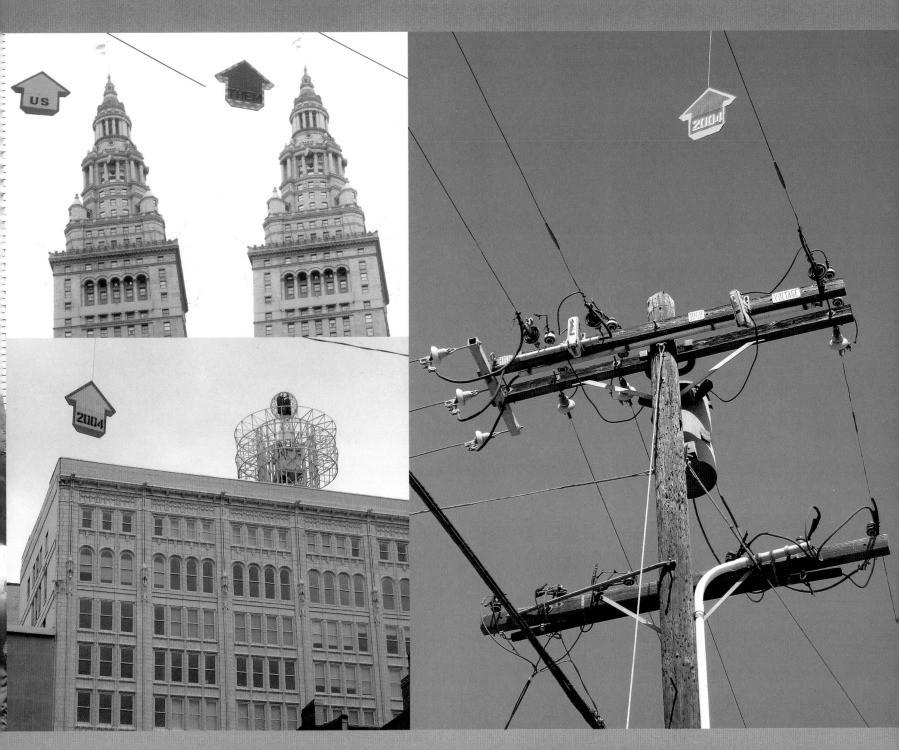

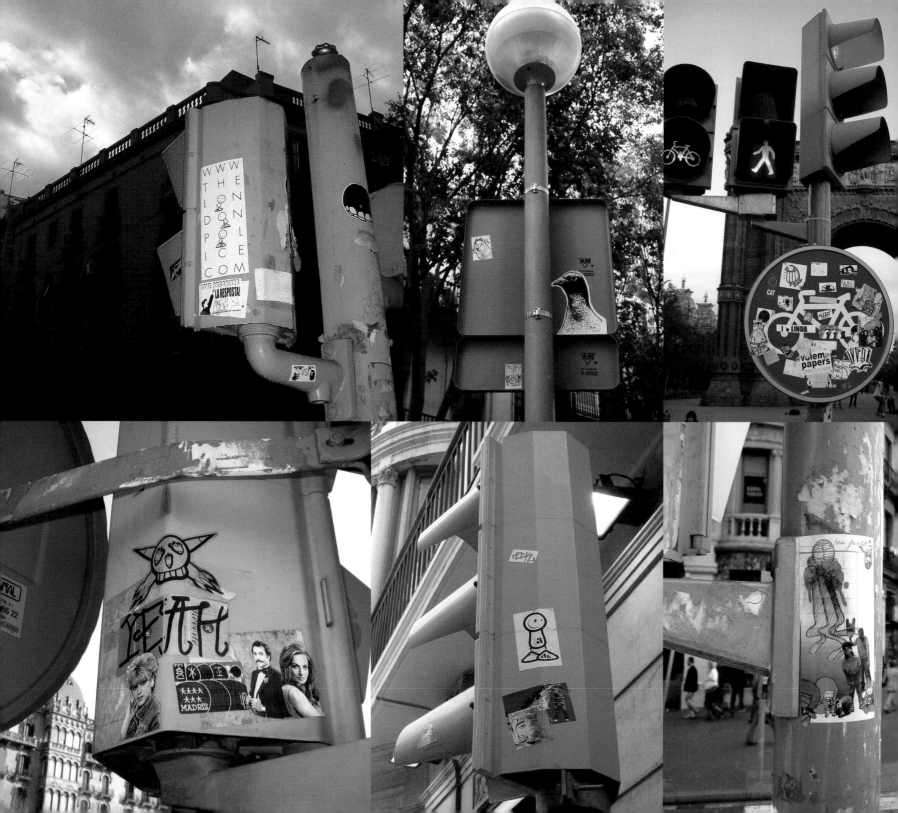

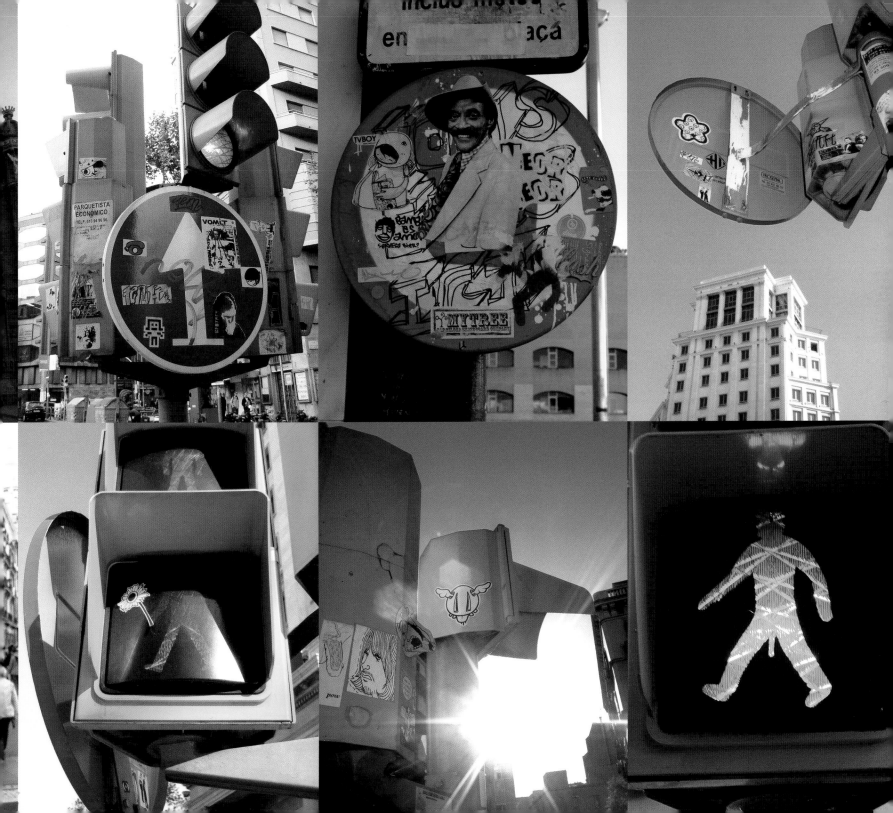

THE LONDON POLICE are three guys based in Amsterdam (two British and one American). They have been operating together for five years and the characters they draw are recognized by their bold, graphic line quality and limited palette of colors.

THE LONDON POLICE message is so simple: to get up wherever and whenever possible. They operate as a crew and, since visiting New York, they like to produce giant lads on the sides of buildings. TLP also loves to collaborate with graphic design magazines, shows, and happenings.

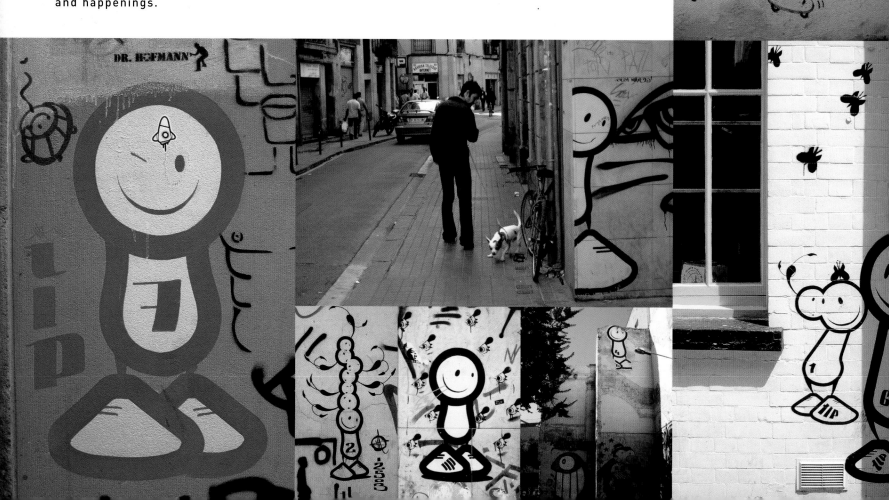

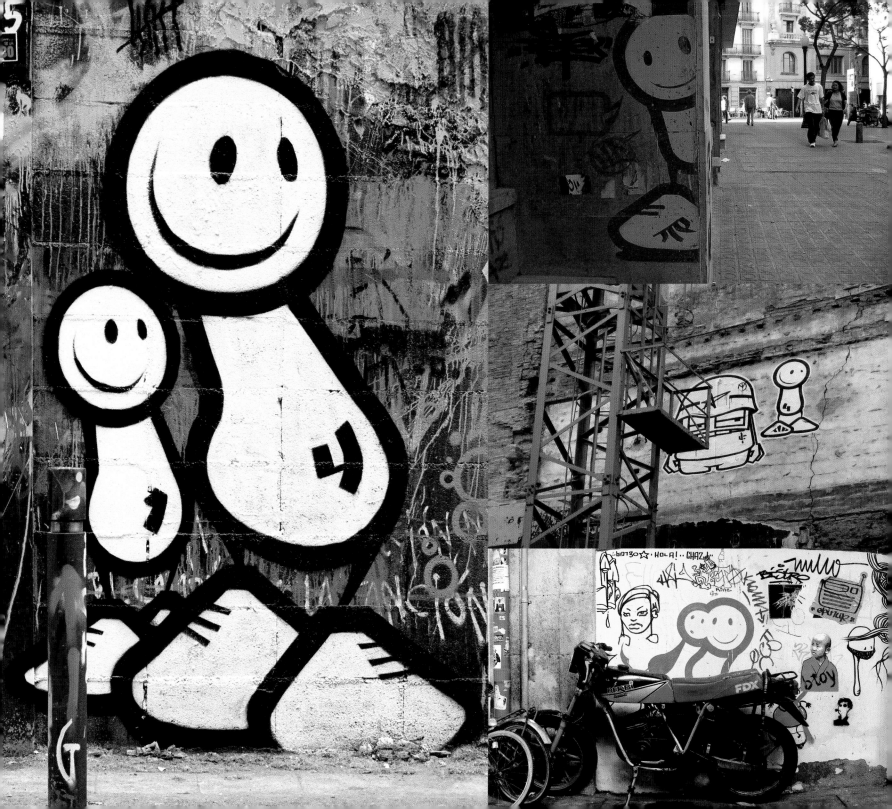

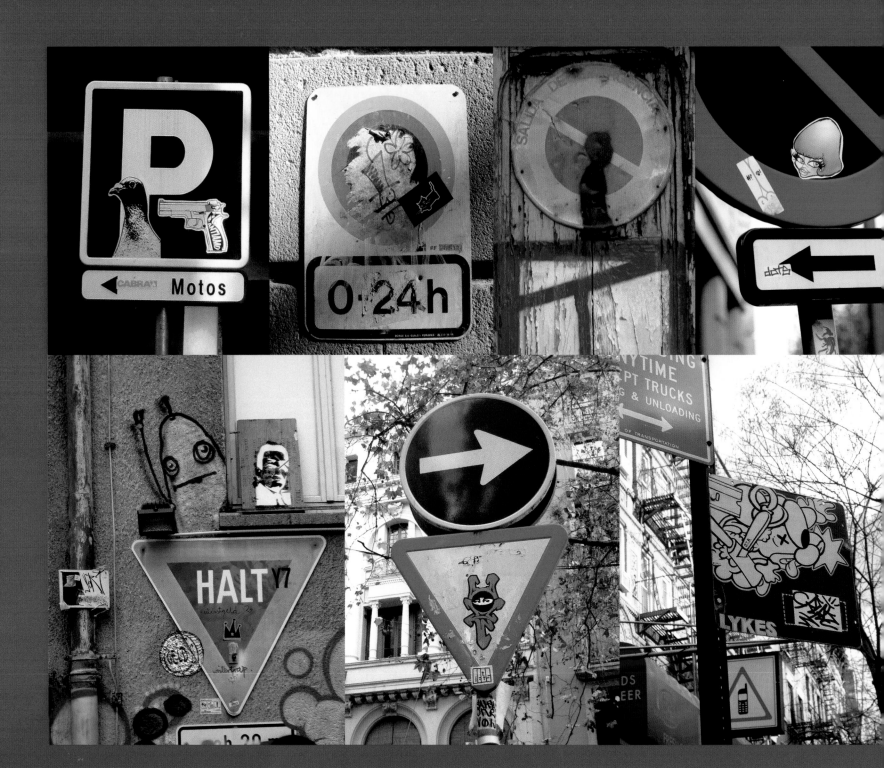

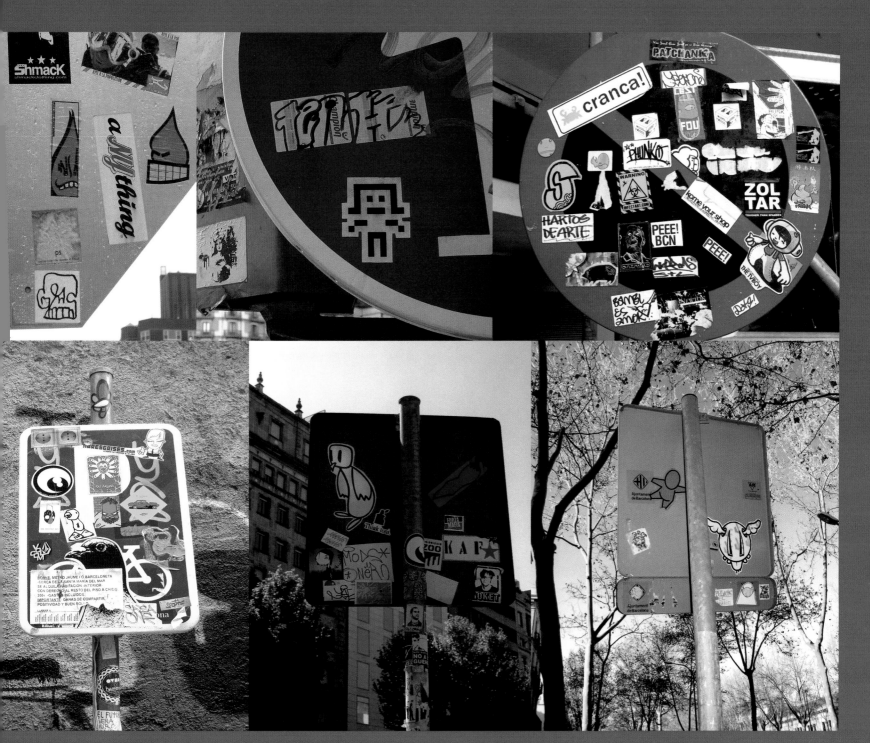

ON THESE PAGES TRAFFIC SIGNS ON BARCELONA, FRANKFURT AND NEW YORK CITY.

159

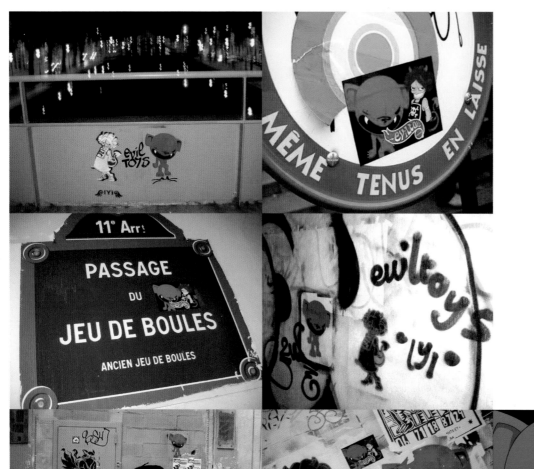

AGE LYL 24, SOK 25 **CITY** PARIS **WORKING AREA** L: VISUAL COMMUNICATION, S: GRAPHIC DESIGN **SPRAY FRIENDS** L: MY SOKET EVILMATE, ALL THE EVIL STREET ARTISTS . . . ACT EVIL, THINK EVIL, BE EVIL!, S: MY LYL EVILMATE, AND SEE ABOVE. **SPRAY ENEMIES** L: ANGELS, CUTE AND INNOCENT CHILDREN, THE INGALLS FAMILY . . . , S: INNOCENT AND SILLY SPIRIT, LIKE CHRISTMAS, DISNEY (EXCEPT STITCH) AND BRITNEY . . . **ARTIST YOU WOULD LIKE TO COLLABORATE WITH** L: WOW... SO MANY PEOPLE! HALF OF THE STREET ART COMMUNITY, I GUESS, S: THE OTHER HALF OF THE STREET ART COMMUNITY ! **YOUR FIRST GRAFFITI** L: THIS YEAR, IN JANUARY. THE RESULT WAS TERRIBLE, I GUESS I'M NOT SO GOOD AT PAINTING . . . , S: TWO WEEKS BEFORE LYL, BUT NOW I'M AN ADDICT . . . **YOUR DEFINITION OF STREET ART** L: A POST-GRAFFITI MOVEMENT BASED ON THE PRINCIPLE OF FREE EXPRESSION, INTENDED FOR EVERYBODY, LOCATED EVERYWHERE, AND MADE TO ENLARGE PEOPLE'S ARTISTIC HORIZONS, S: ART IS STREET AND STREET IS OUR ! **FUTURE** EVILIZE MORE AND MORE WALLS, CITIES, PEOPLE, ALWAYS, ALL THE TIME ;) **FAME** "I'M GONNA LIVE FOREVER . . . I'M GONNA LEARN HOW TO FLY . . ." **INSPIRATION** L & S: MUCHA, TOULOUSE LAUTREC, TIM BURTON, EMILY THE STRANGE, FLYING FORTRESS, ALEXONE . . . L: GIL ELVGREN, MIST, CLAIRE WENDLING, RUN777, 9TH CONCEPT . . . , S: RENE GRUAU, SUPAKITCH, ATLAS, MISS TIC, G, LOISEL . . . **SURVIVAL KIT** L: MY DIGITAL CAMERA, A BUNCH OF EVILTOYS STICKERS, MY OLD PUMA SHOES, GOOD WORKING EYES, AND EVIL MOOD ;), S: A DIGITAL OR ARGENTIC CAMERA, STICKERS, THREE POSCAS (RED, WHITE, & BLACK), MY EVIL CAP AND— OF COURSE—EVIL MOOD.

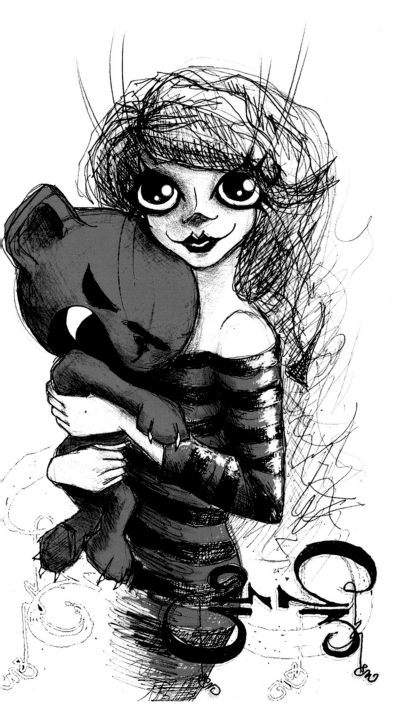

LYL and SOKET come from Paris. While they each do their own graffiti and illustrations, together they have created EVIL TOYS, their little museum of horrors, filled with diabolical creatures. The Evil Toys logo is a nostalgic throwback to our childhood, since it bears a strong resemblance to the MATTEL trademark. More information at www.fotolog.net/lyl9 and www.fotolog.net/soket.

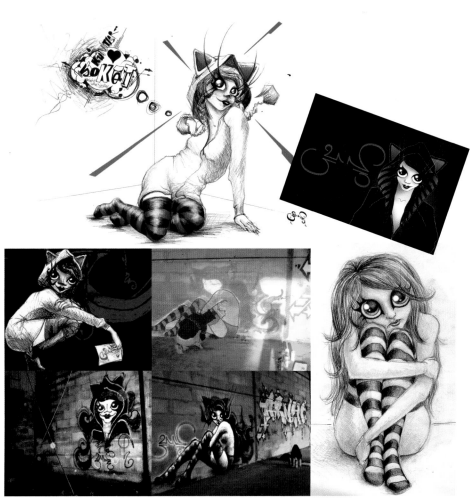

The biggest artistic expression of graffiti par excellence is the mural, with which the artist can display, in all its splendor, his or her mastery of technique and creativity.

Due to the murals' large size, the artists often use scaffolding to carry out this arduous task, so murals are generally found in outlying districts, abandoned factories, or industrial zones where the police tend to be more lenient.

Large murals help the general public see graffiti as art, rather than vandalism, so many municipalities designate certain spots in central locations where the artists can create more or less legally. These works of art blend perfectly with the urban architecture and landscape. The murals put together by different artists and collectives are the most striking, since we can see how the union of totally opposite styles, characters, wild-style letters, stencils, spray, and acrylic, come together in perfect harmony with truly interesting results.

Every year graffiti artists congregate in almost all the world's great capitals. This helps them get to know each other, share tricks and anecdotes, learn new styles, and—most important—enhance their mutual respect and admiration. Street art or post-graffiti is an artistic watershed which has now become part of art history.

STREETARAMA

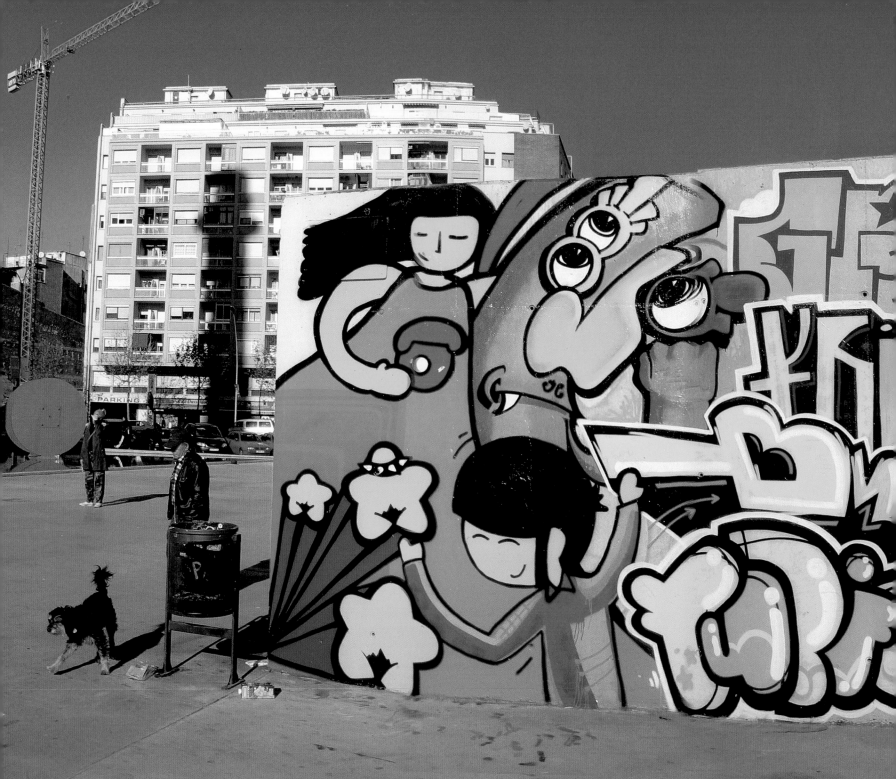

BIG MURAL BY RING+SAVAGE GIRL+KAN1+MR.EPS+GRANO+FRIK+BUJIA+YUBYA+LEINA BROWN+MEGAN. "LES TRES XIMENEIES" PARK. BARCELONA.

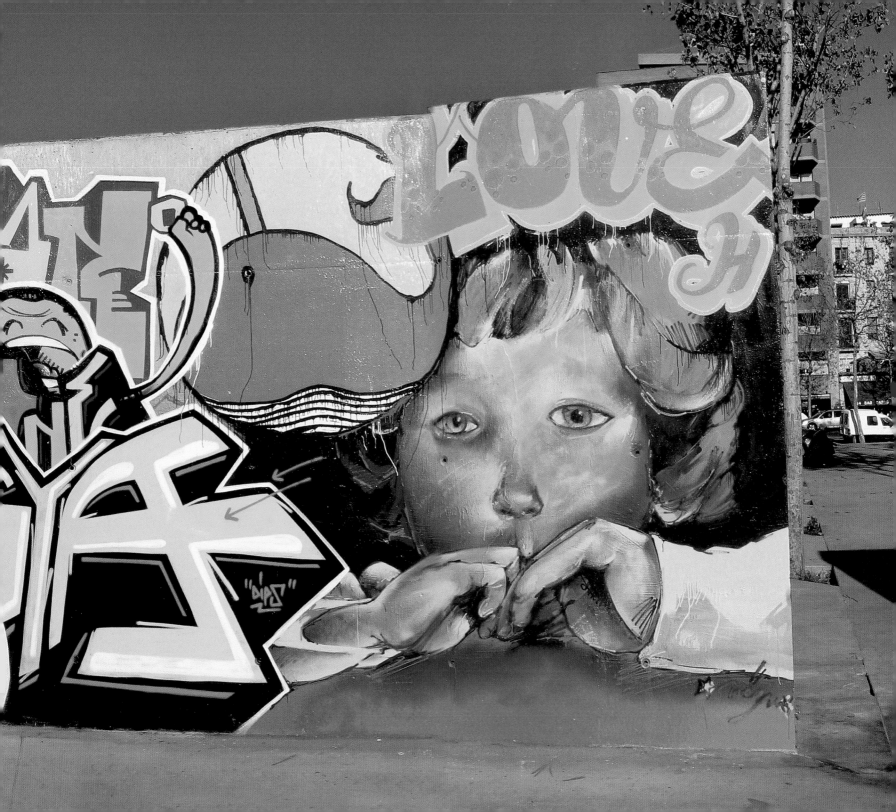

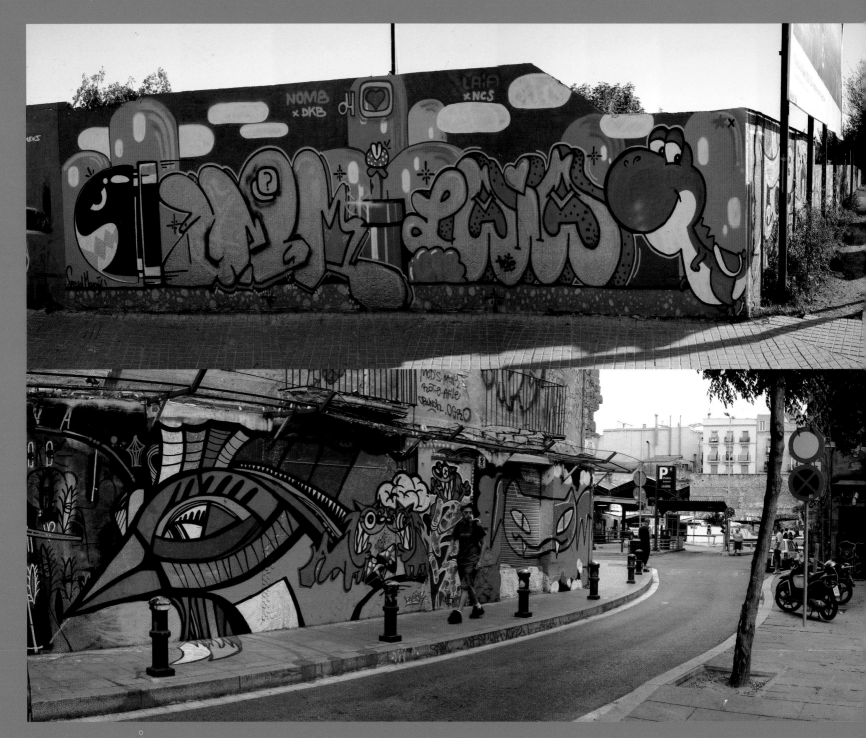

ABOVE WALL BY KODE+KENOR+EL PUTO ZAIK+CHANOIR.

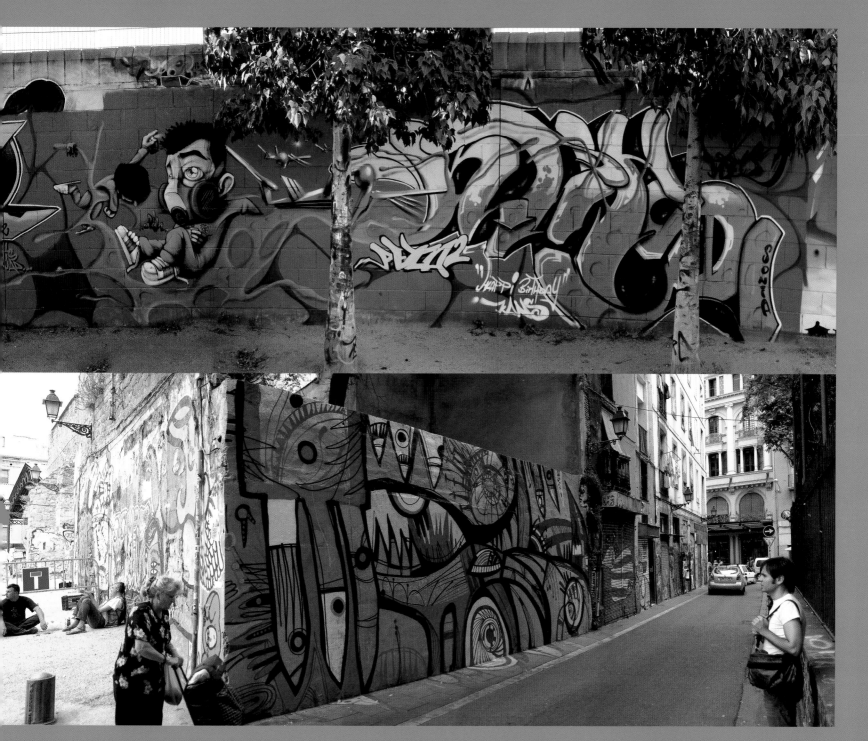

THIS PAGE SECOND ROW MURAL BY KODE AND KENOR.

SPRAY FILE 22

BIRDIE

www.birdiebcn.tk

BIRDIE uses sarcastic, threatening-looking birds as a tag. Hundreds of his birds live on the big city's walls, filling them with fun and color. While he mainly uses this character as his signature, he also surprises us from time to time with elaborate, giant murals, either solo projects or in collaboration with other graffiti painters. Like most of the artists, BIRDIE paints on the street for the sheer pleasure of doing it.

NAME HELIOS **AGE** 18 **CITY** BARCELONA **WORKING AREA** BARCELONA **SPRAY FRIENDS** MEN, AMH'S, RN1'S, TDC'S **SPRAY ENEMIES** . . . **ARTIST YOU WOULD LIKE TO COLLABORATE WITH** AMH'S **YOUR FIRST GRAFFITI** MY FIRST GRAFFITI WAS AT THE OLD MUSEUM OF CONTEMPORARY ART, WHEN IT WAS AN IMPROVISED GRAFFITI WORKSHOP **YOUR DEFINITION OF STREET ART** FREE EXPRESSION **FUTURE** NONE, JUST TO GO ON PAINTING **FAME** IS EASY TO GET BUT DIFFICULT TO KEEP **SURVIVAL KIT** TAKER, CHALK, WHITE BALLPOINT PEN, STICKERS.

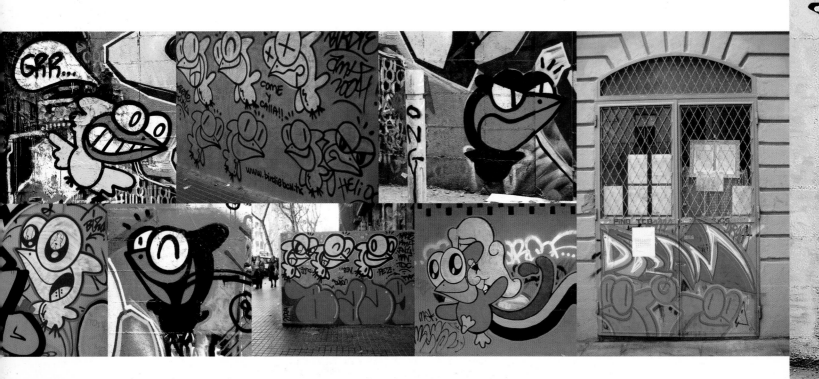

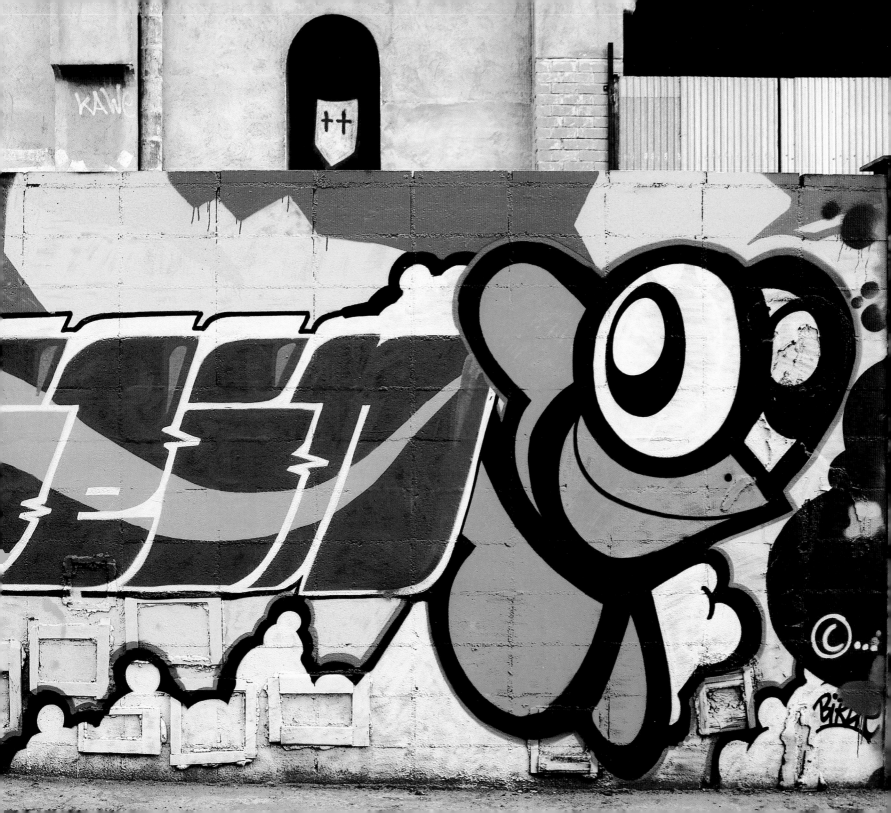

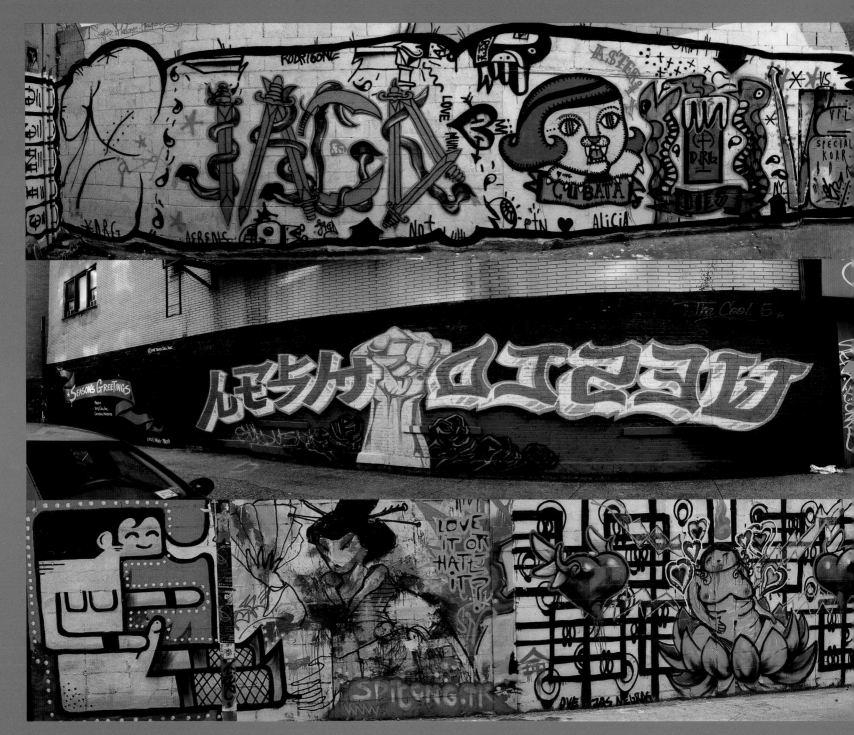

This page from top murals by 1980 crew (1). The cool five (2). Spit Ong (3).

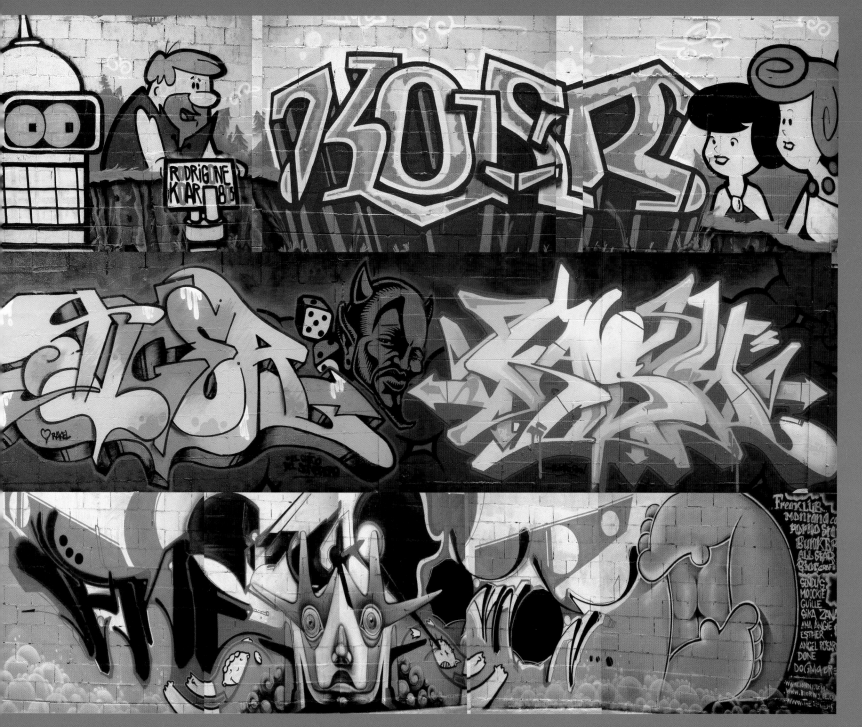

THIS PAGE FROM TOP MURALS BY RODRIGONE+KOAR FROM 1980 CREW (1). FREAKLÜB, PLUS OTHERS (3).

171

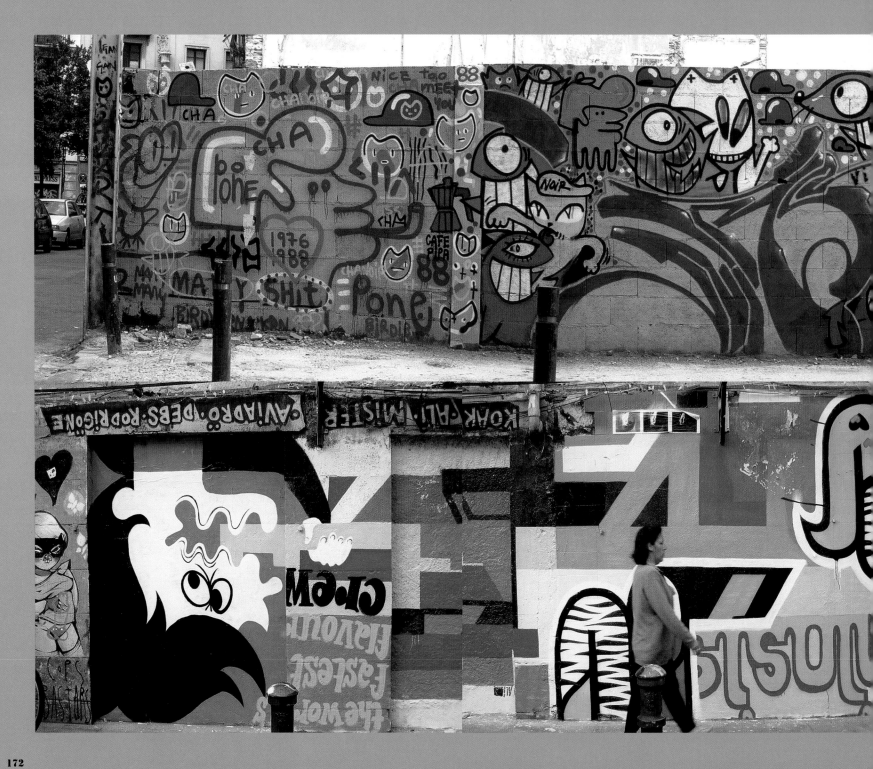

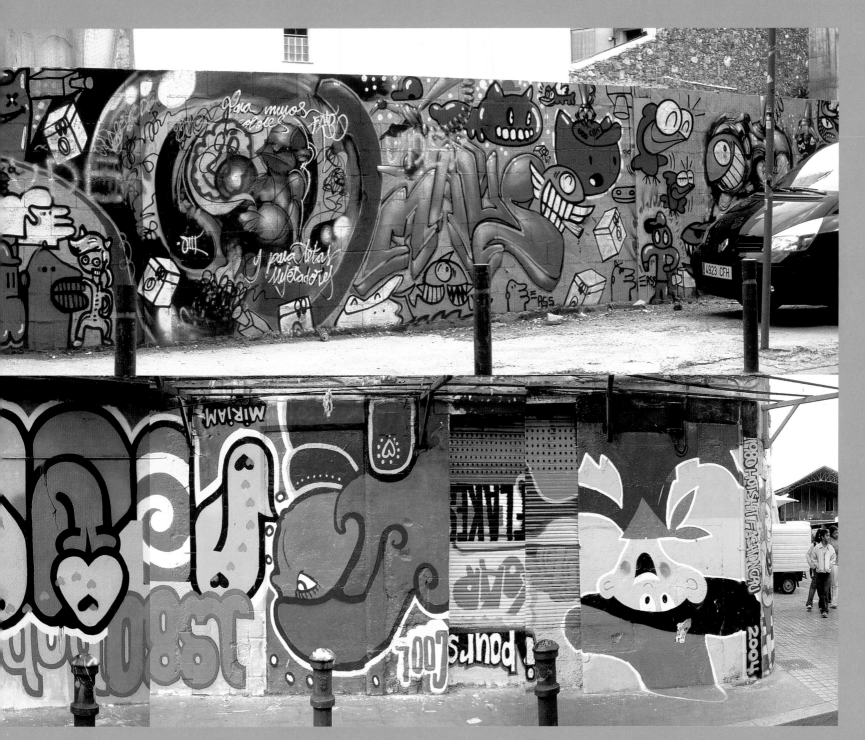

ON THESE PAGES TOP ROW MURAL BY CHANOIR+PEZ. BOTTOM ROW REVERSED MURAL BY 1980 CREW.

FAFI

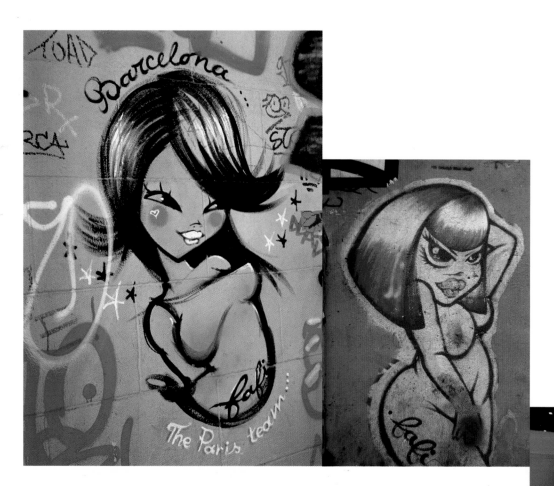

FAFI is known inside the graffiti scene because of her libidinous sexy girls. She began early in the 1990s painting her artworks all over the streets of Tolouse (France) and step by step her "fafinettes" have been painted worldwide. Since then she has had a lot of exhibitions in cities such as Paris, Los Angeles, Tokyo, and New York. Together with her boyfriend TILT and the group LE CLUB 70, FAFI has painted fantastic murals across Europe, the United States, and Asia. In 2002, Sony supported her vinyl dolls collection and began her own fashion clothing trademark. She has already published several monographic books with her art, and her girls have appeared on the cover and in the pages of the Japanese VOGUE edition, as well as on French Diet Coke cans. Some of her products can be found in shops such as Colette in Paris. FAFI is a "nonstop" phenomenom.

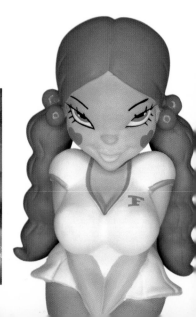

NAME FAFI **CITY** TOULOUSE/PARIS **WORKING AREA** THE STREETS, FORGOTTEN AND HIDDEN PLACES. **SPRAY FRIENDS** LECLUB, SHARP, JON ONE, COPE 2 MAC CREW, OS GEMEOS, KORALIE & SUPAKITCH, 123 KLAN, ZORI 4, T.KID,INK 76… **SPRAY ENEMIES** WHAT? **ARTIST YOU WOULD LIKE TO COLLABORATE WITH** THOSE WHO ARE COOL **YOUR FIRST GRAFFITI** IN 1994, ON A TRAIN DURING NEW YEAR'S EVE **YOUR DEFINITION OF STREET ART** FREE, COOL SPIRIT, RESPECT, COMPETITION, MOTIVATION, INSPIRATION. FUTURE TRANSLATE ALL MY FEELINGS INTO THIS ART **FAME** BEING SUCCESFUL IN CHOOSING WHAT I LOVE TO DO **SURVIVAL KIT** TWO BRUSHES, A BIG AND A SMALL, AND A BLACK ACRYLIC CAN

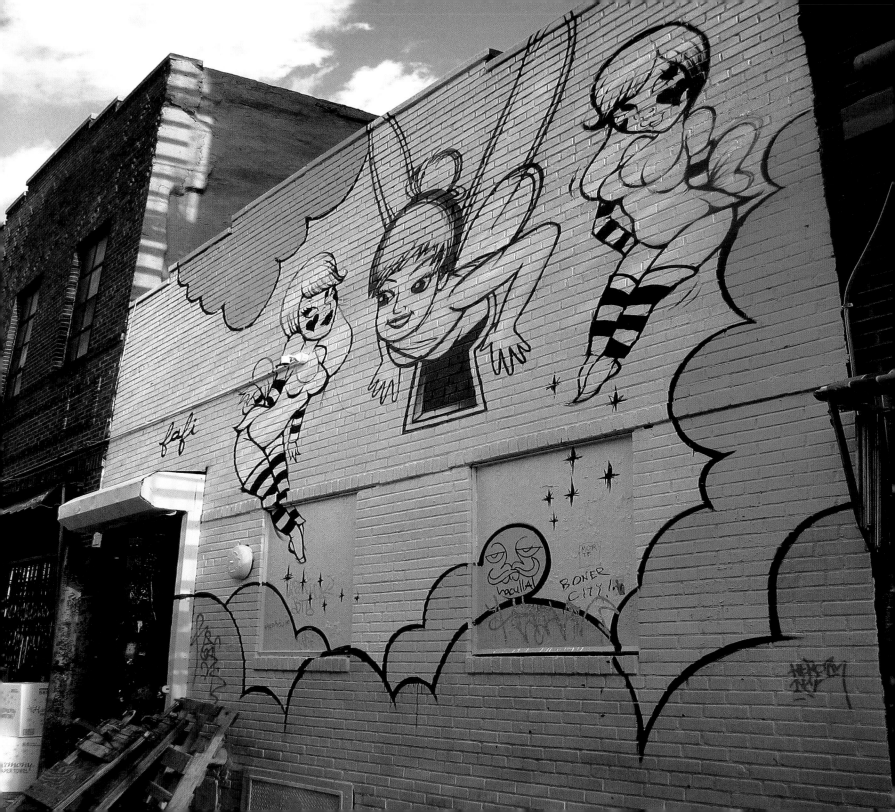

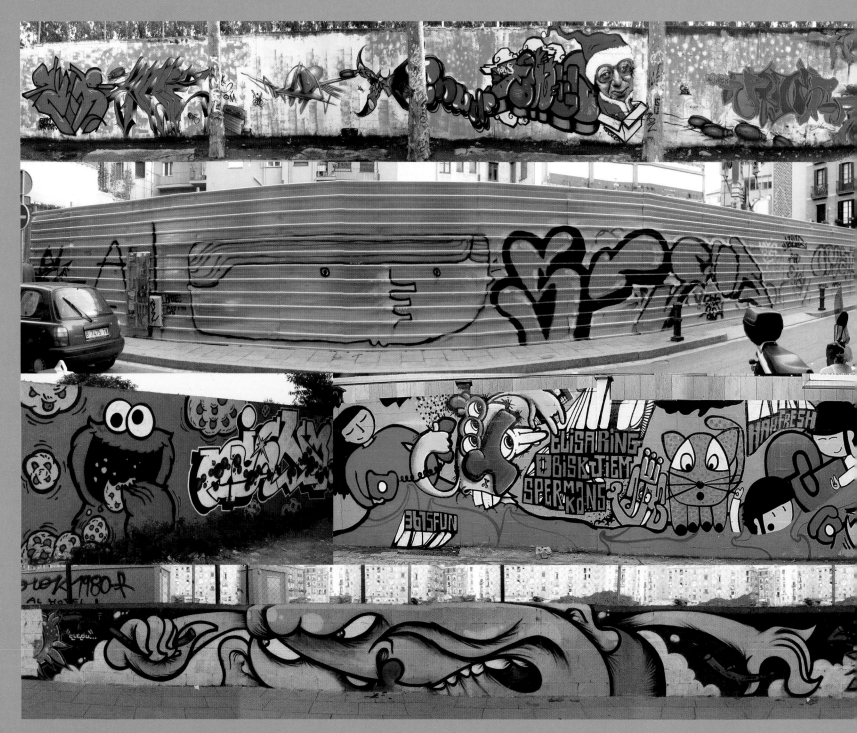

THIS PAGE FROM TOP LEFT TO RIGHT MURALS BY SAGÜE (1). SPIT (2). RING+SPERM+KANS+ELISA+OBISK+JIEM (4). BOTTOM ROW BIG MURAL BY EL EDU+JLOCA.

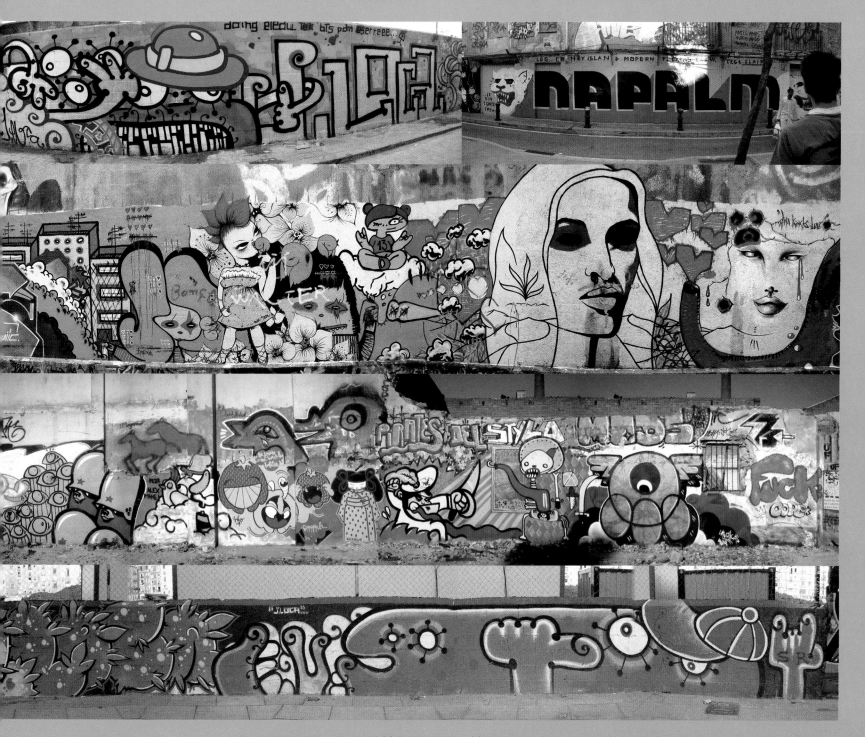

THIS PAGE FROM TOP LEFT TO RIGHT JLOCA (1). MISS VAN+SIXE+DIVA (3). PEZ+SUPAKITCH+KORALIE+FLYING FORTRESS PLUS OTHERS (4). BOTTOM ROW BIG MURAL BY EL EDU+JLOCA.

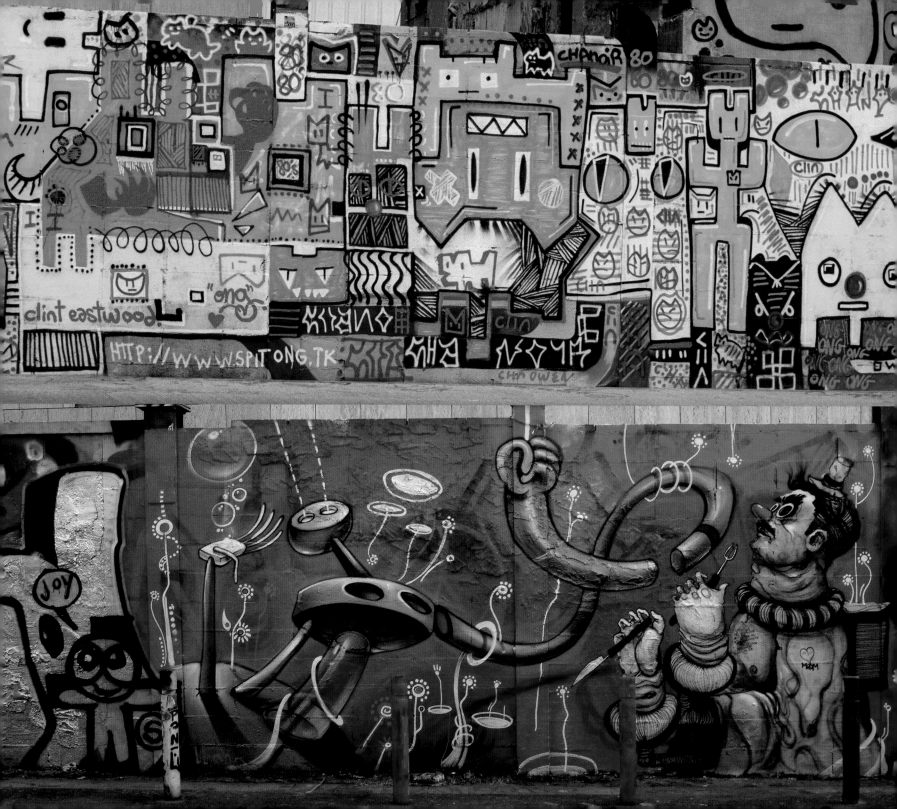

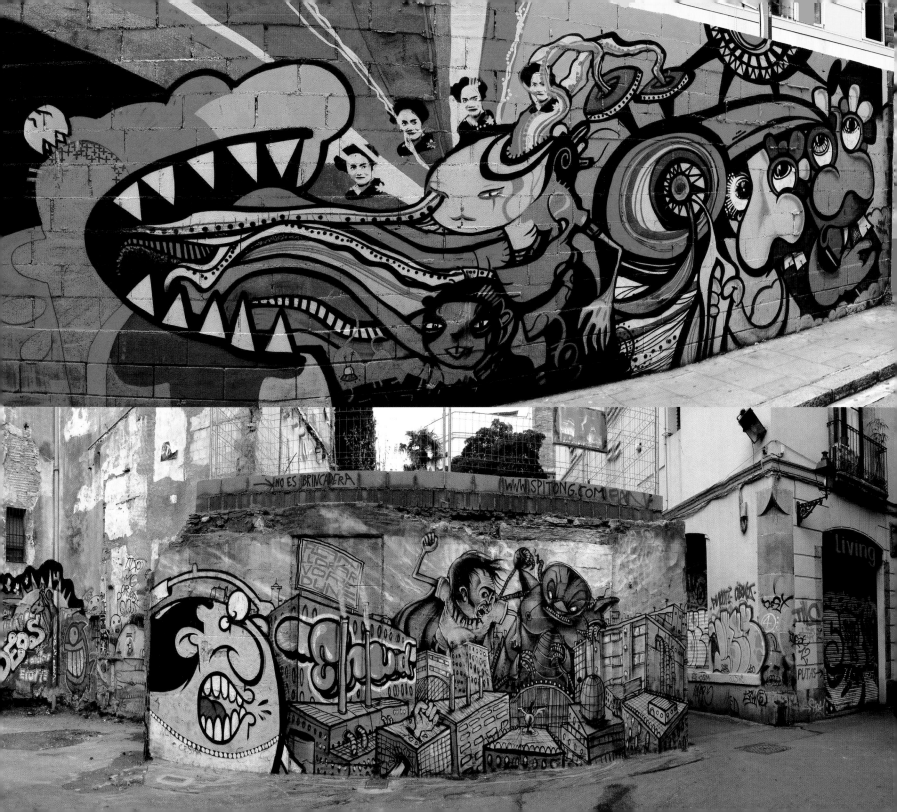

Although he was born in Bogota, CHANOIR was raised in Paris, one of the art capitals of the world.

He belongs to a generation who grew up watching television, and he is inspired by the cartoons of the 1980s.

His main character is the cat, CHA, which he began painting on the streets of Paris in the mid-1990s. Over time, his cats began to take on their own personalities and went on from the Parisian streets to become famous on the Barcelona graffiti scene. His style is very simple and reminiscent of the US artist Keith Haring.

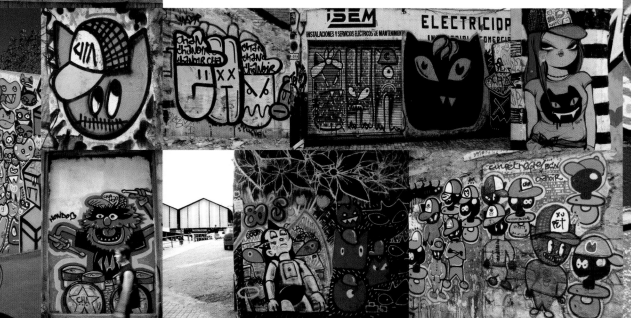

FOLLOWING PAGES BIG MURAL BY CHANOIR IN BARCELONA.

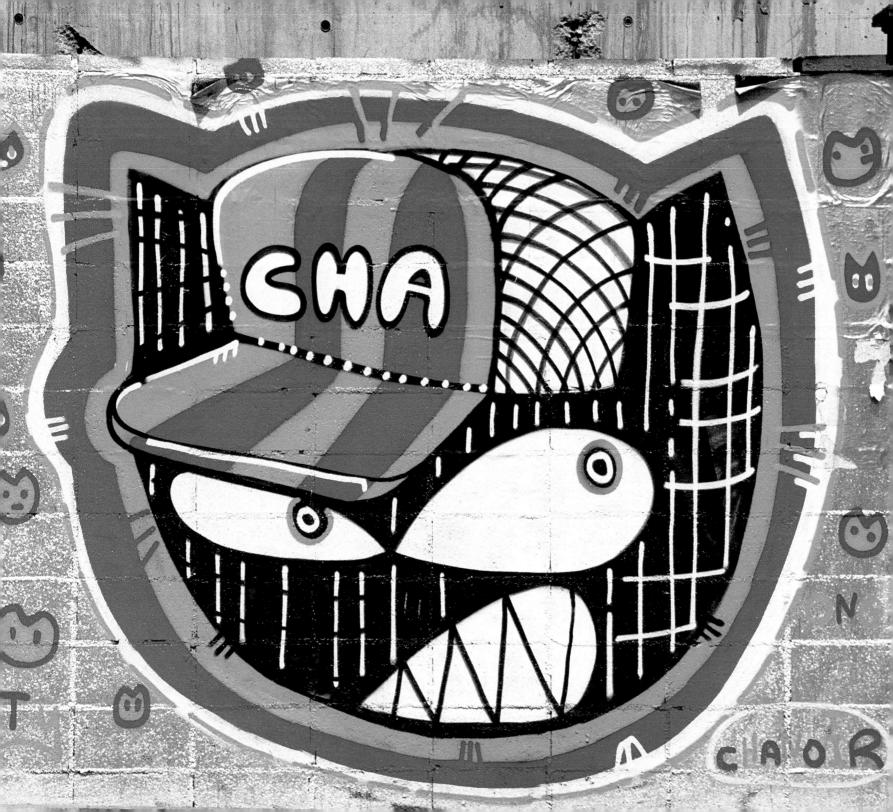

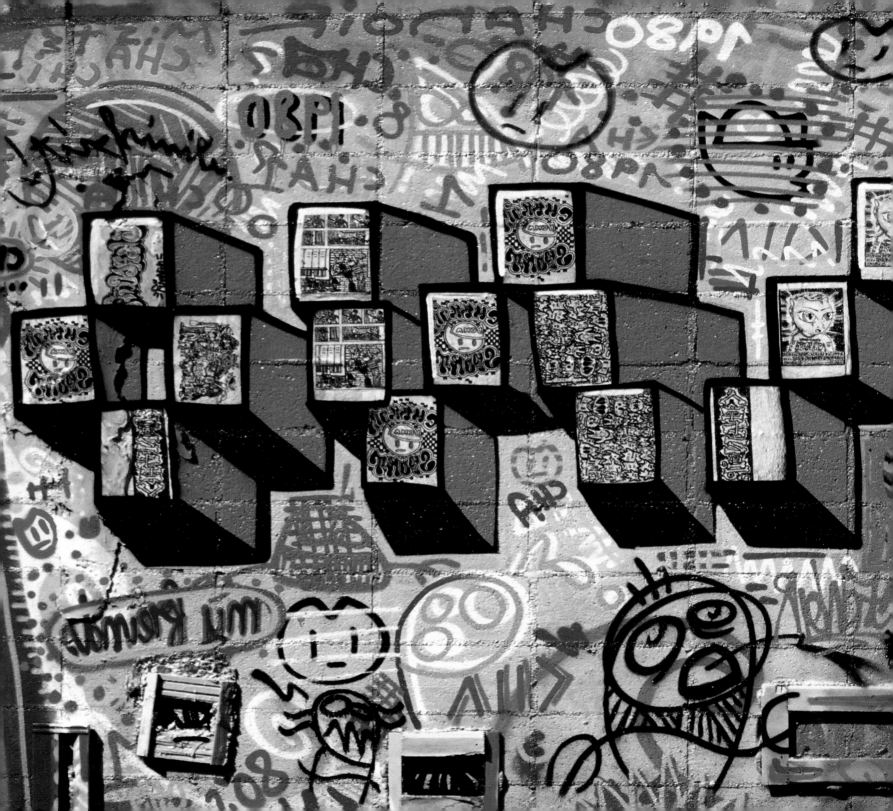

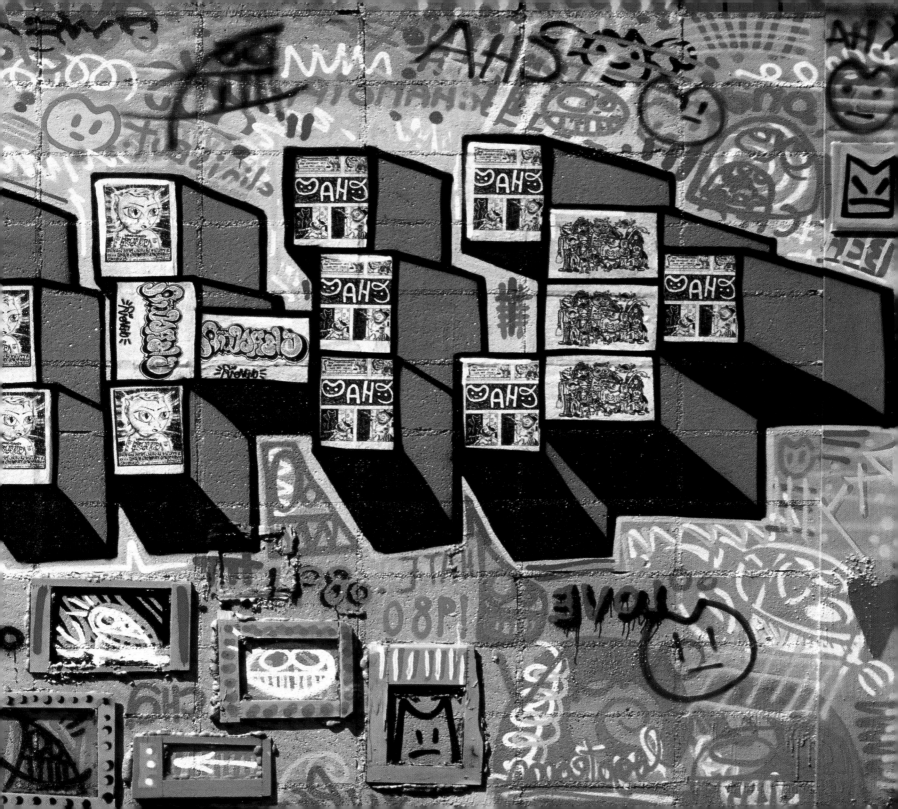

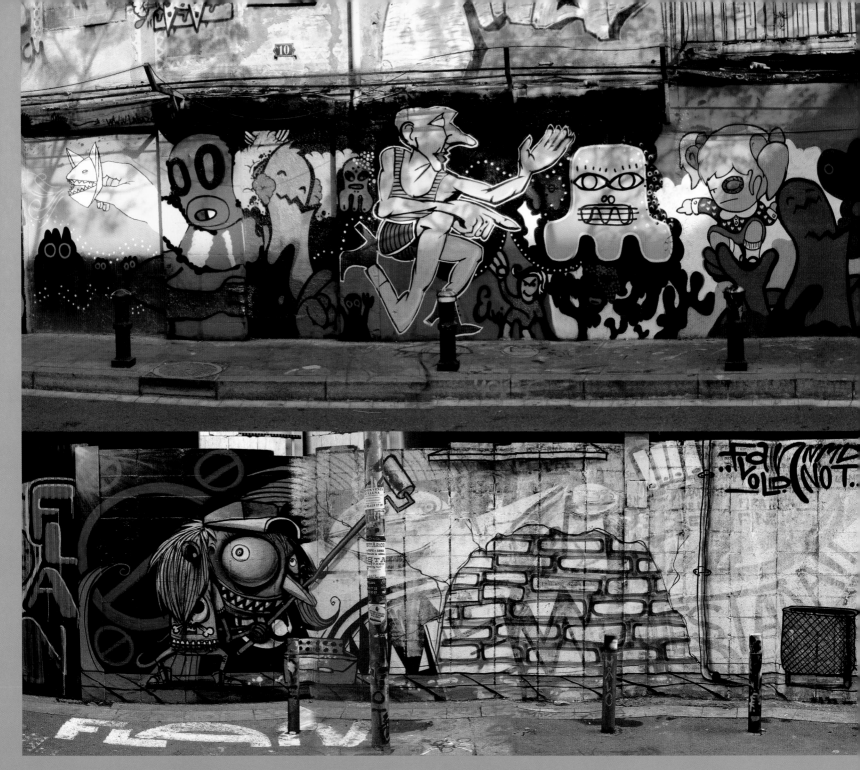

TOP ROW AND SPREAD MURAL BY FREAKLÜB+BORIS HOPPEK+TOFER. BOTTOM ROW MURAL BY FLAN.

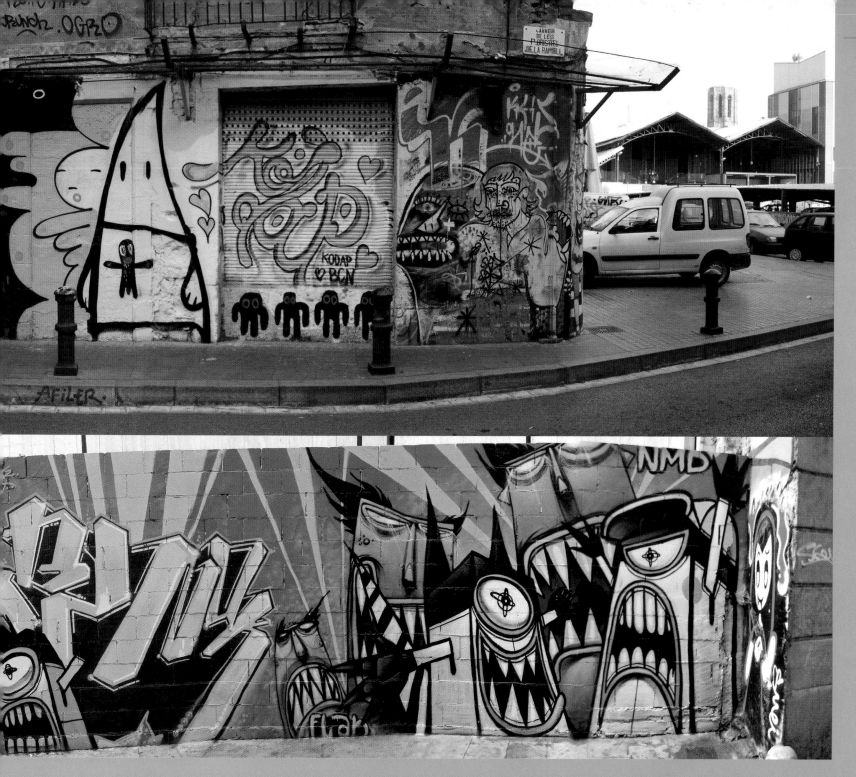

THIS PAGE BOTTOM ROW MURAL BY FLAN.

185

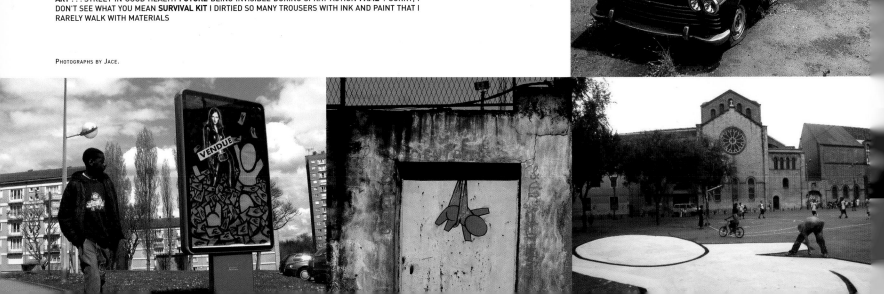

Gouzou, his main character, was born of JACE's creativity and has become a truly local celebrity on Reunion Island, a small island on the Asian ocean where this artist lives. He works half-time as a drawing teacher combined with his "work" on the streets.

JACE interacts with the billboards, making social critique with a hint of humor.

As many artists who have created their own style, JACE travels around the world frequently, leaving evidence of his art in cities such as Barcelona.

NAME JACE **AGE** 31 **CITY** REUNION ISLAND (INDIAN OCEAN) **WORKING AREA** JUST AROUND THE CORNER . . . **SPRAY FRIENDS** THE MOON AND THE STARS, FAT CAP, PUBLIC . . . **SPRAY ENEMIES** GAZ TOXICITY, RAIN, BARBLE WIRES, DOGS, COPS, WANABEE TOYS !!!! **ARTIST YOU WOULD LIKE TO COLLABORATE WITH** THERE'S A LOT OF ARTISTS THAT I APPRECIATE AND RESPECT AND WHO INSPIRE ME , BUT THEY ARE NOT NECESSARILY PEOPLE I WANT TO COLLABORATE WITH. MY KIND OF PAINTING IS NOT EASY TO MIX WITH SOMEONE ELSE'S **YOUR FIRST GRAFFITI** I WROTE "WALL" UNDER A BRIDGE IN 1989, IT WAS A BLUE FILLING WITH OUTLINE AND HIGHLIGHT AND IT'S STILL THERE !!!!!! **YOUR DEFINITION OF STREET ART** . . . STREET IN GOOD HEALTH **FUTURE** BEING INVISIBLE DURING SPRAY ACTION **FAME** ? SORRY, I DON'T SEE WHAT YOU MEAN **SURVIVAL KIT** I DIRTIED SO MANY TROUSERS WITH INK AND PAINT THAT I RARELY WALK WITH MATERIALS

PHOTOGRAPHS BY JACE.

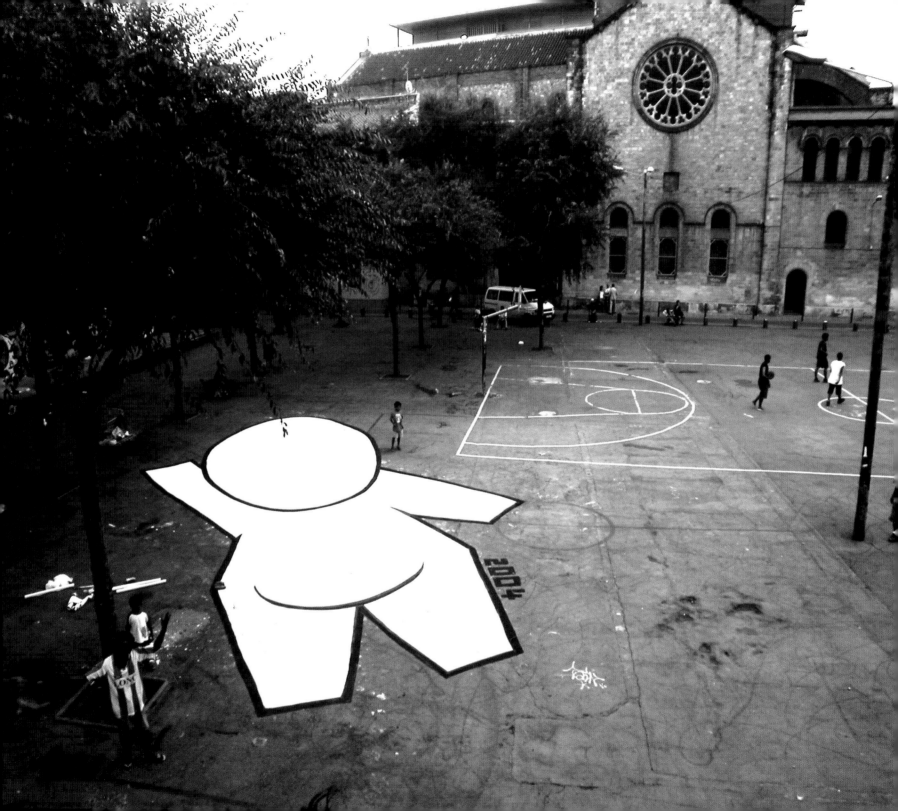

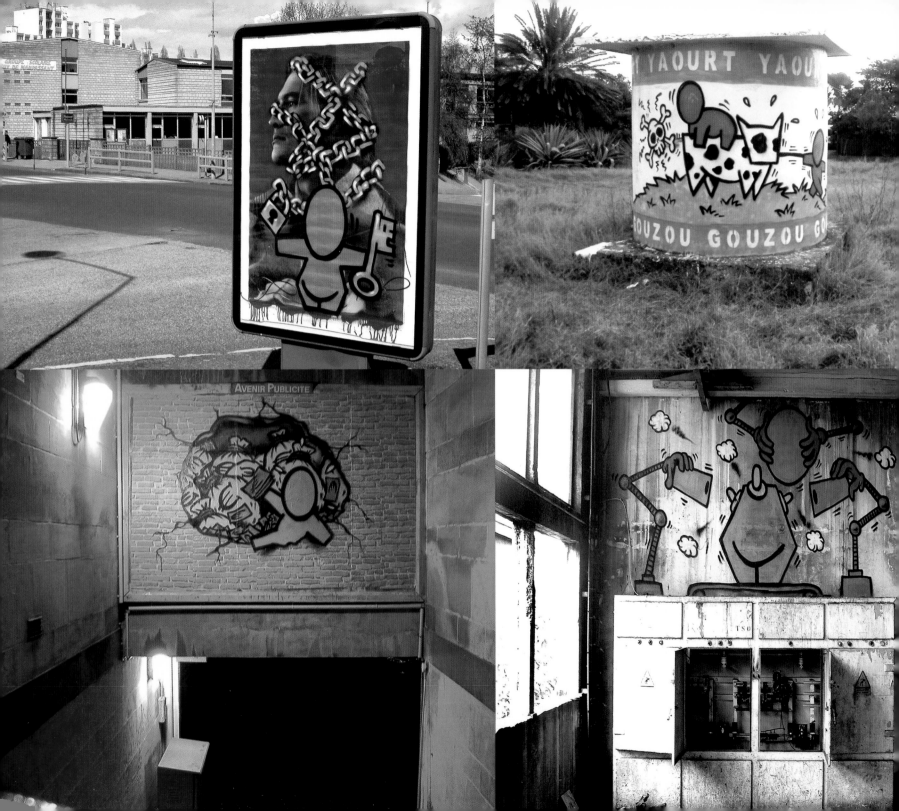

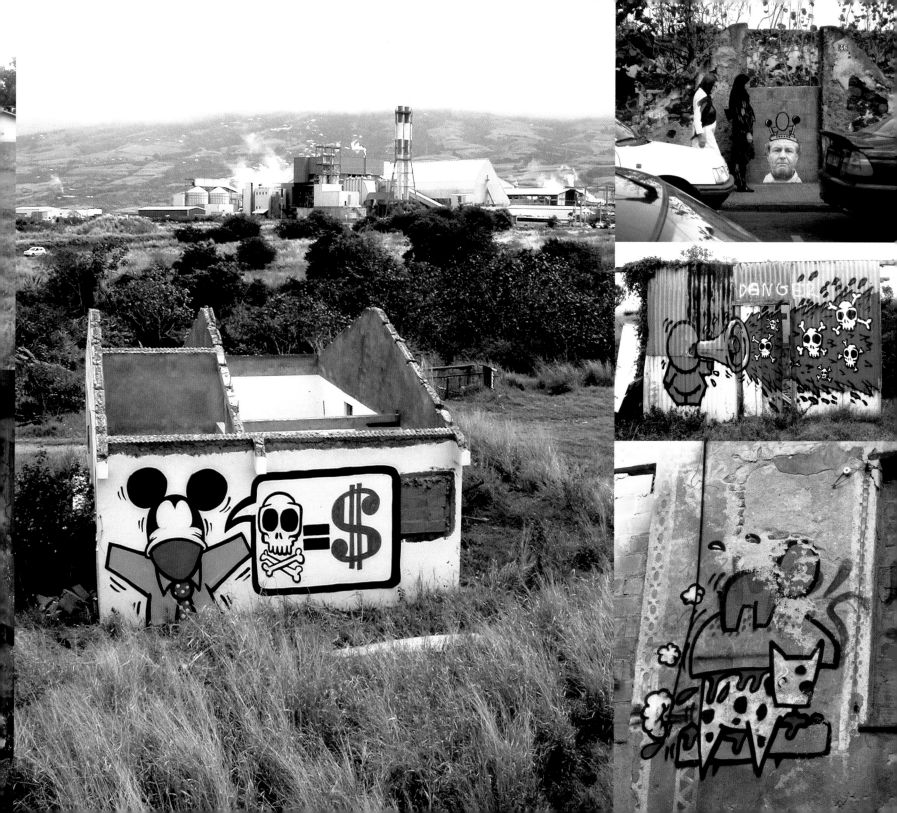

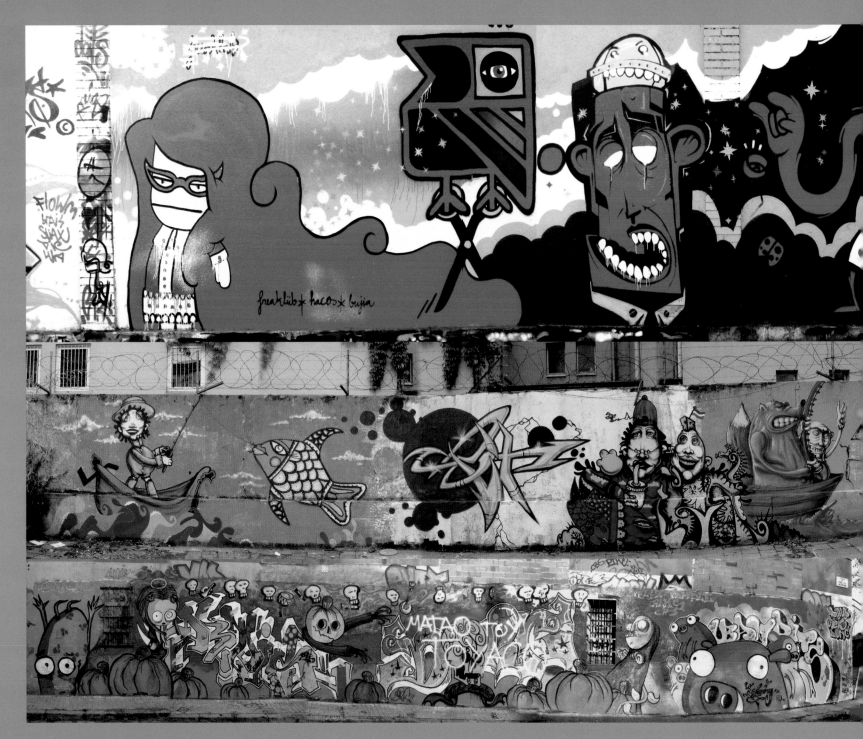

TOP ROW SPREAD GIGANTIC MURAL BY FREAKLÜB+HAKO+BUJÍA. THIS PAGE SECOND ROW MURAL IN FRANKFURT (GERMANY). THIRD ROW MURAL BY THE BANDITS CREW.

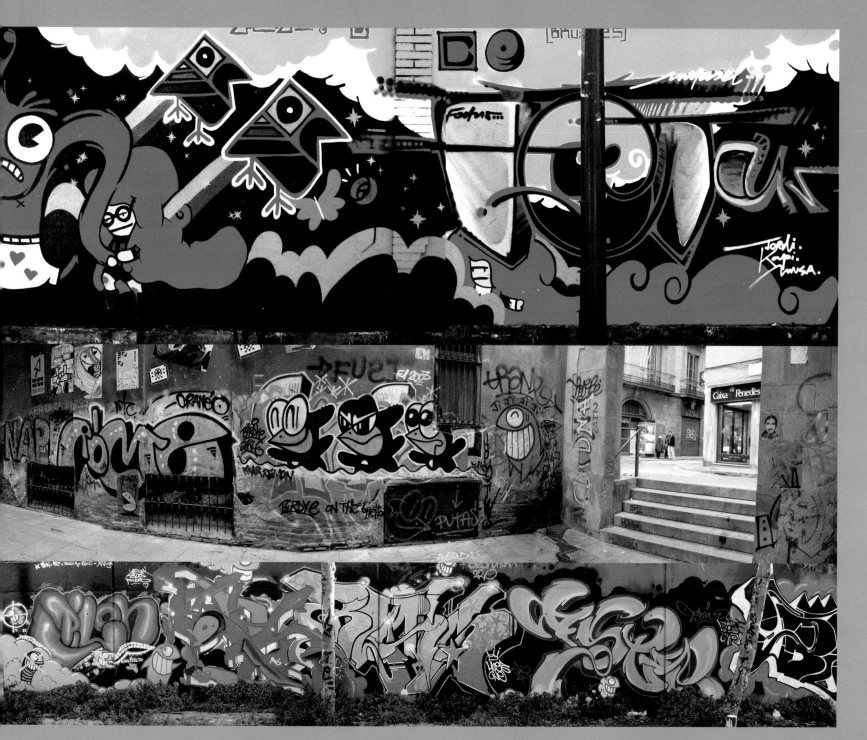

THIS PAGE SECOND AND THIRD ROW MURALS BY BIRDIE+PEZ AND OTHERS.

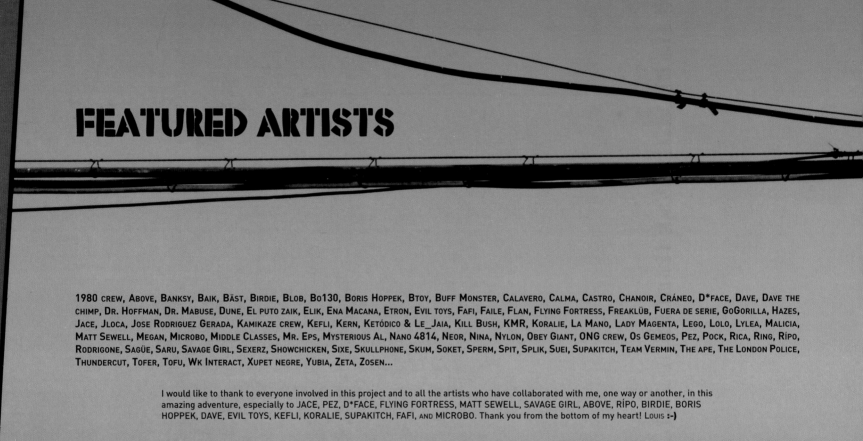

FEATURED ARTISTS

1980 crew, Above, Banksy, Baik, Bäst, Birdie, Blob, Bo130, Boris Hoppek, Btoy, Buff Monster, Calavero, Calma, Castro, Chanoir, Cráneo, D*face, Dave, Dave the chimp, Dr. Hoffman, Dr. Mabuse, Dune, El puto zaik, Elik, Ena Macana, Etron, Evil toys, Fafi, Faile, Flan, Flying Fortress, Freaklüb, Fuera de serie, GoGorilla, Hazes, Jace, Jloca, Jose Rodriguez Gerada, Kamikaze crew, Kefli, Kern, Ketódico & Le_Jaia, Kill Bush, KMR, Koralie, La Mano, Lady Magenta, Lego, Lolo, Lylea, Malicia, Matt Sewell, Megan, Microbo, Middle Classes, Mr. Eps, Mysterious Al, Nano 4814, Neor, Nina, Nylon, Obey Giant, ONG crew, Os Gemeos, Pez, Pock, Rica, Ring, Rípo, Rodrigone, Sagüe, Saru, Savage Girl, Sexerz, Showchicken, Sixe, Skullphone, Skum, Soket, Sperm, Spit, Splik, Suei, Supakitch, Team Vermin, The ape, The London Police, Thundercut, Tofer, Tofu, Wk Interact, Xupet negre, Yubia, Zeta, Zosen...

I would like to thank to everyone involved in this project and to all the artists who have collaborated with me, one way or another, in this amazing adventure, especially to JACE, PEZ, D*FACE, FLYING FORTRESS, MATT SEWELL, SAVAGE GIRL, ABOVE, RÍPO, BIRDIE, BORIS HOPPEK, DAVE, EVIL TOYS, KEFLI, KORALIE, SUPAKITCH, FAFI, and MICROBO. Thank you from the bottom of my heart! LOUIS :-)

ALL PHOTOGRAPHS BY LOUIS BOU EXCEPT INDICATED